Race and Urban Space in
Contemporary
American Culture

Race and Urban Space in Contemporary American Culture

Liam Kennedy

FITZROY DEARBORN PUBLISHERS
CHICAGO • LONDON

© Liam Kennedy, 2000

Published in the United Kingdom by
Edinburgh University Press Ltd
22 George Square, Edinburgh

Published in the United States of America by
Fitzroy Dearborn Publishers
919 North Michigan Avenue,
Chicago, Illinois 60611

Typeset in Melior by
Pioneer Associates, Perthshire, and
printed and bound in Great Britain by
The University Press, Cambridge

A Cataloging-in-Publication record for this book is
available from the Library of Congress

ISBN 1-57958-280-X Fitzroy Dearborn

Contents

To Maria

Acknowledgements

My work on this book was assisted by grants from the Arts and Humanities Research Board and the University of Birmingham, and by a fellowship from the University of Iowa. Portions of the text, in somewhat different form, were published in the *Journal of American Studies* 30 (1996), *Modern Fiction Studies* 43/1 (1997), *Writing and Race* (London: Longman, 1997), Criminal Proceedings (London: Pluto Press, 1997), and *Urban Space and Representation* (London: Pluto Press, 1999). I am grateful to the editors involved – Michael Heale, Donald Pease, Tim Youngs, Peter Messent, Maria Balshaw and Anne Beech – for their advice and support.

Thanks to Bill Savage in Chicago for leading me through the streets of that city; and to Stephen Shapiro who did a similar job in NYC. I am indebted to the good folks in (if not all of) Iowa City who provided a stimulating environment in which to rethink American Studies scholarship. Warm thanks to Maureen Montgomery, John Raeburn and Barbara Eckstein for their time and conversation.

The Urban Cultures Seminar group, based at University of Birmingham, provided an invaluable forum for testing out ideas and for heated discussion about American urbanism. Thanks to all participants and in particular to Jude Davies and Carol Smith, a model intellectual partnership. Extra thanks to Peter Brooker for his support of the seminar and for his encouragement and patience as editor of the 'Tendencies' series at Edinburgh University Press. Working on the 'Three Cities' project, based at Birmingham and University of Nottingham (but now disseminated to all spaces the Internet can reach – visit our website at www.nottingham.ac.uk/3cities) also challenged and shaped my thinking on urban representation. My thanks to Douglas Tallack for his intellectual guidance.

Among my colleagues at University of Birmingham, I owe special

thanks to Scott Lucas, a good friend as well as a considerate head of department. I am also grateful to the many students at Birmingham who redirected and sustained my interest in representations of American urbanism.

Thanks to Nathan and Jake who allowed me to see American cities through the eyes of children. Finally, love and respect to Maria Balshaw, as well as thanks for her intelligent criticism. I am forever attached to the space we share.

Series Editor's Introduction

Contemporary history continues to witness a series of momentous changes, altering what was only recently familiar ideological, political and economic terrain. These changes have prompted a new awareness of subjective, sexual, ethnic, racial, religious and cultural identities and of the ways these are constructed in metropolitan centres, regions and nations at a time when these spheres are themselves undergoing a period of critical transition. Recent theory has simultaneously encouraged a scepticism towards the supposed authenticity of personal or common histories, making identity the site of textualised narrative constructions and reconstructions rather than of transparent record. In addition, new developments in communication and information technology appear to be altering our fundamental perceptions of knowledge, of time and space, of relations between the real and the virtual, and of the local and the global.

The varied discourses of literature and media culture have sought to explore these changes, presenting life as it is negotiated on the borderlines of new hybridised, performative, migrant and marginalised identities, with all the mixed potential and tension these involve. What emerge are new, sometimes contradictory perceptions of subjectivity or of relations between individuals, social groups, ideologies and nations, as the inner and public life are rewritten in a cultural environment caught up in religious and political conflict and the networks of global consumption, control and communication.

The series 'Tendencies: Identities, Texts, Cultures' follows these debates and shows how the formations of identity are being articulated in contemporary literary and cultural texts, often as significantly in their hybridised language and modes as in their manifest content.

Volumes in the series concentrate upon tendencies in contemporary writing and cultural forms, principally in the work of writers,

artists and cultural producers over the last two decades. Throughout, its consistent interest lies in the making and unmaking of individual, social and national identities. Each volume draws on relevant theory and critical debate in its discussion *inter alia* of questions of gender and sexuality, race and ethnicity, class, creed and nation, in the structuring of contemporary subjectivities.

The kinds of texts selected for study vary from volume to volume, but most often comprise written or visual texts available in English or widely distributed in English translation. Since identities are most often confirmed or redefined within the structures of story and narrative, the series is especially interested in the use of narrative forms, including fiction, autobiography, travel and historical writing, journalism, film and television.

Authors are encouraged to pursue intertextual relations between these forms, to examine the relations between cultural texts and relevant theoretical or political discourse, and to consider cross-generic and intermedia forms where these too bear upon the main concerns of the series.

Peter Brooker
University College, Northampton

The Miasma of Urbanisation

In his novel *Philadelphia Fire* (1990) John Edgar Wideman's narrator, commenting on how to respond to 'the tragedy of a city burning', proposes:

What we need is realism, the naturalistic panorama of a cityscape unfolding. Demographics, statistics, objectivity. Perhaps a view of the city from on high, the fish-eye lens catching everything within its distortion, skyscraper heads together, rising like sucked up through a straw. If we could arrange the building blocks, the rivers, boulevards, bridges, harbor, etc. etc. into some semblance of order, of reality, then we could begin disentangling ourselves from this miasma, this fever of shakes and jitters, of self-defeating selfishness called urbanization.[1]

Wideman 's narrator articulates a common desire for urban legibility: to know the city as a whole, to render it visible and readable. This is a fantasy of much modern and postmodern urban aesthetics and theorising, in which quests for legibility have long stimulated efforts to explain the 'truth' of the city.[2] However, Wideman also slyly undermines the quest, suggesting that the effort to obtain a privileged perspective on the city produces a 'distortion ' of its object. The will to transparency only produces opacity, and point of view remains mired in the 'miasma ' of urbanisation. Wideman not only offers a formal lesson in urban perception here, he is also addressing issues of cultural and ideological distortion. The city the narrator is trying to get an objective perspective on is a particular city, Philadelphia, at a significant time in its history, the aftermath of an incident in which police fire-bombed a row-house killing members of an Afrocentric cult. In other words, the vision he seeks is one of racial clarity; that it is not forthcoming is indicative not of the failure of his vision (optical or ideological) but of the ways in which 'race' is entangled with common perceptions of 'the city'.

The promise of legibility has a particular significance when we consider the role of race in representations of the city. Noting that 'racialised metaphor' is commonly used to articulate contemporary urbanism, Michael Keith and Malcolm Cross argue that race 'is a privileged metaphor through which the confused text of the city is rendered comprehensible'.[3] In other words, race commonly functions to frame ways of seeing and reading the city, though this is not necessarily an explicit or transparent practice. As Wideman implies above, the relationship between the city as material environment and as imaginary space is one that is rendered opaque as well as transparent by the workings of representation. He draws our attention to the (il)legibility of race as this is composed within networks of spatial production and cultural representation. In this study, the generative relations of space, race, and representation are brought under analysis with the understanding that they provide us with a provisional framing of the city as a readable and visible entity.

The socio-spatial restructuring of the American city in the 1980s and 1990s has been widely represented in literary and visual forms – including novels, journalism, photography, film and television – which have contributed to the forming of a new urban imaginary, a conceptual restructuring which not only reflects but also shapes contemporary urbanism. This imaginary is not a unified construct, but rather a confusing and conflicting ideological terrain of values and assumptions, fears and desires, in which race plays an important structuring role. Not for the first time, but in distinctive and intensive ways, the 'problem of race' in the United States has been focused in urban centres in the last twenty years, and more specifically within the postindustrial ghetto.[4] In this book I will examine some of the ways in which race is posed as a 'problem ' in representations of American cities and analyse ways in which it has been represented as a lived experience and a complex ideological formation conditioned by urbanisation. My study is consciously skewed towards a white (WASP and ethnic) and black (African-American) axis of urban relations and I will argue that patterns of concentration and dispersal, and of acculturation and social mobility, have shaped distinctive imaginary investments in the spaces of the urban core on the part of both white and black cultural producers.[5]

POSTMODERN URBANISM AND THE
CRISIS OF URBANITY

The cores of American cities have been radically transformed in the

last twenty years: accelerated patterns of deindustrialisation and growth of service-based urban economies; new patterns of decentralisation and recentralisation, with the movement of people and offices to suburban areas offset by economic and cultural redevelopment of core neighbourhoods; the influx of immigrants, mostly from sources in south-east Asia and Latin America; the regeneration of the culture industries of city cores under the influence of an unregulated global capitalism; the privatisation and militarisation of publics spaces; and the concentration of a new urban 'underclass – all have contributed to changes in the spatial, cultural and political form of the city. The redifferentiation of urban space caused by these changes has produced new forms of concentration and separation and new conceptions of centrality and marginality. It has also prompted anxious concerns about the uses and perceptions of urban cores as cities implode into fragmented spaces and explode into metastasised urban agglomerations. While these changes have historical roots stretching well beyond the last twenty years they have coalesced in this period to produce a perceptible crisis of urbanity which poses compelling questions: what are cities for? what does civic identity mean? 'can we all get along?'. The last of these questions, voiced by Rodney King in the aftermath of violence in Los Angeles in 1992, is perhaps the most haunting refrain of the urban imaginary I examine.

This crisis of urbanity has become a notable issue of representation in American culture and I will return to it throughout this study. In the formulation of the classic tradition of American urban studies (from the Chicago School onwards) urbanity is the phenomenon of collectivity which emerges from the close proximity of strangers and face-to-face relations in public urban space.[6] It valorises the multifarious forms of social interaction and interdependence in the city – the erotic and aesthetic variety of street life, the close encounters with strangers, the freedoms of access and movement in public spaces – positing these as the very essence of urban life and the necessary conditions of democratic citizenship. Today, this pluralistic view of urban life still has its adherents but is now broadly questioned as the close proximity of strangers in the city refuses to cohere into a civic unity and public space becomes increasingly privatised, commodified and militarised. The crisis of urbanity in the United States reflects both the inadequacies of its conventional formulations and its failure to ideologically map the difference of urban social relations. What remains of the classic discourse tends toward nostalgic lament for the 'loss' of public space while postmodern urban planners and designers revalorise the meaning of urbanity to promote 'liveable'

spaces for the (predominantly white) middle classes.[7] In each instance the centrality of race to the configuration of contemporary urbanism is rarely acknowledged.

While it is a truism that the American city is always being reinvented and exists in a perpetual state of reconstruction – driven by dialectics of growth and decline, settlement and flux – this is not a comfortable assumption for all Americans. Contemporaneous and seemingly contradictory forces of regeneration and decline have not only followed economic patterns but have referred to broader ideological investments in the city; they impinge on a public consciousness of urban development and stimulate a deep-seated ambivalence toward the city which has a long cultural history in the United States. The American city has long been 'an abstract receptacle for displaced feelings about other things', and narratives of anti-urbanism can be traced from at least the mid nineteenth century.[8] Robert Beauregard has argued that since the mid twentieth century anti-urbanism has been powerfully motivated within 'a fully developed discourse on urban decline' in the United States, one that has been expanded and elaborated upon to express wide-ranging social contradictions and antagonisms in the last fifty years. This discourse is tied to the material conditions and transformations of urban society, but it is also a symbolic screen for national concerns. As Beauregard observes, the discourse 'functions to site decline in the cities. It provides a spatial fix for our more generalized insecurities and complaints'.[9] In the 1980s and 1990s the discourse of urban decline has served to focus anxieties about the dissolution of the national culture, about citizenship and about race relations. It has mediated the crisis of urbanity as a register of contemporary concerns about the formation and functions of American society. This mediation has compressed the meanings of urban transformation into stock representations – narratives, images and metaphors – of decline.

With reference to race in particular, Beauregard argues that 'urban decline and race become intertwined as cause and consequence ... by displacing race onto decline white society avoids its complicity in inequalities and injustices ... by displacing decline onto race American society abandons the city to minorities'.[10] Perhaps the most potently racialised metaphor of decline applied to the cores of contemporary American cities is that of the underclass. The concept of the underclass has been widely disseminated, though never clearly defined. On the one hand, it refers to the hypersegregation of the postindustrial ghetto – the intense concentration of poverty in increasingly isolated inner-city areas – and the deproletarianisation

of the urban poor. On the other hand, the underclass is a compelling and powerful myth of behavioural deficiencies which combines common assumptions about poverty and race. It generates images of criminals, delinquents, crack addicts and unwed mothers, and of an urban scene in which crime, drugs, unemployment, welfare dependency, indiscriminate violence and educational failure are norms of existence. More insidiously it signifies 'blackness'; it is a term of racial categorisation that connotes and normalises what Daniel Moynihan once egregiously termed 'a tangle of pathology' in urban black poverty.[11] Applied to the underclass, the metaphor of urban decline associates spatial deprivation and decay with the pathological separateness of black ghetto poverty.

New spatial patterns of racial difference and segregation are not only naturalised by discourses of decline but also by discourses of regeneration. The reenchantment with urban cores signified by gentrification and redevelopment of central cities posits an urbanism – of lifestyles in liveable spaces – which is thoroughly, if rarely explicitly, racialised. This revalorisation of urban cultural capital promotes an ersatz celebration of urbanity as a highly regulated and commodified experience of community. It is evident not only in the gentrification of urban cores but more broadly in the 'new urbanism' of postmodern planning and design. The new urbanism emerged, in part, as a reaction against modernist planning associated with sprawl, the isolation of buildings from the environment, and the dominance of the automobile, to project plans for denser forms of settlement based on 'town' or 'neighbourhood' models, to revalue pedestrian movement and revive the life of the street, and reduce transport pollution. However, even as it seeks to correct planning errors of the past the new urbanism reproduces the modernist belief in planning social cohesiveness and conformity through the built environment. As Michael Sorkin observes, 'new urbanist developments are underpinned by a labyrinth of restrictive covenants, building regulations, homeowners' association codes of behavior, and engineered demographic sterility'. More than this, he argues, they 'produce a new kind of spatial apartheid' by 'harboring a single species – the white middle class – in a habitat of dulling uniformity'.[12] The new urbanism is supported by discourses of neotraditionalism, environmentalism and communitarianism which have taken a strong hold on American urban planning and design in recent years – proclaiming goals of producing 'liveable' or 'safe' cities they compound nostalgia, insecurity and paranoia in the relations between race and space.

The spatial apartheid promoted by postmodern urbanism involves

both social and mental structures of exclusion as these are materi-
alised in the built environment of American cities. Mike Davis has
produced an influential analysis of these structures as characteristic
features of what he terms 'fortress L.A.':

Welcome to post-liberal Los Angeles, where the defense of luxury lifestyles
is translated into a proliferation of new repressions in space and movement,
undergirded by the ubiquitous 'armed response.' This obsession with phys-
ical security systems, and, collaterally, with the architectural policing of
social boundaries, has become a zeitgeist of urban restructuring, a master
narrative in the emerging built environment of the 1990s.[13]

For Davis, social inequality and spatial segregation are reinforced by
a fortress mentality, itself responding to 'underlying relations of
repression, surveillance and exclusion' in the city.[14] Davis' warnings
about 'the destruction of public space' have resonated with a wide
readership (and his apocalyptic prose has earned him a key role as a
commentator on 'the culture of fear' in 1990s America).[15] In urban
studies many commentators have followed him in drawing attention
to the increasing control and privatisation of space in American
cities. The fortress aesthetic Davis identifies in the built environment
of Los Angeles has been broadly recognised and analysed: common
examples include the inward-turning shopping mall, the indoor atri-
ums of corporate office buildings, the proliferations of theme parks
and festival marketplaces, all spaces that are rigorously disciplined
through practices of gating, signage and surveillance. It is an aesthet-
ic that denotes an escapist and exclusionary urbanism in which 'form
follows fear' as much as it follows finance, and the privatisation of
space is dependent upon externalised others, often identified with
'the street'.[16]

While the classic discourse of urbanity often works to idealise
urban encounter and contact, the more common reality of the post-
modern city is avoidance and denial. It is widely argued that the pre-
dominant structure of feeling in urban social encounter in the United
States is fear and the response is to reduce contact, as Richard
Sennett observes when he remarks 'we now measure urban spaces in
terms of how easy it is to drive through them, to get out of them'.[17]
Perhaps, but there remains the question of who 'we' are in relation to
the space of fear. Confrontation with difference in urban space is a
positional and relational matter – demarcating the self and the other,
the citizen and the stranger – and in some part dependent upon the
mental productions and cultural representations of stereotyping.
Race can play a significant role here, structuring barely conscious

perceptions and prejudices. Beauregard argues that 'as cities become increasingly black and Hispanic, they literally become psychologically unthinkable for whites'.[18] This is inaccurate, for what happens is that cities become more intensely psychologised as sites of racial anxieties, symbolic scenes of repression and conflict in which race is projected as a disturbing force of disorder. These considerations of a racialised postmodern urbanism will be returned to in this study, most particularly in the first chapter which deals with 'white paranoia' about urban others. As well as examining images of blackness in the white mind, though, I will go on to examine forms of black-produced representations of paranoia and desire about the postmodern city which establish alternative articulations of urban blackness.

If the idea of urbanity has been all but abandoned in its classic form and crudely diminished by postmodern urbanism, it nonetheless hovers as a horizon of possibility in imaginary associations with place. Place, understood as a space of provisional self-definition or communal definition, remains powerfully affective in urban culture. Places are charged with emotional and mythical meanings; the localised stories, images and memories associated with place can provide meaningful cultural and historical bearings for urban individuals and communities. Some theorists argue that place is being erased by the spatial experiences of late capitalism – the simulacral, the hyperreal, the depthless – yet it persists as a site of spatial contiguity, of interdependence and entailment, which take on contours of identity and location through representation. The symbolic importance of place must be set against the idea that fear and disassociation are the dominant modes of postmodern urban experience. Associations with place also produce imaginary intersections between ethnic and racial groups. John Eyles has argued that 'the effects of race and ethnicity vary' in responses to place:

For blacks, race and place remain closely intertwined because of majority group prejudice and discrimination as well as the operation of the urban economy. For the members of groups based on religion and ethnic origin, ethnicity and place have become more or less dissociated, with associations being largely determined by ethnic desires rather than majority group pressures.[19]

Eyles is right to draw attention to the ways in which the divisions and uses of urban space differentiate ethnic and racial groups and shape responses to place. Yet his categorical description of this difference is reductive, for desire and discrimination are not symmetrically opposed conditions for ethnic and racial responses to place. The

structures of feeling expressed in desire, memory and paranoia are differentially experienced by cultural groups but not evenly distributed among them. As we shall see, the imaginative investments in the transformations of urban space by white and black cultural producers more often than not conflict but are also closely entwined.

As a space of difference the city is not simply a crucible of ethnoracial relations (the 'melting pot') or a multicultural smorgasbord (the 'urban mosaic'), but a site of intersubjective and collective encounters through which the formation of identity is spatialised. The nature of the encounters registered in literary and visual representations examined here suggest the intensity of the crisis of urbanity, as the point of contact in public space is only rarely portrayed as one of engagement or community. However, if (as Davis suggests) 'repression, surveillance and exclusion' are the underlying relations of postmodern urbanism, the forms they take in representation have accentuated rather than diminished the connections between white ethnic and black associations with urban spaces. The urgency attached to many representations of race relations in American cities demands recognition of how all urban dwellers are affected by the failures of social interaction and interdependence in the city. This urgency is eloquently evoked in the lower frequencies of the narrator's address to the reader in Wideman's *Philadelphia Fire*: 'Who am I? One of you. With you in the ashes of this city we share. Or if you're not in this city, another one like it. If not now, soon. Soon enough to make it worthwhile for you to imagine this one, where I am'.[20]

URBAN SPACE AND REPRESENTATION

As the city changes, so too the academic disciplines geared to study it, and the models of reading and seeing which represent it. Long a subject for cross-disciplinary study in the humanities and social sciences, the city has in recent years become the focus of a great deal of new theoretical work by scholars in urban sociology, cultural geography, and critical theory. This current thinking has blended social theory, aesthetics and cultural critique, generating new vocabularies which are reframing questions of identity, location, place, positionality, territoriality and diaspora.[21] These disciplinary and theoretical convergences have not provided a unitary method but there is a detectable common interest: the making of space as a social product.

Our common understanding of space is that it is simply there, intangible but given. To treat space as a social product, though, prompts fresh consideration of the instrumentality of space as a

register of not only built forms but also of embedded ideologies. This entails a demystifying of space as natural and transparent so that it is understood as a product with particular, localised meanings. Such demystification has already been well advanced by the work of Henri Lefebvre, David Harvey, Edward Soja and others who have tapped the critical potentials of spatiality as a positive response to the decline of historicism (the waning sense of history and grand narratives) in the postmodern era. Lefebvre has produced voluminous meditations on 'the production of space', advancing schematic and typological analyses which have had a profound impact on contemporary studies of urban space and spatiality. He wants us to see that space is not simply the parameter or stage of social relations and actions, rather that it is operative in the 'assembly' of these. He argues that traditional dualities of physical space and mental space are bridged by the processes of the production of space, especially as these are enacted through 'spatial practice', which he founds on the material experience of social relations in 'everyday life'.[22] Harvey and Soja have built on and influentially promoted these ideas in Anglo-America contexts to emphasise the productivity of urban space under conditions of an advanced (postmodern and global) capitalist political economy.[23]

These theorists are variously concerned to expose the workings of power – to unveil capitalism – in the spatial forms and fabrics of the city. However, while questions of representation figure centrally in their thinking, their critiques of the 'illusion of transparency' in conceptions of space tend to delimit the role of representation (and more particularly its cultural forms – ideational, narratological and imagistic) in the production of space. They share a concern (due in some part to their Marxist orientations) that images or textual representations of reality may be attributed a false 'epistemological precedence' over the realities of lived social space.[24] This seems a legitimate concern given their politicised interests, but it threatens to ignore the workings of representation in the production of space as simultaneously real, symbolic and imaginary. The making of urban space requires critical consideration of the conditions and effects of the signifying practices, discourses and images which give it legible form. Analysis of the formations and functions of representation is one of the ways in which study of literary and visual culture can contribute to the new understandings of space and spatiality. Representation does powerful cultural work to produce and maintain, but also to challenge and question, common notions of urban existence; in doing so it shapes the metaphors, narratives and syntax which are

widely used to describe the experience of urban living. Analysis of visual and textual representations of urban space is not simply a study of images of places or narratives of urban consciousness. Rather it responds to the cultural work of representations of urban space, which offer us specific reading and visual practices for approaching the spatiality of the city.

Literary and visual representations are active in the spatial productions and reproductions of the city as visual culture and as psychic space. Vision and visuality are recurrent issues of critical attention in this study, for they respond to ideological conditions of visibility which (as we saw with John Edgar Wideman's commentary above) are already saturated with meanings, including racial(ised) meanings. The relation between power and vision, for example, is evidenced in many strands of urban life: in the surveillance of the urban populace; in the scopophilic and voyeuristic desires (to look, to be seen) associated with urban street and commodity relations; in the signage which directs and prohibits movement; and in the sighting of bodies as erotic or dangerous. While urban vision may be ubiquitous, its workings are not at all transparent: in considering the legibility of race in urban space we need to be attentive to the meanings of both visibility and invisibility. We must also recognise that the desire for legibility is a powerful animus in representations of urban space where the presence and meanings of race may be only very obliquely recorded. Urban space and subjectivity are intricately related and we can analyse the formations of unconscious as well as conscious responses to race in literary and visual representations. Categories of spatial duality – of inside and outside, of self and other – are commonly used in representation to portray the city as a psychic space, resonant with drives and impulses which trigger memory, stimulate desire, or cause fear. In this psychic environment race is often figured as uncanny, an eruptive force in the symbolic order of the city; the subject of acts of repression, displacement and dislocation.

While this study combines analysis of novels, films (narrative and documentary), journalism and photography, it is not intended as a comprehensive survey of representative urban texts, rather it offers close critical analysis of selected texts which variously reflect and critique emergent patterns of postmodern urbanism and which are particularly responsive to issues of race and racism in the production of urban space. The interdisciplinary treatment of literary and visual texts respects the discrete conventions of different modes and mediums of representation while showing how these expressive forms interact with each other as well as with broader productions of

urban space. Throughout this study I will examine how practices of reading and seeing the city inscribed in textual representations work to render race legible. Conceptually, the relations between race, space and representation connect the subject areas around which the chapters are structured: white paranoia about urban decline; imagined urban communities of the past; the racialised underclass and the postindustrial ghetto; and urban crime and justice.

The first chapter examines selected texts that reflect a public paranoia about urban decline and represent whiteness as an increasingly visible and insecure social category in urban contexts. It provides close critical analysis of Tom Wolfe's novel *Bonfire of the Vanities* (1987) and the films *Falling Down* (1992) and *Strange Days* (1996). These texts very explicitly depict New York and Los Angeles as unevenly developed, polarised and segregated cities. With different degrees of critical consciousness and purpose they posit a paranoid urban imaginary which projects white fears and fantasies onto scenes of social disorder and degeneration. The spatial divisions that secure relations of centredness and marginality are transgressed to produce disorienting experiences for the protagonists who encounter threatening others. The liberal perspectives that characterise the texts produce muddled messages about pluralism, multiculturalism, justice and citizenship, yet attest to the efficacy of the discourse of urban decline as a register of (post)national concerns.

Urban spaces constitute key sites of memory for ethnic and racial groups. The second chapter examines how selected texts interpret the historical development of associations between identity and place and reconstruct the urban past in the terms of the present. The urban histories represented reflect diverse responses to patterns of immigration and migration, economic progress and socio-cultural assimilation, and to the meanings and values of community. I argue that memory has become an important resource of urban identity amidst the socio-spatial restructurings of postmodern urbanism, but emphasise that it is not the privileged preserve of any cultural group and is a highly unstable ground for competing reclamations of the urban past. The memory work of urban representation is inflected by a volatile cultural pluralism and I chart the effects of this on developments in American literature to show how and why the 'reclaiming' of the urban past from distinctly ethnic and racial perspectives has become a significant issue of representation in American literature since the 1970s. Textual analysis is focused on novels by Irish-American and African-American authors: William Kennedy's *Ironweed* (1983), Colum McCann's *This Side of Brightness*

(1998), Toni Morrison's *Jazz* (1993) and John Edgar Wideman's *Philadelphia Fire* (1991). These texts all treat urban spaces as *lieux de mémoire*, unstable sites inscribing buried connections between the urban past and present, but they significantly diverge in their different cultural perspectives on the changing configurations of urban space, showing how differently rooted and routed forms of urban passage (ethnic and racial) find form in narrative memory.

As noted above, the myth of the underclass has become a potent interpretive framework for focusing 'the problem of race' in the American city, and isolating it in particular ways within the post-industrial ghetto. The third chapter will begin by examining the myth of the underclass as a cultural and political construct that has a distinct historical emergence and development in public discourse and argue that it articulates and reinforces common assumptions about race and urban poverty. These assumptions have been reconfigured in the proliferating narratives of the underclass that, since the mid 1980s, have crossed many modes and mediums of representation. I look closely at examples from journalism, photography, documentary film and narrative film. The first three texts examined – Alex Kotlowitz's ethnographic journalism *There Are No Children Here: The Story of Two Boys Growing Up in the Other America* (1991), the film *Hoop Dreams* (1994) and Camilo José Vergara's book of photojournalism *The New American Ghetto* (1998) – all represent documentary ventures into the inner city to record 'how the other half lives'. As liberal ethnographies of underclass life they encourage different modes of empathic identification – with narratives of innocence and aspiration, with images of spatial deprivation – but also reinforce a sense of intractable difference and distance surrounding the black ghetto poor. The section on narrative film focuses on representations of the postindustrial ghetto in African-American cinema, recording the emergence of a 'new ghetto aesthetic' in this cinema in the 1990s and analysing the films *Boyz N the Hood* (1991) and *Just Another Girl on the IRT* (1992). In some ways echoing the documentary impulses of the above texts these films use a coming-of-age trope to link knowledge, space and empowerment as a complex network of forces in racial identity formation, but produce different and mixed messages about the postindustrial ghetto as a site of blackness.

The final chapter focuses on issues of race, crime and justice as represented in selected novels and films. Crime genres have proved notably malleable in responding to contemporary urbanism and a number of writers and filmmakers have sought to stretch or challenge genre conventions in their treatments of race and racism. The first

section looks at the hard-boiled detective fiction of the African-American author Walter Mosley, with close attention to his novel *Devil in a Blue Dress* (1990). It argues that Mosley very self-consciously appropriates elements of conventionally white detective fiction and combines them with tropes of African-American literature (such as invisibility and passing) to write a *noir* history of black life in postwar Los Angeles and investigate the shifting meanings of racial difference and identity. This is followed by a detailed comparative analysis of Richard Price's novel *Clockers* (1992) and Spike Lee's film of the same name based on the novel, released in 1995. These texts are driven by social concerns in their representations of the drug-dealing subculture of blighted black neighbourhoods, but they articulate these concerns in different ways and with different results. The novel tells a crime story of shifting points of view – black and white, clocker and cop – and assembles immense social detail in an ambitious effort to reinvent the social realist novel and report on the state of racial affairs in urban America. Lee's film switches focus – privileging the point of view of the black clocker – and uses striking cinematography to shift the moral and social implications of the narrative into a distinctively African-American register of concerns. Taken together, these texts raise fascinating questions about the ethos of the writer/filmmaker's spatial and ideological relationships to the realities of black urban poverty.

Literary and visual representations make the production of urban space available for analysis, but they do not define the meaning of the American city or even an American city. They provide provisional frames of legibility. Even by bringing selected texts together for the purposes of analysis, I make no greater claim for my own syntheses and critique. The 'truth' of the city is not in these pages. What is here, I hope, is the rudiments of an interdisciplinary mapping of relations between space, race and representation which may provide useful guidelines for further critical inquiry. I do not offer an answer to the 'miasma' of urbanisation, but work to identify some elements of legibility within it.

Notes

1. John Edgar Wideman, *Philadelphia Fire* (New York: Vintage, 1990), p. 157.
2. Efforts to render the city legible can produce metaphorical procedures

which all too easily idealise their object and function as quests for revelatory meaning. Donald Preziosi suggests that 'what urban studies is clearly after, by and large, is what does not (quite) "meet the eye" . . . what, behind the glittered quiddity of the city, can be constru(ct)ed as its (hi)story. The city's truth'. What Preziosi addresses here is our fascination with the ways in which cities 'touch upon certain indispensable features of our modernity' and our postmodernity. Donald Preziosi, 'Oublier La Citta', *Strategies: A Journal of Theory, Culture and Politics* 3 (1990), p. 260.

3. Michael Keith and Malcolm Cross, 'Racism and the Postmodern City', in Malcolm Cross and Michael Keith (eds), *Racism, the City and the State* (London: Routledge, 1993), p. 9.

4. Stuart Hall offers instructive comment on how media define the 'problem of race' and more broadly 'classify out the world in terms of the category of race'. Stuart Hall, 'The Whites of their Eyes: Racist Ideologies and the Media', in Gail Dines and Jean M. Humez (eds), *Gender, Race and Class in Media: A Text-Reader* (Thousand Oaks, CA: Sage, 1995), p. 20.

5. My focus on a white/black axis of urban relations necessarily delimits recognition of the more complex interplay and territorialisations of urban identity represented by multiple ethno-racial groupings in the contemporary United States. But it is also a recognition of the continuing cultural vitality of this axis, even as it is variously shifted by urban transformations and dialogised by the expressive cultures of Hispanic, Asian-American, and many other groupings.

6. See, for example, Robert E. Park, Ernest W. Burgess and R. D. McKenzie (eds), *The City* (Chicago, IL: University of Chicago Press, 1967); Jane Jacobs, *The Death and Life of Great American Cities* (New York: Random House, 1961); Richard Sennett, *The Fall of Public Man* (New York: Knopf, 1977) and *Flesh and Stone* (London: Faber and Faber, 1994); William Whyte, *The Social Life of Small Urban Spaces* (Washington, DC: Conservative Foundation, 1980); and Marshall Berman, *All That Is Solid Melts into Air: The Experience of Modernity* (London: Verso, 1983).

7. Motifs of nostalgia and loss are present in the writings on public space by Jacobs, Sennett and Berman, above. Michael Brill has described the literature on public space as a 'literature of loss'. Michael Brill, 'Transformation, Nostalgia, and Illusion in Public Life and Public Place', in Irwin Altman and Ervin H. Zube (eds), *Public Places and Spaces* (New York: Plenum, 1989), p. 8. For an incisive analysis of postmodern revalorisation of urbanity, see Kevin Robins, 'Prisoners of the City: Whatever Could a Postmodern City Be?', in Erica Carter, James Donald and Judith Squires (eds), *Space and Place: Theories of Identity and Location* (London: Lawrence and Wishart, 1994), pp. 303–30.

8. Leo Marx, 'The Puzzle of Anti-Urbanism in Classic American Literature', *The Pilot and the Passenger* (Oxford: Oxford University Press, 1988), p. 210.

9. Robert Beauregard, *Voices of Decline: The Postwar Fate of U.S. Cities* (Oxford: Blackwell, 1993), p. 6.

10. Ibid., pp. 290–1.

11. See Lee Rainwater and William L Yancey, *The Moynihan Report and the Politics of Controversy* (Cambridge, MA: MIT Press, 1967), pp. 39–125.

12. Michael Sorkin, 'Acting Urban', *Urban Land* (October 1998), p. 10, p. 111.

13. Mike Davis, *City of Quartz: Excavating the Future in Los Angeles* (London: Verso, 1990), p. 223.

14. Ibid., p. 238.
15. Ibid., p. 226. Obsession with personal safety and social insulation is a key characteristic of 'the culture of fear' now widely diagnosed (and animated) by American media and cultural criticism. See David Glassner, *The Culture of Fear* (New York: Basic Books, 1999). Davis' rich descriptive prose in *City of Quartz* veers between sharp social critique of this culture and apocalyptic inflation of it. 'In Los Angeles there are too many signs of approaching helter-skelter', he writes, 'a whole generation is being shunted toward some impossible Armageddon' (p. 316). While he astutely questions postmodern urbanists' hyping of 'Los Angeles as the paradigm of the future' (p. 86) he himself cannot resist the sweep of metaphor, claiming the city 'has come to play the double role of utopia and dystopia for advanced capitalism' (p. 18). In his commentary on the destruction of public space Davis is indignant and hortatory about the need to remedy underlying social conditions of this destruction, but he is also nostalgic about what is lost, romanticising his own class and ethnic locus. The ethos of his position as an urban intellectual has distinctive political markers, yet bears striking structural similarities to that of many other (more politically conservative) white ethnic writers who comment on the 'decline' of the cities of their youth. White ethnic representations of urban passage are examined in some detail in Chapter 2 of this study.
16. Martha Rosler comments on the street as a site of exclusion:
 Demoted to a site of surveillance and vehicular passage, the street is abandoned to maintenance services and the occasional spectacle. And increasingly, the street is a waste space left to the socially fugitive and the unhoused – those unable to buy or to serve. The creation of 'waste space' is as much a part of the social production of signification in modern life as the built environment. It is this 'empty' space, to which the destitute are relegated, that is increasingly identified with – or as – 'the street.' The waste space resides where society used to stand.
 Martha Rosler, 'Fragments of a Metropolitan Viewpoint', in Brian Wallis (ed.), *If You Lived Here: The City in Art, Theory, and Social Activism: A Project by Martha Rosler* (Seattle, WA: Bay Press, 1991), p. 19.
17. Richard Sennett, *Flesh and Stone*, pp. 17–18.
18. Beauregard, *Voices of Decline*, p. 289.
19. John Eyles, 'Group Identity and Urban Space: The North American Experience', in Michael Chisholm and David M. Smith (eds), *Shared Space: Divided Space: Essays on Conflict and Territorial Organization* (New York: Unwin Hyman, 1990), p. 62.
20. Wideman, *Philadelphia Fire*, p. 120.
21. Productive examples of the cross-fertilisation of disciplines around cultural geography include: Sharon Zukin, *Landscapes of Power: From Detroit to Disney World* (Berkeley, CA: University of California Press, 1991); Derek Gregory, Ron Martin and Graham Smith (eds), *Human Geography: Society, Space, and Social Science* (Minneapolis, MN: University of Minnesota Press, 1994); Doreen Massey, *Space, Place, and Gender* (Minneapolis, MN: University of Minnesota Press, 1994); David Sibley, *Geographies of Exclusion* (London and New York: Routledge, 1995); Patricia Yaeger (ed.), *The Geography of Identity* (Ann Arbor, MI: University of Michigan Press, 1996); Linda McDowell (ed.), *Undoing Place?: A Geographical Reader* (London: Arnold, 1998).

22. Henri Lefebvre, *The Production of Space*, trans. Donald Nicholson-Smith (Oxford: Blackwell, 1991).
23. See David Harvey, *The Condition of Postmodernity* (Oxford: Blackwell, 1989) and Edward Soja, *Postmodern Geographies: The Reassertion of Space in Critical Social Theory* (London: Verso, 1989).
24. Soja, *Postmodern Geographies*, p. 125.

White Noise

A discourse of urban decline has been centrally embedded in American responses to the city since the mid twentieth century. It provides, in Robert Beauregard's terms, 'a spatial fix' for 'generalised insecurities and anxieties' about American society.[1] In the 1980s and 1990s this discourse remained open-ended in relation to the uneven development of urban space, while taking on distinctive ideological investments and meanings. A major function of the discourse in this period was to focus anxieties about the emergence of a new urban order in the context of forces of globalisation and postnationalism which posed new challenges to the securities of 'American' identity. New York and Los Angeles, newly nominated as 'global cities', drew particular attention as their rapid restructurings provided a spatial fix for debates on citizenship, multiculturalism and race relations. With the cartographies of these cities in many ways defined by the workings of late imperialism they began to appear in cultural representations as emblematic sites of strain and fracture in the symbolic order of the national culture. In this chapter I will examine literary and film representations of these cities which allegorise the discourse of urban decline to (re)produce a paranoid urban imaginary focused on issues of ethno-racial difference in urban space. In the texts centrally examined here, this paranoia signifies a growing visibility of whiteness as a social category and more especially of white male selfhood as a fragile and besieged identity.

Drawing attention to 'whiteness' in narrative representation has become a common interest in literary, film and cultural studies in recent years. Crucial to this critical project is the insistence that whiteness neither exists outside of culture nor transcends race but functions as the invisible norm of dominant cultural values and assumptions while concealing its dependency upon racialised others. To examine whiteness as a category of identity formation is no

simple matter though. As Richard Dyer notes, whiteness is 'everything and nothing . . . [it] both disappears behind and is subsumed into other identities', with the result that 'white domination is then hard to grasp in terms of the characteristics and practices of white people'.[2] One way we can begin to particularise recognitions of American whiteness is to place it in the context of the peculiar conditions of the United Sates as an imperial culture – conditions which very much influence the texts I will shortly examine.

Imperialism is commonly disavowed in discourses of American identity (it is what others do abroad) yet remains a crucially defining feature of American history, stretching from the conquest of the New World to the creation of the New World Order. Recent studies have challenged this common disavowal to argue that the United States is an imperial nation in which domestic cultures and mythologies have been, and still are, shaped by the global workings of empire building. 'Imperialism as a political or economic process', Amy Kaplan argues, 'is inseparable from the social relations and cultural discourses of race, gender, ethnicity, and class at home'.[3] That there is little common acknowledgement of such interconnections is not surprising if we consider that they exist within the virtually invisible American *imperium* of 'Empire as a way of life', a naturalised system of meanings and values.[4] This invisibility of empire, the result of hegemonic imperial relations, has strong historical and imaginary correlations with the invisibility of whiteness. More particularly, it has long worked to secure the white male's privileged role of universal subject – at once central and invisible – while displacing questions of race onto others. This displacement is also a form of dependency, for the historical formation of imperial white manhood has required a self-disciplining mastery of the other. In Eric Lott's words,

the domination of international others has depended on mastering the other at home – and in oneself: an internal colonisation whose achievement is fragile at best and which is often exceeded or threatened by the gender and racial arrangements on which it depends.[5]

Lott is right to suggest that this internal colonisation is rarely stable, and I believe that the very public emergence of specifically white male anxieties and anger in the United States in recent years reveals the workings of the imperial unconscious of white American manhood. Here, I am particularly concerned to examine how issues of white male (self-)mastery are mediated in paranoid responses to racialised urban spaces.[6]

Almost forty years ago Lewis Mumford, in *The City in History*, commented upon what he perceived as 'the intensified struggle with-in' urban culture, suggesting that urban life encourages a 'paranoid psychal structure'; the city, he observed, is 'the container of disruptive internal forces, directed towards ceaseless destruction and extermi-nation'.[7] Mumford's vision of the psychodrama of the city, in which chaotic feelings of fear and anxiety signify a collectivised paranoia, has had no clear influence on mainstream urban studies in the United States. However, ideas of urban paranoia have found a fresh resonance in the work of American analysts of postmodern urbanism, most notably in studies of what is often described as the privatisation of public space. As we have already seen, Mike Davis provides an influential example in his study *City of Quartz: Excavating the Future of Los Angeles* (1990) where he argues that 'underlying rela-tions of repression, surveillance and exclusion ... characterize the fragmented, paranoid spatiality towards which Los Angeles seems to aspire'. For Davis, this paranoid spatiality is fuelled by 'imaginary dangers' conjured by urban elites and by 'the neo-military syntax of contemporary architecture'.[8]

What I particularly want to draw out of Davis' analysis and expand upon in my study of literature and film is his concept of 'paranoid spatiality'. While Davis uses it to highlight elements of fear and prejudice in spatial policing and planning he pays relatively little attention to the subjectivity of desires, anxieties and repressions that paranoid spatiality can signify. While there is considerable psycho-analytical debate over the sources and pathogenesis of paranoia as a subjective condition, common elements of Freudian and post-Freudian thought draw attention to the breakdown of subject-object boundaries, the fragmentation or decentring of the self, the concomitant loss of an illusory sense of transcendence, and the projection of aggression and subsequent regarding of that projection as an external threat. In such views normative imaginary relations – of self and other, of the familiar and the unfamiliar – break down, threatening the unity and integrity of the subject.[9] Though imaginary, these distinctly spatialised relations are also manifested in the positioning of the human body. Elisabeth Grosz observes:

It is our positioning within space, both as the point of perspectival access to space, and also as an object for others in space, that gives the subject a coher-ent identity. . . . The subject's relation to its own body provides it with basic spatial concepts by which it can reflect on its own position. Form and size, direction, centredness (centricity), location, dimension and orientation are

derived from perceptual relations. These are not conceptual impositions on space, but our ways of living as bodies in space.[10]

The paranoid dilemma of dislocation (mental and corporeal) within space is a key trope in the texts I now turn to – it is also racialised as a dilemma of white male selfhood.

'IT'S THE THIRD WORLD DOWN THERE': *THE BONFIRE OF THE VANITIES*

Remarking upon the uneven and inequitable redevelopment of New York in the mid 1980s, Marshall Berman concluded that it marked a culmination of 'the long-term transformation of New York into a place where capital from anywhere in the world is instantly at home, while everybody without capital is increasingly out of place'.[11] Berman was not alone at this point in railing at the impending 'urbicide' of the city, but there was precious little dialogic give and take between voices on the political left, those of developers and their friend Mayor Koch, and the vacillating liberal expressions of the *New York Times*. At the very least all were aware that New York was changing fast and that one product was intensified ethnic, racial and class animus. Whereas Berman and others wanted to harness and politically channel dissent, Koch and friends were keen to simultaneously ignore it and heavily police it, while the *Times* worried about 'the fragmentation of New York City into an urban vision of Yugoslavia'.[12] New tribalisations stimulated new passions and even events of violent horror in the mid to late 1980s. From Bernard Goetz's shooting of four black teenagers on a subway train in 1984, to the cases of 'wilding' in Central Park in 1989, fear and division seemed to be the proving ground of New York's new urbanism. Such 'flash cases', as Wesley Brown noted (referring in particular to the Goetz case) 'touched every nerve where safety and menace intertwine with our conflicting emotions about race'.[13] In part taking his cue from such cases, but also from many other unsettling changes in the imperial city, one author decided New York in the mid 1980s was a story begging to be told. Step forward Tom Wolfe, who, with no noticeable modesty, believed he was the writer best suited to the job. *The Bonfire of the Vanities* was published in 1987.[14]

In his essay 'Stalking the Billion-Footed Beast: A Literary Manifesto for the New Social Novel', published in *Harper's Magazine* in 1989, Wolfe tells us that he very deliberately conceived *Bonfire* as:

a novel *of the city* in the sense that Balzac and Zola had written *of Paris* and Dickens and Thackeray had written novels *of London*, with the city always in the foreground, exerting its relentless pressure on the souls of its inhabitants.[15]

In detailing his novel's conception Wolfe uses the essay as a platform to debunk postmodern fiction in favour of social realism. He confides:

To me the idea of writing a novel about this astonishing metropolis, a big novel, cramming as much of New York City between covers as you could, was the most tempting, the most challenging, and the most obvious idea an American writer could possibly have. (p. 45)

He professes his surprise that contemporary writers had no interest in such a challenge, preferring to flee the social terrain for private and esoteric exercises in formal reflexivity. He dismisses the work of two generations of American writers, accusing them of having lost the will and nerve to 'wrestle the beast' (p. 56) of social reality. Fusing this willingness to document and report with the 'freedom of fiction' (p. 56) to condense and dramatise produces Wolfe's recipe for the social realism which the age demands.

The past three decades have been decades of tremendous and at times convulsive social change, especially in large cities, and the tide of the fourth great wave of immigration has made the picture seem all the more chaotic, random and discontinuous, to use the literary clichés of the recent past. The economy with which realistic fiction can bring the many currents of a city together in a single, fairly simple story was something that I eventually found exhilarating. (p. 56)

This picture of urban change, he argues, is not 'incomprehensible' (p. 52) to the writer willing to engage its realities.

As literary criticism Wolfe's essay is a brilliant example of muck-raking, grandstanding journalism. Neither his critique of postmodernist writing nor his wilful ignorance of continued traditions of urban realism can stand up to close analysis. As a rationale of his aims and ambitions in writing his 'big novel' of New York City, on the other hand, it is an intriguing portrait of an author's working assumptions. It underscores his faith not only in 'a highly detailed realism based on reporting' (p. 56) but in the totalising, encompassing properties of social realist narrative. It is this totalising perspective, enhanced by his satirical approach to his subject matter, which guides his assumption that realism can provide a necessary comprehension of

the urban totality at a time of increasing fragmentation and polarisation in urban social relations. This effort to totalise remains important despite Wolfe's quite conspicuous failure to bring 'the many currents of a city together' in his novel. We might argue that this failure is evident enough at a documentary level – there is no mention of homelessness, for example – but more importantly it is evident in the hierarchy of voices and values his narrative constructs. Far from representing the diverse social realities of a polyglot metropolis he constructs a narrative of two cities – represented by the black Bronx and white Wall Street/Park Avenue – and focalises all the action through the consciousness of white protagonists. Such evident failings, however, must be set against Wolfe's undaunted faith in a totalising realist narrative and we need to ask: what drives this need to totalise (beyond cockeyed literary criticism) and what comprehension of the city does its failure leave us with? With these questions in mind, I want to interrogate Wolfe's realist aesthetic and satirical perspective to consider how *Bonfire's* narrative of urban decline functions to both illuminate and gloss postnational divisions in American (urban) society.

Bonfire begins with a prologue in which the white Mayor of New York City is addressing a black audience in Harlem. As demonstrators heckle and disrupt the meeting, the Mayor, panicked and angry, thinks of rich white New Yorkers watching on television:

Do you really think this is *your* city any longer? Open your eyes! The greatest city of the twentieth century! Do you think *money* will keep it yours?

Come down from your swell co-ops, you general partners and merger lawyers! It's the Third World down there! Puerto Ricans, West Indians, Haitians, Dominicans, Cubans, Colombians, Hondurans, Koreans, Chinese, Thais, Vietnamese, Ecuadorians, Panamanians, Filipinos, Albanians, Senegalese, and Afro-Americans! Go visit the frontiers, you gutless wonders! Morningside Heights, St. Nicholas Park, Washington Heights, Fort Tyron – *porque pagar mas*! The Bronx – the Bronx is finished for you! . . .

And you, you Wasp charity-ballers sitting on your mounds of inherited money up in your co-ops . . . And you German-Jewish financiers who have finally made it into the same buildings . . . do you really think you're insulated from the *Third World*? (pp. 13–14)

This passage is clearly intended by Wolfe to establish the symbolic geography of a city in which 'the fourth great wave of immigrants . . . is now pouring in' and challenging established structures of political and economic power. He positions New York at a point of monumental

social change, but also suggests that this change is not understood by white New Yorkers. The Mayor's thoughts may be 'paranoid' (p. 14) but they are rhetorically constructed as a warning or wake-up-call which articulates broad social fears and anxieties that echo throughout the novel. More particularly, the Mayor's thoughts form a highly fitting preface to the central narrative which documents the 'fall' of Sherman McCoy (one of the upper middle-class Wasps the Mayor imaginatively addresses) from highly successful bonds trader to degraded criminal, against a backdrop of racial tension and media manipulation. Blamed for the fatal injuring of a young black man, Sherman's subsequent trial positions him as the 'Great White Defendant' (p. 151), the symbolic fall guy of a tribalised urban polity and of white fears of retrocession. As we shall see, the Mayor's warning is an emblematic displacement of Wolfe's own rhetorical designs and satirical intentions in *Bonfire*. Here and throughout the novel he dramatises the prejudices and anxieties of white New Yorkers while assuming his omniscient, satirical distance from these.

While the Mayor imagines New York as a volatile mosaic of ethno-racial enclaves, Wolfe more fully depicts it in a narrower frame, that of the 'dual city' characterised by extremes of wealth and poverty. The 'dual city' concept emerged into public consciousness in the late 1970s and early 1980s as journalists sought to describe uneven development in major cities.[16] As economic restructuring and occupational polarisation produced a more sharply stratified social structure, commentators focused upon the developments at both the top and bottom ends of the income distribution. The widening gap between rich and poor became a focus of much media imagery in the 1980s, usually in the form of juxtaposed contrasts – affluence and degradation, gentrification and displacement, glitter and squalor – which dramatised, though they did little to analyse, social divisions. It is this model of stark dualities that Wolfe has recourse to in his narrative framing of New York as a totality, even as he pays attention to the spatial arrangements of ethno-racial and class differences in the city. Representations of urban duality and spatial difference in *Bonfire* require close consideration, for it is one of Wolfe's central conceits that his realist narrative can traverse very different spaces of New York life and produce a 'story' which comprehends their connectedness. Throughout the novel, moreover, categories of duality and spatiality – of inside and outside, of self and other – naturalise the symbolic order of the city, reproducing social divisions and power relations.

Wolfe's social knowledge and satirical talents coincide most

fruitfully in his treatment of the Wasp pole of his dual city. He illus-
trates the distinctive spatial features of Sherman McCoy's world as
determined by two closely linked factors, conspicuous wealth and
social insulation. Sherman lives in a $2.6 million co-op apartment on
Park Avenue. With its 'twelve-foot ceilings' and 'two wings, one for
the white Anglo-Saxon Protestants who own the place and one for
the help' (p. 17), it is designed to look like a mansion 'except that you
arrived at the front door via an elevator (opening upon your own pri-
vate vestibule) instead of the street' (p. 159). The apartment, expen-
sively decorated by Sherman's wife, is the most conspicuous signa-
ture of the McCoy's status, displaying the signs of economic and cul-
tural capital which affirm the style, distinction and exclusivity of
their class habitus. Their domestic space is also designed to reflect
their need for social insulation from the urban poor. The private ele-
vator stop, controlled by an apartment doorman, is not only a sign of
exclusive wealth but of greater security from the world outside, and
the concept of 'insulation' repeatedly echoes in Sherman's thoughts.
Reflecting on how his father had always taken the subway to Wall
Street, he recoils from the thought of the potentially dangerous social
contact this might mean:

Insulation! That was the ticket. That was the term Rawlie Thorpe used. 'If
you want to live in New York,' he once told Sherman, 'you've got to insulate,
insulate, insulate,' meaning insulate yourself from those people. . . . If you
could go breezing down the FDR Drive in a taxi, then why file into the
trenches of the urban wars? (pp. 65–6)

This desire for spatial insulation posits an external other, a threatening
mass referred to by Sherman as 'those people' who live 'out there'
(pp. 63–4). It is a desire that reflects a growing social polarisation
oriented not only around wealth but also around fear.

Privatisation of space has become a widely documented feature
of the development of urban form in global cities, with the built
environment reflecting socio-economic restructuring. In *Bonfire* Wolfe
refers us to images of this privatisation in descriptions of Sherman's
employers, 'the investment-banking firm of Pierce and Pierce
[which] occupied the fiftieth, fifty-first, fifty-second, fifty-third, and
fifty-fourth floors of a glass tower that rose up sixty stories from out
of the gloomy groin of Wall Street' (p. 67). The glass tower, an over-
determined symbol of postmodern architecture, appears here as a
capitalist citadel, both surveying and shutting out the surrounding
city space. This withdrawal from the urban environment underlines

the firm's involvement in other, global systems of communication. Wolfe draws ironic attention to this when he describes the offices of Pierce and Pierce, part of which have been designed by the firm's head to resemble an English country house. Fake fireplaces and mahogany-clad walls greet the visitor:

Things British . . . were multiplying on the fiftieth floor at Pierce and Pierce day by day. Alas, there wasn't much Eugene Lopowitz could do about the ceiling, which was barely eight feet above the floor. The floor had been raised one foot. Beneath it ran enough cables and wires to electrify Guatemala. The wires provided the power for the computer terminals and telephones of the bond trading room. The ceiling had been lowered one foot, to make room for light housings and air-conditioning ducts and a few more miles of wire. The floor had risen; the ceiling had descended; it was as if you were in an English mansion which had been squashed. (pp. 67–8)

Wolfe lampoons the colonial identifications of the firm's leaders while locating the invisible source of the firm's power in the wires that link it to global lines of communication and control. This is a striking image of what Manuel Castells has termed 'the space of flows', describing the accelerated electronic movements of money and information which organise new systems of power in the global reticulation of communications networks and financial circuits.[17] The symbolic withdrawal from the immediate city environment corresponds with the construction of a highly abstracted, hyper-real space of late capitalist communication. Working in this space fills Sherman with an ecstatic sense of power, confirming his self-identification as a 'Master of the Universe' for whom there is 'no limit whatsoever!' (p. 19).

Wolfe offers some astute insights on the socio-spatial restructuring which shapes the lives and values of upper middle-class professionals in the 'regenerated' urban core of mid 1980s New York. He is less interested in class analysis, though, than in satirising the lifestyles of what he views as an elite urban subculture more popularly recognised as 'yuppies'. He depicts them as the shallow avatars of a postmodern culture of stylish materialism, caricature figures of narcissism, totemism and vanity. It is this satirical critique of yuppie lifestyles which won Wolfe the widest praise for his novel and which is most often associated with its commercial success. But Wolfe's representation of a crisis of urbanity is not simply defined by the myopic vanities of his yuppies, for these only take on dramatic meaning in his text in relation to the 'Third World' barbarians gathering at the gates of the city. To better understand his concerns

about the privatisation of space we must examine the most disturbing component of urban decline in *Bonfire*, the presence of race.

When Wolfe turns to the opposite pole of his dual city it is clear that he has little or no knowledge of either the social or the interior worlds of the people occupying the blighted spaces of urban poverty. Rather than document their lives he constructs scenes of contrast and juxtaposition in which the urban poor – invariably 'blacks and Latins' (p. 51) – function as symbolic projections of the fears and prejudices of his white protagonists. Early in the novel as Sherman walks his dog in front of his Park Avenue co-op he becomes aware of a figure approaching him on the sidewalk:

Even from fifty feet away, in the darkness, he could tell. It was that deep worry that lives in the base of the skull of every resident of Park Avenue south of Ninety-sixth Street – a black youth, tall, rangy, wearing white sneakers. Now he was forty feet away, thirty-five. Sherman stared at him. Well, let him come! I'm not budging! It's my territory! I'm not giving way for any street punks! (p. 25)

This stereotype imagery of the 'urban wars' is also displayed in the everyday anxieties of the assistant district attorney Larry Kramer, who travels to work in the Bronx by subway. Kramer carries his work shoes in a plastic shopping bag and wears sneakers on the subway ride in order to deflect attention: 'On the D train these sneakers were like a sign around the neck reading SLUM or EL BARRIO' (p. 45). In articulating such white fears Wolfe deals less with the specifics of race relations than with the imagery of racial stereotype and mines a rich seam of urban mythology associated with the 'lower depths' of the city.

This urban mythology is most fully dramatised in a key scene that launches the central narrative of Sherman's 'fall'. Taking a wrong turning on their way from Kennedy airport, Sherman and his mistress Maria find themselves driving through the south Bronx late at night. Sherman's increasing panic is recorded in a dream-like sequence of images:

A vague smoky abysmal uneasiness was seeping into Sherman's skull . . . he couldn't get his bearings. His sense of direction was slipping away . . .

It was as if he had fallen into a junkyard. He seemed to be underneath the expressway. In the blackness he could make out a cyclone fence over on the left . . . something caught in it. . . . A woman's head! No, it was a chair with three legs and a burnt seat with the charred stuffing hanging out in great wads, rammed halfway through a cyclone fence . . .

– astonishing. Utterly empty, a vast open terrain. Block after block – how many? six? eight? a dozen? – entire blocks of the city without a building left standing. There were streets and curbing and sidewalks and light poles and nothing else. The eerie grid of a city was spread out before him, lit by the chemical yellow of the street lamps. Here and there were traces of rubble and slag . . . in a ghastly yellow gloaming. (pp. 92–6)

With these hallucinatory scenes Wolfe dramatises the white middle-class New Yorker's worst nightmare, to be lost in the degraded city spaces of the other, the black underclass. The 'grid of a city' Sherman sees spread out before him in this uncanny 'gloaming' is that of an alien city, one that does not correspond with the rational, horizontal grid plan that he knows: 'Sherman had lost track of the grid pattern altogether. It no longer looked like New York' (p. 97). This nightmare culminates in a scene of confused violence as Sherman and Maria, trying to reach the safety of the expressway, find the ramp blocked by a tyre and encounter 'two young black men' (p. 101). In the melee that ensues Sherman and Maria drive off, but knock over and fatally injure one of the men. In their excitement following this ordeal, 'desperate to escape the Bronx' (p. 105), they congratulate each other: 'We were in the goddamned jungle', Sherman tells Maria, 'and we were attacked . . . and we fought our way out' (p. 111).

Their journey through the south Bronx is narrated as a colonial adventure in a wild, frontier space, a space of urban depravity rather than deprivation. It is not black poverty, but white fear, which dominates the scene and this paranoid spatiality focalises dual city contrasts throughout the novel. Wolfe's most concentrated symbol of paranoid spatiality is the Bronx County Building that houses the court where Sherman's trial takes place. We are first introduced to the building and its environs through the eyes of Larry Kramer, who prosecutes the trial. Kramer emerges from the subway and reflects on the vista which confronts him:

He looked up – and for an instant he could see the Old Bronx in all its glory. . . . O golden Jewish hills of long ago! Up there at the top of the hill, 161st Street and the Grand Concourse had been the summit of the Jewish dream, of the new Canaan, the new Jewish borough of New York, the Bronx! . . . Did you want an apartment on the Concourse? Today you could have your pick. The Grand Hotel of the Jewish dream was now a welfare hotel, and the Bronx, the Promised Land, was 70 percent black and Puerto Rican. (pp. 46–7)

This image of ethnic succession (as degeneration) sets the scene for

the symbolic position of 'the other great building at the top of the hill, the building where he worked, the Bronx County Building' (p. 47). This 'prodigious limestone parthenon' (p. 47) is less a symbol of justice than an 'island fortress of the Power, of the white people . . . [a] Gibraltar in the poor sad Sargasso Sea of the Bronx' (p. 48). Yet again Wolfe uses colonial and frontier imagery to depict the spatial arrangements of race relations. The court workers order in food rather than venture onto the streets and if they work beyond sundown they must 'wagon train' (pp. 195–6), moving their cars closer to the building under the supervision of armed court officers. While the siege mentality has become naturalised it is also laced with the fears sounded by the Mayor in the novel's prologue. The Bronx, a barely governable space, is the hard-edge of a battle for the future of the city. Surveying the urban landscape from the sixth floor of the court building the District Attorney Abe Weiss views the Bronx as 'the Laboratory of Human Relations', reflecting that where once Irish, Jews and Italians populated the streets below, now 'there's none down there . . . and so how long are they gonna be up here in this building?' (pp. 542–3).

Wolfe offers many examples of paranoid spatiality, showing that white fears and fantasies are mapped onto the urban spaces of a virtually apartheid city. In his efforts to satirise this paranoia, though, he reproduces rather than challenges stereotype in his representation of racialised minorities. In scripting the unease of a white ruling class he draws on urban myths of black criminality and depravity in which race orders conceptions of self and other. The 'blacks and Latins' of the novel remain an abstract phenomenon, a socio-psychological fantasy which is crucial to Wolfe's metaphoric totalisation of the city. Wolfe presents his reader with a universalised and fantastical urbanism that elides close analysis or understanding of the empirical realities of racial subordination or economic immiseration. He is unable, as omniscient author, to comfortably transcend through satire the racialised images and discourses he invokes through stereotyping. Throughout the novel he works to offset his treatment of race by foregrounding the flawed perspectives of his white characters. A key example is his use of a British journalist as investigator and recorder of the events surrounding the driving incident and Sherman's subsequent trial. Peter Fallow, a snobbish expatriate working for a tabloid New York newspaper, narrates his experiences in the Bronx projects as a lurid 'tale of the lower depths' (p. 284). Fallow's perspective may be ignorant and egotistical, but it is a perspective that correlates with the novel's broader pathologisations of race and poverty. As a

knowing, late twentieth-century 'tale of the lower depths' *Bonfire* invites a voyeuristic, even imperialistic, relationship between its implied reader and the alien, degenerate urban world it depicts.

This relationship is most tellingly reflected in the central narrative of Sherman's fall from status and power. As the narrative develops, the urban 'depths', often figured as underworld or labyrinth, come to represent the psychological space into which Sherman 'falls'. It is this narrative of subjective deterioration which encodes the deepest moral drive of the novel, one that has ultimately less to do with class or race than with masculinity. *Bonfire* caricatures distinct models of masculinity. There is the inept Kramer, obsessed with his physique, admiring his 'powerful deltoids' (p. 41) and hoping to attract women by tensing 'his sternocleidomastoid muscles to make his neck fan out like a wrestler's' (p. 45). There are the young black men 'wearing big sneakers with enormous laces', walking 'with a pumping gait known as the Pimp Roll' (p. 46). And there are the Irish cops, the self-styled 'Donkeys' whose machismo is defined by toughness and loyalty (pp. 401–2). Sherman's masculinity, too, is first represented as caricature. He is a self-styled 'Master of the Universe', a man who can make 'a $50,000 commission' from a single telephone call, one of Wall Street's elite for whom 'there was . . . no limit whatsoever!' (p. 19). His sense of mastery is evoked in the ecstatic sense of power he feels at work in the bond trading room of Pierce and Pierce:

It was a vast space, perhaps sixty by eighty feet, but with the same eight-foot ceiling bearing down on your head. It was an oppressive space with a ferocious glare, writhing silhouettes, and the roar. The glare came from a wall of plate glass that faced south, looking out over New York Harbor, the Statue of Liberty, Staten Island, and the Brooklyn and New Jersey shores. The writhing silhouettes were the arms and torsos of young men, few of them older than forty. They had their suit jackets off. They were moving about in an agitated manner and sweating early in the morning and shouting, which created the roar. It was the sound of well-educated young white men baying for money on the bond market. (p. 68)

For Sherman, this command post of capitalist power is the centre of the universe, and he exults in the flows of male adrenaline which surround him: 'The shouts, the imprecations, the gesticulations, the fucking fear and greed, enveloped him, and he loved it' (p. 69). It is a space of aggressive masculinity where physical aggression is sublimated in economic competitiveness. As such, it directs the violent energies of the civilised entrepreneurs into professional competitiveness, driven by the injunction to 'Make it Now!' (p. 70).

Wolfe establishes his protagonist's inflated sense of masculinity so that he can bring this into crisis and then regenerate it in a new form. While he uses the story of Sherman's decline to show the white middle-class 'fear of falling', of losing status, this story's psychological focus is more specifically that of a crisis of white male (self-)mastery. The narrative hints as much in the first scene in which we encounter Sherman, 'kneeling in his front hall trying to put a leash on a dachs-hund' (p. 17), preparing to visit his mistress while avoiding his wife's suspicions. The image of servility, linked to his female attachments, contrasts his sense of universal mastery with middle-class male powerlessness. That his manhood might be remade is first intimated after the fateful car drive in the Bronx:

All at once a wonderful feeling swept over Sherman. . . . He had fought his way out of an ambush on the nightmare terrain, and he had prevailed. He had saved a woman. The time had come to act like a man, and he had acted and prevailed. He was not merely a Master of the Universe; he was more; he was a man. (p. 115)

Sherman's sense that there is more to manhood than economic mastery, at first a fleeting insight, forms the redemptive ground of his fall.

Sherman's journey of remasculinisation reaches its nadir when he is arrested and then detained in the cells of the Bronx County Building. His experience is one of nightmarish abjection as he is arrested by 'the brutes from the outer boroughs' (p. 497), subjected to a body search, and placed in a cell with underclass inmates. Surrounded by excrement, vomit and vermin he is mocked and intimidated by a 'black youth' (p. 524) in the cell. Barely able to think in his fear and confusion Sherman yet 'knew it was time to draw a line, stop this' (p. 525), and stands up to his tormentor. Although he is soon released and has to undergo further humiliation at the hands of the press and friends, this experience of arrest functions as the beginnings of a symbolic rebirth. As he becomes newly conscious of the vanities of what once seemed a secure and familiar world, his own 'civilised' self seems to him little more than a veneer of habits and behaviour. As he tells his lawyer,

something's gradually dawned on me over the past few days. I'm not Sherman McCoy anymore. I'm somebody else without a proper name. I've been that other person ever since the day I was arrested. . . . I'm a different human being. I exist *down here* now. (p. 692)

Entering the lower depths of the urban justice system Sherman dis-
covers what it means to 'act like a man'. Both appalled and fascinated
by his own decline, his paranoid subjectivity becomes the locus of
the novel's split urban consciousness, divided between civilising
rationality and primitive urge. As his patrician Wasp identity crumbles
he embraces its bestial counterpart, affirming that it is time 'to turn
into an animal and fight' (p. 693). This embrace of the bestial self
echoes the naturalist narratives of writers such as Frank Norris and
Jack London, but Wolfe seems to be looking backward to a yet older,
more celebrated myth of male self-empowerment – the frontier myth
of imperial white manhood that depends on mastery of threatening
others. At the novel's end Sherman shows that his masculinity has
been reconstructed in this new (old) register. As the trial is contro-
versially dismissed and Sherman is forced to flee an angry black
'mob' (p. 718), he is suddenly confronted by one of the demonstrators:

the tall black man with the earring. He goes reeling to one side. All at once
he's directly in front of Sherman. . . . Face to face! And now what? He just
stares. Sherman's transfixed . . . terrified. . . . *Now*! He ducks, pivots on his
hip, and turns his back – *now!* – *it begins now*! He wheels about and drives
his fist in the man's solar plexus. . . . The big sonofabitch is sinking, with his
mouth open and his eyes bugged out and his Adam's apple convulsing. He
hits the floor. (p. 720)

Sherman comes to embody the national myth of imperial white man-
hood, his narrative descent into the urban depths re-allegorising the
frontier tale of the lone white male in the wilderness and his violent
assertion of identity.[18]
 It is one of the striking ironies of Wolfe's treatment of white mas-
culinity that what begins as a critique of the imperial vanities of a
capitalist 'Master of the Universe' ends up as a celebration of a pre-
capitalist model of masculinity that is no less imperial in its ideo-
logical and historical foundations. Regeneration through violence
remains an appealing mythology in the reproduction of white male
identity. At the centre of Wolfe's story of 'convulsive social change',
as cities pass 'to the nonwhite majorities', is the new victim of post-
national divisions, the white middle-class male. Wolfe's ambivalent
treatment of the insecurities and anxieties of white men (prefiguring
that of many writers and filmmakers in the 1990s) characterises a
fable of urban decline which both expresses and evades the contra-
dictions of class, racial and gender divisions in urban society. While
he draws ironic and critical attention to the white male's loss of the
privileged role of universal subject, he nonetheless assumes that the

decentred subjectivity of the white male provides the primary focus for the contradictions and conflicts of his society.

It is should not be surprising to find Wolfe celebrating, however ironically, the rebellious individuality of white males, for this has been the focus of many of his new journalistic narratives.[19] This celebration, as a form of narrative closure, also indicates that his ideas of what constitutes social realism are deeply influenced by his new journalistic premises and working practices. Wolfe's assumption that realism can hold the decentred whole together, that it is still possible to conceive of the city as a synthetic totality, requires that he close down the polyphonic urban complexities he claims as his subject – he can only display the inadequacies of this assumption in his own execution of a realist narrative. This is less a failing of realism than a failure of Wolfe's realism, a failure exacerbated by the models of sociological analysis he relies upon as the backbone of his documentary approach. He has argued that 'the fundamental unit in analysing behavior is not the individual, but some sort of status group or status structure'.[20] This not only leads him to rely heavily on caricature and stereotype, as we have seen, but to valorise his position as an omniscient cultural critic able to interpret and demystify 'status group' experiences. In his new journalism Wolfe has long worked to describe subcultural differences within a transcendent authorial perspective which he assumes the reader will share. Commenting on this strategy, David Eason has noted that it operates 'to reinvent textually the consensus which cultural fragmentation had called into question'.[21] This strategy is at work in *Bonfire*, shaping its narrative of urban decline as a cautionary tale for white middle-class males.

Wolfe's national allegory of postnational decline posits the dual city as a microcosm of contemporary American society and the paradigmatic site of its (dystopian) future. *Bonfire* narrates a crisis of urbanity that subsumes both the dominant socio-economic order and its pathologised other, the racialised underclass, into a closed system of symbolic conflicts. In doing so it not only parodies but also projects and reaffirms white paranoia about tribalisation and retrocession. Using race as a privileged metaphor and the realist novel as a privileged mode of representation, Wolfe seeks to render New York City 'comprehensible' as a totality. However, he is unable to comprehend, to tell 'a single, fairly simple story' about this city. His very failure underscores the significance of the discourse of urban decline in articulating the social and ideological contradictions surrounding the anxieties of a postnationalist era.

ALIEN NATION: *FALLING DOWN*

Los Angeles, like New York, is very much an imperial city, econom-
ically and culturally formed by the dynamics of American empire
building. In the last twenty years it has taken on a leading interna-
tional role as a hub of the global flows of late capitalism and a point
of focus for the United States' technocratic contributions to the New
World Order. Imperial relations are also evident in the high levels of
immigrant population from Mexico and Central America and South
East Asia that have increased dramatically in the last twenty-five
years. It is a city in which economic and cultural formations are
rigidly stratified along racial and class lines. Mike Davis has
described Los Angeles as a 'fortress city' which is 'brutally divided
between "fortified cells" of affluent society and "places of terror"
where the police battle the criminalised poor'. It is a city of
apartheid, he argues, in which segregation and policing of urban
spaces is plotted in political and urban planning to the benefit of
the white middle class to create a spatial grid of exclusions separating
this class from the 'Third World service proletariat' and urban poor and
homeless.[22] The 'paranoid spatiality' Davis identifies in Los Angeles
and associates with the city's 'underlying relations of repression,
surveillance and exclusion' has been strikingly reproduced in many
Hollywood films in the 1990s.

It may be that film is a peculiarly well-suited medium for the
expression of urban paranoia. Consider, first, how cinematic repre-
sentation is commonly associated with modern perception of the city.
Often credited with normalising urban time and space, cinematic
representation may also be said to have accentuated growing fears and
anxieties about restructurings of modern urban life. In Hollywood
film the city has long functioned to focus psychic processes of
paranoia, hysteria and repression. I am thinking, for example, of the
unease provoked by urban space in film noir where paranoia is
invariably the predominant structure of feeling (though it may have
varied sources – sexuality, communism and race are recurrent
examples). In the classic noir of the 1940s and 1950s dislocation in
space is the common fate of characters whose paranoia suffuses the
mise-en-scène of deracinated city environments.[23] The visual legacy
of such filmmaking is apparent in the filming of postmodern cities
today, though the formal techniques are now responding to different
ideological and social conditions. For postmodern subjects in Holly-
wood film, for whom spatial awareness is heightened in relation to
an over-determined semiology of urban signs and scenes, the city is

commonly represented as an uncanny simulacrum of self, an always already interiorised space. In the optics of postmodernism the urban scene continues to compel viewer fascination in the panoramas, visual grids and darkened spaces of the city even as the city dissolves as an object of analysis.[24] While uncertainty about the meanings and boundaries of the city is hardly new in Hollywood film, it has been much exacerbated by the postmodern transformations of the spatial registers of representation. This is especially apparent in the films under review here, *Falling Down* (1992) and *Strange Days* (1995), wherein the postmodern urbanscape of Los Angeles forms not just the backdrop against but also the spatial imaginary within which white male protagonists encounter and project the psychodrama of paranoid spatiality.

I begin with *Falling Down*, an especially intriguing example of Hollywood's response to postmodern urbanism, given the irony and knowingness of the filmmakers in their representation of spatial differences and in their treatment of white male paranoia. *Falling Down* is a 'talky': that is, a film designed for controversy. It tells the story of the last day in the life of a white middle-class man who, having lost his job and estranged from his wife and child, finally snaps and vents his anger in a violent journey through downtown Los Angeles where he comes into conflict with Koreans, Latinos and a white neo-Nazi among others, before he is finally killed by a white policeman. In some areas the film was accused of racist or ethnic stereotyping and drew much publicised protests from Asian-American and Latino groups. It also accelerated media interest in the status of the white male as victim in US society.[25] The lead actor Michael Douglas, the director Joel Schumacher and the producers Warner Brothers all insisted the film had been widely misunderstood or misinterpreted. With varied inflections they all stressed the 'realism' of the film. Douglas (seemingly ignorant of the charged vocabulary he used) reflected: 'I felt there was a deep, dark, growing cancer in the streets of our cities, and more and more people are going to disintegrate. This film ... was giving these problems a voice'.[26] Schumacher, recalling his first thoughts on the screenplay, observed:

There was an everyday insanity about it. Darkly funny, but containing a monstrous anger that actually reflected the views of a wide cross-section of American society. It was a script that dealt with racist, bigoted people who were angry that all they had worked for was disappearing.[27]

Echoing these comments a Warner Brothers spokesman responded to charges that the film was racist and anti-immigrant:

We don't believe it condones any of this at all. Quite the contrary, it is holding up a mirror to the things going wrong in our society. We view the film as a wakeup call to the many people who blame their problems on others.[28]

This last statement, which most acutely defines the film's moralising agenda, also illuminates the difficulties the filmmakers faced in selling their interpretation. Their stated intentions notwithstanding it is by no means clear to whom this 'wakeup call' is addressed or what it says. To be sure, *Falling Down* does set out to dramatise white male prejudices and anxieties and closes on the death of the protagonist who carried these to violently extreme ends. But in its borrowing of established filmic codes of masculinity and in its depiction of ethnic and racial stereotypes the film sends out very mixed, confused messages about the hysterical white male subject it constructs at its centre.

 Falling Down is advertised as 'The adventures of an ordinary man at war with the everyday world'. His ordinariness is stressed by Joel Schumacher who has stated 'This is not a bad guy, but he's had it'.[29] In the course of the film we discover that the ostensible reasons for his violent rampage are that he has lost his job as a defence worker and his wife has left him taking their child and placed a restraining order on her husband. Without the roles of white-collar worker, husband and father to secure his sense of ordinariness the traditional 'fear of falling' gives way to paranoia and violent anger. At several points in the film he attempts to articulate his frustrations and sense of victimisation – 'I lost my job ... it lost me. . . . I'm overeducated, underskilled ... maybe it's the other way around. . . . I'm not economically viable' – and near the end seems bewildered – 'I'm the bad guy? How'd that happen? I've helped defend America ... they gave it to plastic surgeons ... they lied to me'. In such moments of the protagonist's pathetic self-analysis the film further promotes his 'ordinariness' and the virtual anonymity of his character – throughout much of the film he is known simply as D-FENS, the name on his carplate – to present him as 'not a bad guy', an errant everyman whose dilemma is understandable even as his actions are unjustifiable. In its careful characterisation of D-FENS as a dupe of Cold War and Reaganomic ideologies the film hints at the imperial relations which have played a part in securing his identity as ordinary, as white male. However, even as D-FENS' imperial subjectivity disintegrates the

film sustains an imperialist vision of 'the things going wrong' in the society around him.

While D-FENS' loss of job, wife and child are presented as reasons for his breakdown we soon recognise that these losses are supplemented by more varied anxieties and prejudices. The opening scene of the film hints at these supplementary pressures at the same time as it establishes his everyman credentials. The film begins with a tight close-up of the sweating face of D-FENS and then pans to the vehicles and people surrounding him in a traffic jam on a Los Angeles freeway. A sense of frustration and growing tension is achieved as rapid intercutting juxtaposes D-FENS' features with the expressions of people within his gaze and of signs adorning neighbouring vehicles and the roadside. Added to this visual mayhem is a growing cacophony of indeterminate sounds. The tension is finally broken when D-FENS scrambles out of his car, gasps for air, and tells an irate motorist 'I'm going home'. Like the film as a whole this scene is symbolically over-determined in its representation of the protagonist's dilemma. It sends us a profusion of sounds and signals that function at different levels of connotation and invite different forms of recognition. Manifestly, we have a scene of everyday frustration, a traffic jam, which should elicit a sense of empathy from the viewer and reinforce D-FENS' identity as everyman. But the scene also elicits recognition of a different sort of frustration for the profusion of sounds and signals work to symbolise this traffic jam as a gridlocked multiracial America populated by different peoples zoned in their own private spaces, isolated in their own concerns, and aggressively warning off others. It is this image of contemporary America as a fractured, disputatious polity that is predominantly reinforced in the film narrative as the *sine qua non* of D-FENS' falling down.

With this scene we are introduced not only to paranoid spatiality as a theme but as a condition of visibility which will focus representation of the city for the viewing audience. The enclosing space which surrounds D-FENS in this opening scene – technically signified by the circling movement of the craning, panning camera – is the interiorised space of his paranoia from which there is no escape into the public spaces of the city. This is further signified throughout the film by the camera's medium long shots of D-FENS walking through alien spaces, at once an incongruous figure out of place but also centred by camera viewpoint. In other words, the urban topography through which he moves mirrors components of his disturbed subjectivity; he is at once dislocated in the space of the city and inured in the space of his own psychosis.

This opening scene suitably prefaces the narrative of D-FENS' journey homeward through downtown Los Angeles. His assertion that he is 'going home' would appear to be a last desperate and deluded effort to reunite with his wife and child, but it clearly has a broader symbolic import. His odyssey across Los Angeles to his wife's house in Venice Beach is constructed as a series of 'adventures' in an 'everyday world' which is depicted as a social matrix of territorialised enclaves of power and exclusion based on race, ethnicity, class and gender. The America D-FENS discovers on his journey is not the one he believed he was defending. It is peopled by numerous others – Korean shopkeepers, Latino gang members, homeless people and the retired rich – all making claims, as his estranged wife does, to their own territories and all defining him as an alien presence. Long before he is killed it becomes apparent to the viewer that there is no 'home', no secure place, for D-FENS in this America. What is less apparent, perhaps, is that his growing sense of alienation suffuses the enframing of his experiences as a morality tale of white male paranoia. As he moves through these alien territories (perversely echoing the colonial travels of white male adventurers) the disintegration of his imperial subjectivity is sublimated in the film's projection of his paranoia onto a pathologised urban scene of social disorder and degeneration. What begins as a tale of white male paranoia becomes an encompassing critique of the conditions of both this paranoia and its objects.

The paranoid spatiality Mike Davis refers to in *City of Quartz* is much in evidence in *Falling Down*, but with the crucial distinction that its beleaguered victim is a white middle-class male. At times the film echoes some of Davis' observations, particularly his view that little or no 'genuinely democratic space' exists in the city – at one point D-FENS complains that a private golf course he enters should be given over to 'children playing . . . families having picnics'. But the film elides critique of the hierarchical structures of urban power which construct repressions in space and movement in favour of a levelling critique of all claims to territory – whether from rich white golfers or Latino gang members – which diminish democratic citizenship. This levelling critique, much facilitated by the picaresque movement of D-FENS through disparate social spaces, strains to conceal the ambivalence and contradictions of the film's liberal moralising. A potent example is a scene set in a public park populated by poor and homeless people. The camera surveys these people and foregrounds excessive images of poverty: there is an emaciated white man holding a sign which reads 'We are dying of AIDS please

help us!'; there is a black man in a wheelchair holding a sign reading 'Homeless Vet Need Food Need Money'; there are two young black men with a trolley full of empty cans, being arrested by the police – and the background is filled with predominantly African-American and Latino people. Whatever the filmmakers' intentions in presenting us with these images their crude stereotypes compose an obscene depiction of a collective 'underclass' existence, with these people represented as degenerative signifiers of social immiseration and victimisation.[30] This is poverty as spectacle; an aesthetic trans-figuration of lived experiences into reified images that detach the viewer from the subjects viewed. As D-FENS moves through the park we share his position of imperial tourism. As with so much of the film, the camera colonises and exoticises scenes of intractable other-ness (allowing the viewer voyeuristic pleasures) and ultimately levels distinctions between different social subjects by dissolving difference and conflict into moral equivalence.

I do not mean to suggest that the filmmakers should have adopted Davis' leftist perspective in order to portray the 'reality' of social relations in Los Angeles. Rather, I want to draw attention to ways in which they acknowledge race and class antagonisms while privileg-ing the perspectives of a (de)centred white male subjectivity. The film's central dialectic of self and other, focused on D-FENS' para-noia, subtly encodes racialised relationships of power and control. This is particularly notable in a scene in which D-FENS observes the arrest of a black man who, holding a placard bearing the words 'Not Economically Viable', is picketing a bank to protest discrimination. As the arrest takes place D-FENS and the black man stare at one another for a moment and the latter says 'Don't forget me'. The scene posits a point of identification between the two men (we note that they are dressed almost identically) to suggest a shared plight. This is a startling scene of calculated misrecognition, which has the white man appropriate the space of the black protester. The gaze between the two men is presented as one of equal recognition, a gaze of empa-thy (perhaps even of nascent class consciousness) which transcends racial difference – D-FENS will later use the phrase 'not economically viable' in trying to articulate his dilemma. However, given the privileges accorded D-FENS' imperial vision throughout the film his gaze can only function to colonise and determine the meanings of 'blackness'.[31] The crude liberalism motivating this scene at once idealises and negates the alterity of the black subject. More than this, it induces historical amnesia. 'Don't forget me', the black man says, but this is precisely what viewers are asked to do, to forget the historical

content of his experience. Such amnesia allows the film to have its race and class conflicts and to forget the histories of these conflicts.[32]

In the film's self-conscious representation of the boundaries of American identity it incorporates narratives of imperial history which shadow D-FENS' adventures in an alien nation. These narratives – of colonisation, expansion, regeneration through violence, and dependency upon the racial other – have long been important to Hollywood's representation of white American manhood. They are strongly associated with two genres that clearly influence *Falling Down*, those of the Western and the vigilante film. Common to these genres is the retelling of the frontier tale of the lone white male in the wilderness and his violent assertion of identity 'against the threats of racial uprising, female independence, and the feminisation of helpless white men'.[33] It is a tale Hollywood has told again and again, an ur-narrative of white American manhood which is present in such celebrated films as *The Searchers* (1956) and *Taxi Driver* (1976) as well as in more standardised fare.[34]

Falling Down retells this tale while ironically undercutting its potency in several ways. D-FENS' journey home may be viewed as an inversion of the national allegory of American expansion that has precedents in the Western genre. Like Western film heroes before him he literally and metaphorically runs out of space, his westward journey across the city ends on a pier in the Pacific Ocean. As if to reinforce our perception of the Western intertexts D-FENS faces the policeman Prendergast on the pier and says to him 'you want to draw? . . . it's perfect . . . showdown between the sheriff and the bad guy'. Like vigilante film heroes before him D-FENS learns self-reliance in the urban frontier, quickly establishing his skills of survival and violent action – at one point he appropriates and wears military clothing in what is a clear reference to the Vietnam vet vigilante films. Like numerous Western and vigilante heroes D-FENS is represented as a liminal figure in his dislocation from social norms and uneasy psychological association with racial others. Think of Ethan Edwards' separation from family intercourse and his latent self-loathing in *The Searchers*, or of Travis Bickle's alienation from the nightmarish urban mass and his self-aggrandising search for violent redemption in *Taxi Driver*. There are significant differences between these films but each of them critically interrogates the frontier tale of white American manhood (even if they stop short of underlining its imperial unconscious). What differentiates *Falling Down* is the element of ironic parody in retelling this tale, which intertextually incorporates and deflates the mythologies of liminal

white heroism and regeneration through violence. Although D-FENS adopts violence as a response to the racialised landscape he finds himself in, there is no obvious regeneration or renewal for him in the America he once identified with.

Falling Down is a smart film, but it struggles to delimit interpretations of D-FENS' excessively over-determined paranoia and to convince viewers that he represents an ultimately (mythologically) redundant model of white masculinity. The film is deeply knowing about the codes and conventions of representing white male violence and pulls the audience in different directions, at one moment eliciting our pleasure in the wisecracks and spectacle accompanying D-FENS' rampage, at another seeking to distance audiences from him by rendering him absurd or psychotic. This is a delicate balancing act which points up the filmmakers ambivalent responses to their subject matter as well as their efforts to parade and parody white male paranoia. A telling example of their efforts to control audience perceptions of D-FENS' violence occurs in a scene in which he encounters an army surplus store owner who is (in Carol Clover's words) 'a homophobic, racist, anti-environmental, misogynist, neo-Nazi'.[35] Refusing the neo-Nazi's overtures of fascist kinship and in response to his subsequent violence D-FENS lectures him on freedom of speech and kills him. The scene is all too obviously intended to assure us that D-FENS is not a figure of violent prejudices, just an ordinary guy who's 'had it'. However, the meaning of this scene of violence is not easily secured by reference to his 'ordinary', if extreme, breakdown. D-FENS does not kill the neo-Nazi in an act of self-defence but in response to a threat of sodomy and the scene of violence is also one of homoerotic and homophobic impulses and identifications.[36] As such the scene registers the confusions of agency and powerlessness represented in and by the white male paranoiac.

To focus on D-FENS' failings as a liminal hero of violent white masculinity may confine us to much too narrow an interpretation of the film's liberal politics and its narrative power. It overlooks two important points. First, it discounts or at least underestimates the pleasures viewers may take in watching the spectacle of violent white anger, pleasures that are not necessarily contained or dissolved by the closure of D-FENS' death. The second point this interpretation misses is that even as the film parodies the tale of regeneration through violence in the narrative of D-FENS it reproduces it more soberly in the narrative of his double within the film, the white policeman Prendergast. Like D-FENS, Prendergast is a prosaic figure of liminal and victimised white manhood, though on a more mundane

scale. He is a model of 'weak' (feminised) masculinity, deskbound and about to retire because his wife emotionally dominates and manipulates him. He appears a mild-mannered, introspective man who has little social engagement with his colleagues and lacks their respect. But it is Prendergast who maps the movements of D-FENS across the city, tracks him down and kills him. To Prendergast's police colleagues D-FENS is virtually invisible: described by witnesses to his violence as a white man in a white shirt and tie, he is everybody and nobody to the police. Prendergast, on the other hand, understands D-FENS' motivations and intuits the reasons for his anger as a psychotic extension of his own sense of degraded masculinity. The showdown between Prendergast and D-FENS has a structural inevitability as does the latter's death at the hands of the former.

The narrative effect of this execution of the hysterical white male is to elevate the weak masculinity of Prendergast by fusing it with violence. To put this another way, if all too simply, D-FENS must die so Prendergast can live again: at the end of the film he asserts control over his wife, refuses retirement, and insults his commanding officer. Regeneration through violence is still possible, but not for the lone white vigilante. It is earned by a (liberal) hero who takes responsibility for his actions, refuses to blame others for his dilemmas, and follows the rule of law even as he dissents from it. D-FENS' death is both a self-sacrifice and a mode of symbolic transference that ensures the reproduction of white masculine authority in a new register. *Falling Down* may parody the imperial individualism of white American manhood but it does not negate it, rather it retells the story of the (re)making of this manhood as a morality tale for a multiracial, postnational United States.

This returns us to the liberal politics of the film and we should recall the producers' view that *Falling Down* is 'a wakeup call to the many people who blame their problems on others'. D-FENS has blamed others and look at the violent result, ditto: take responsibility for your life and your relations with others. However, this call seems directed only towards white males. Women and minority peoples in the film are not offered any clear focalisation of their anxieties and angers, they exist as a mass of others threatening the authority of white men. While the film renders whiteness visible in ironic and critical ways and works to suggest that the white male is no longer the secure centre of American identity, it also (mimicking the structure of *Bonfire*) places this figure at its centre in order to 'mirror' and moralise about 'the things going wrong' in American society. The assumption is that Americans may live in a fractured, Balkanised

society but they can only understand the realities and dangers of this from the perspective of the white male. This assumption is clear in director Joel Schumacher's comments:

As I saw it this movie was reflecting existing attitudes in society. Usually, the movies that reflect anger in the street do so from the standpoint of Afro-Americans, a race thing. The fact is, they are not the only angry people in America.[37]

This seems a reasonable point, and certainly the social anxieties and problems of white males merit serious representation (their ubiquitous presence in the mass media notwithstanding). However, to assume, as Schumacher does, that a film dealing with the latter represents society-wide attitudes and transcends race only reinforces the normative centredness and privileged invisibility of whiteness. In *Falling Down* 'anger in the street' is very much 'a race thing', for the protagonists' appropriation of victim status introjects the anger of racial others as a symbolic screen for white paranoia and resentment.

HELTER SKELTER: *STRANGE DAYS*

Strange Days is another smart film, and also another muddled one, indeed it all but collapses under the symbolic weight of its social messages, its mix of genres and intertextual references, and its reflexive concerns with the acts of filming and spectatorship. The director Kathryn Bigelow, echoing Schumacher, refers to her film as a 'wake-up-call', and as with *Falling Down* it is a call that is confused in its enunciation.[38] A major theme of the film is the growing tensions within Los Angeles as the millennium approaches – the film is set in LA on the last two days of the century. The major protagonist, Lenny Nero, is an ex-policeman turned to peddling an illegal device – SQUID (Superconducting Quantum Interference Device) – which records peoples realties directly from their brain onto a disc which others may playback and so vicariously enter that reality. As the millennium draws closer tension in the already unstable city is heightened by the murder – by white policemen – of a black rap star who had promised to focus much of the urban discontent. Lenny and his erstwhile bodyguard Mace become caught up in the events surrounding the murder and the search for a SQUID disc onto which the murder was accidentally recorded.

The theme of impending apocalypse is a common one in representations of Los Angeles. Mike Davis is all too happy to invoke it:

'In LA there are too many signs of approaching helter skelter... a whole generation is being shunted toward some impossible Armageddon'.[39] Like many filmmakers (and urban geographers) Bigelow views LA as the paradigmatic urban scene of America's future:

[LA]'s the template, isn't it? Perhaps because there is so little history here, there's a fragile balance, an inherent tension. Also it's not a city. There is no centre. And in its lack of identity it has a kind of poly-identity: it's whatever you project onto it, a faceless place that harbors a multitude of identities, all blurred into one. That's not to say the city isn't a microcosm for the rest of the country. LA's polyglot society is critical to the flashpoint world of *Strange Days*, but I don't think it's atypical of the rest of the US. It's just in sharper relief here.[40]

Bigelow infers here and attempts to illustrate through her film that the 'poly-identity' of LA both feeds its paranoid energies and elects it as a potential space of national cohesion and civic democracy.

What Bigelow calls the 'poly-identity' of LA is treated in the film as (thematically) an issue of race and (formally) of visuality – we need to consider the interaction of these elements. *Strange Days* very deliberately invokes the civil disruptions that occurred in Los Angeles in 1992, through the use of imagery and documentary motifs associated with the 'LA riots'. This includes the video recorded beating of Rodney King by white policemen and the televised urban unrest that followed broadcasting of the video and the later acquittal of the policemen. The death of the black rap star, which threatens catastrophic urban violence, occurs when his car has been stopped by white policemen and the SQUID film of this scene is clearly intended to recall for the viewer George Halliday's video recording of the beating of King. At the end of the film the King video is again redramatised but now as the beating of a black woman, Mace, by LA police. Fortunately, the white LAPD chief spots foul play and intervenes to save Mace and avert the millennial disaster the film appeared to moving toward, also making possible a new beginning for the thwarted love of Lenny and Mace. While this closure on a vision of a new dawn for race relations (figured as redemptive love) is heavy handed in narrative terms, it also fails to conceal contradictions within the film's visualisation of racialised issues.

If race is 'a privileged metaphor through which the confused text of the city is rendered comprehensible', we can add that the forms of legibility this metaphor constructs are profoundly visual.[41] This was notably evidenced by the conflicting interpretations that surrounded video footage of Rodney King's beating in 1992 – interpretations which

attested both to the unreliability and the reification of the visual as the surest ground of evidence.[42] *Strange Days*, while making viewers aware of the striking fusion of the eye and the camera lens in comprehension of the urban scene, and also disturbing certain securities of our viewing position, barely questions the racial formation of the visual field it appropriates. The film's visual and dramatic reenactments of the original crime – the beating of King – posit it as a phantasmatic scene of collective urban trauma (for Los Angeles-as-nation), suggesting that through repetition this trauma can be overcome. However, the meanings of the original crime are in the film decontextualised and renarrativised in ways that grossly simplify the role of race in visualisation of the urban scene. The filming of the police beating of Mace is a vulgar effort to focus the visual carnival of millennial unrest on the violent disciplining of a black body; it represents her body as a site of physical and visual violence subject not only to the actions of the police but also to the privileged gaze of an audience consuming the scene of the return of the repressed as spectacle. The scene elicits empathy with a filmic character rather than understanding of the condition of visibility it activates.

Contradictions within the film's treatment of the black body as a site of urban fears and paranoia are echoed in its broader efforts to visualise the meanings of the 'poly-identity' of Los Angeles. Bigelow comments that in watching *Strange Days* 'your eye wanders outward to this complex environment that the principal characters don't bother to acknowledge' – this is true for much of the film and a reminder that a city is in many ways a product of peripheralised vision, never quite in focus.[43] However, her idea that the city of Los Angeles is 'whatever you project onto it' also invokes the utopian promise of the American city as a place where individuals could assume new identities and perform a multiplicity of roles. Many commentators have argued that this concern with the performativity of urban identity has become an excessively anxious one in the postmodern city.[44] In *Strange Days* SQUID metaphorically intensifies the fluidity of identities to suggest that it is a result of new ways of seeing and experiencing the urban scene. SQUID collapses normative boundaries between self and other, inside and outside, and private and public space. What it reflects (or, perhaps, prefigures) is an extreme dislocation of space whereby the subject is intensely immersed in the urban scene, losing distance, detachment and perspective amidst an excess of identification – the result is an appalling parody of the 'blurring' of identities Bigelow offers as the meaning of urbanity in

LA (and of the more common perception of urbanity as the close proximity of strangers).

Strange Days assumes and foregrounds the intensified visuality of the postmodern city, and, its confused ideas notwithstanding, is suggestive of new ways of seeing the city. Cameras are now everywhere in and above contemporary urban environments – video cameras, closed circuit television cameras, and skycams – allowing ever-extending forms of surveillance for individual citizens as well as institutions. The result, Kevin Robins, proposes, is:

the distributed panopticon, the dispersed panorama of the city. . . . With the camcordering of the city we have the fragmentation and devolution of vision as control to the individual level. . . . Visual detachment and perspective are difficult to achieve: these cameras also draw the observer into the urban scene, providing a new directness, intimacy and intensity of vision. . . . These kinds of images – camcorder shots, vigilante documentation, shock reportage, reality voyeurism – have become the basis of a new form of public entertainment . . . reality television.[45]

These kinds of video images, more often than not recording urban dysfunction and discord, may be what offer to connect us most intimately to the postmodern urban scene. Certainly this reality television offers a fitting analogue for the paranoid spatiality that attends contemporary American urbanism. It is a television which projects onto the city the fears and anxieties of its populace, and then plays these back to them as externalised threat. Such television completes the circuit of paranoia as a virtual experience of the urban real. *Strange Days* and reality television propose that a significant transformation is taking place in our visual relation and connection to the urban world, one that projects feelings of dislocation in space as a collective urban experience, not as an individual psychosis (as *Falling Down* would suggest). Paranoid spatiality has become a prominent condition of visibility, not just in Hollywood cinema representations of the city but also in those of the newer technologies of representation that promise a more satisfying connection of postmodern optics and the urban scene.

In her celebrated attack on postwar urbanism, *The Death and Life of Great American Cities* (1961), Jane Jacobs worried that the public spaces of American cities were deteriorating. To enhance informal public contact and make it safe she advocated 'Eyes upon the street, eyes belonging to those we might call the natural inheritors of the street'.[46] Nearly forty years later such informal surveillance is widely

represented as a mechanism of control and exclusion, rather than a spur to the integrative model of urban public life Jacobs envisioned. In the texts examined here the 'eyes upon the street' are not those of its 'natural inheritors' but of those who fear the tribalisations and dangers 'the street' has come to signify. They portray the street as a frontier space in which ethno-racial difference is played out in symbolic conflicts centred on the insecurities of a white male subject. Presented as an aberrant space of disorder and decline the street is voyeuristically reclaimed as a privileged site for the production of a paranoid urban imaginary.

Notes

1. Robert Beauregard, *Voices of Decline: The Postwar Fate of U. S. Cities* (Oxford: Blackwell, 1993), p. 6.
2. Richard Dyer, 'White', *Screen*, 29 (Autumn 1988), pp. 45–6. I should add that the significance of whiteness as a social category has long been apparent to people outside of this category. See bell hooks, 'Representations of Whiteness', *Black Looks: Race and Representation* (London: Turnaround, 1992), pp. 165–78. Other recent studies of whiteness, to which I am indebted, include: David Roediger, *The Wages of Whiteness: Race and the Making of the American Working Class* (London: Verso, 1991); Toni Morrison, *Playing in the Dark: Whiteness and the Literary Imagination* (Cambridge, MA: Harvard University Press, 1992); and Fred Pfeil, *White Guys: Studies in Postmodern Domination and Difference* (London: Verso, 1995).
3. Amy Kaplan, '"Left Alone with America": The Absence of Empire in the Study of American Culture', in Amy Kaplan and Donald Pease (eds), *Cultures of United States Imperialism* (Durham, NC: Duke University Press, 1993), p. 16.
4. See William Appleman Williams, *Empire as a Way of Life: An Essay on the Causes and Character of America's Present Predicament, Along with a few Thoughts about an Alternative* (London: Oxford University Press, 1980).
5. Eric Lott, 'White Like Me: Racial Cross-Dressing and the Construction of American Whiteness', in Kaplan and Pease, *Cultures of United States Imperialism*, p. 476.
6. As whiteness has taken on a new visibility in the United States it has in part been shaped and promoted by the grievances of white males, and especially of middle-class white males. A commonly noted example in the early 1990s was the widespread consternation about economic decline in real wages and growing job insecurity in an age of postindustrial restructuring, which deprived many of this class of the benefits long associated with capital growth. In the view of many commentators what became increasingly exacerbated was the white middle-class 'fear of falling', of losing control over self and society; a fear which has distinctly anxious

connotations for white males who must confront their diminishing ability to assume normative roles of power and authority and transcend the politics of identity formation. See Gary Burtless (ed.), *A Future of Lousy Jobs* (Washington, DC: Brookings Institution, 1990); Barbara Ehrenreich, *Fear of Falling: The Inner Life of the Middle Class* (New York: Perennial, 1990); and Stephanie Coontz, *The Way We Never Were: American Families and the Nostalgia Trap* (New York: Basic Books, 1992).

7. Lewis Mumford, *The City in History: Its Origins, Its Transformations, and Its Prospects* (New York: Harcourt, Brace and World, 1961), pp. 51–3.

8. Mike Davis, *City of Quartz: Excavating the Future in Los Angeles* (London: Verso, 1990), pp. 221–63.

9. See Victor Burgin, *In/Different Spaces: Place and Memory in Visual Culture* (Berkeley, CA: University of California Press, 1996), pp. 117–37.

10. Elisabeth Grosz, *Space, Time, and Perversion: Essays on the Politics of Bodies* (London: Routledge, 1997), p. 8.

11. Marshall Berman, 'Looking at Our City', in Jim Sleeper (ed.), *In Search of New York: A Special Issue of 'Dissent'* (New Brunswick: Transaction Publishers, 1989), p. 21.

12. Quoted in Reggie Nadelson, 'The Melting Pot Boils Over', *Independent*, 15 March 1992, p. 19.

13. Wesley Brown, quoted in Sleeper, *In Search of New York*, p. 37.

14. Tom Wolfe, *The Bonfire of the Vanities* (New York: Farrar, Straus & Giroux, 1987), hereafter abbreviated as *Bonfire*. Following page references are to the 1990 Picador paperback edition of the novel and will be given in the text. The novel was first serialised in *Rolling Stone*, 1986–87.

15. Tom Wolfe, 'Stalking the Billion-Footed Beast: A Literary Manifesto for the New Social Novel', *Harper's Magazine* (November 1989), p. 46. Further page references will be given in the text.

16. For coverage of the journalism, see Beauregard, *Voices of Decline*, pp. 258–60. For an extensive critical examination of the 'dual city' concept, see John Mollenkopf and Manuel Castells (eds), *Dual City: Restructuring New York* (New York: Russell Sage Foundation, 1991).

17. Manuel Castells, *The Informational City* (Oxford: Basil Blackwell, 1989), p. 348.

18. For a detailed analysis of the cultural history of this tale, see Richard Slotkin, *Gunfighter Nation: The Myth of the Frontier in Twentieth-Century America* (New York: Atheneum, 1992).

19. There are many examples throughout Wolfe's writings, including, most famously, the test pilots and astronauts of *The Right Stuff* (1979).

20. Quoted in Tony Schwartz, 'Tom Wolfe: The Great Gadfly', *New York Times Magazine*, 20 December 1981, p. 46.

21. David Eason, 'The New Journalism and the Image-World: Two Modes of Organising Experience', *Critical Studies in Mass Communication* 1 (1984), p. 52.

22. Davis, *City of Quartz*, pp. 221–63.

23. See Joan Copjec (ed.), *Shades of Noir: A Reader* (London: Verso, 1993).

24. James Donald, considering visual and psychic connections in modern cinema, usefully reminds us of Walter Benjamin's observation, 'the camera introduces us to unconscious optics as does psychoanalysis to unconscious impulses'. James Donald, 'The City, The Cinema: Modern Spaces', in Chris Jenks (ed.), *Visual Culture* (London: Routledge, 1995), p. 84.

25. See '"Falling" Gives Rise to Protest', *New York Daily News*, 3 April 1993,

p. 7. The film prompted a *Newsweek* cover story (5 September 1993) on 'white male paranoia'.

26. Quoted in John Parker, *Michael Douglas: Acting on Instinct* (London: Headline, 1994), p. 264.

27. Ibid., p. 259.

28. Robert Friedman, Warner Brothers spokesman in Los Angeles, quoted in '"Falling" Gives Rise to Protest', p. 7.

29. Quoted in Carol Clover, 'White Noise', *Sight and Sound* (May 1993), p. 6.

30. For an analysis of how 'degeneration' signifies urban disorder see David Theo Goldberg, *Racist Culture: Philosophy and the Politics of Meaning* (Oxford: Blackwell, 1993), pp. 200–1.

31. On the image of the black body in the white mind and the significance of 'the look' in a racialised field of vision, see Frantz Fanon, *Black Skins, White Masks*, trans. Charles Lam Markmann (New York: Grove Press, 1967).

32. On historical amnesia as a form of politicised and 'motivated forgetting' aided by visual spectacle, see Michael Rogin, '"Make My Day!": Spectacle as Amnesia in Imperial Politics', in Kaplan and Pease, *Cultures of United States Imperialism*, pp. 499–534.

33. Ibid., p. 511.

34. See Slotkin, *Gunfighter Nation*.

35. Clover, 'White Noise', p. 8.

36. For a complementary and more detailed reading of this scene, see Pfeil, *White Guys*, pp. 240–1.

37. Quoted in Parker, *Michael Douglas*, p. 261.

38. Quoted in Jim Shelley, 'LA is Burning. Happy New Year', *Guardian*, 2 December 1995, p. 12.

39. Davis, *City of Quartz*, p. 316.

40. Quoted in Andrew Hultkrans, 'Interview with Kathryn Bigelow', *Artforum* (November 1995), p. 80.

41. Michael Keith and Malcolm Cross, 'Racism and the Postmodern City', in Malcolm Cross and Michael Keith (eds), *Racism, the City and the State* (London: Routledge, 1993), p. 9.

42. For an incisive commentary, see Judith Butler, 'Endangered/Endangering: Schematic Racism and White Paranoia', in Robert Gooding-Williams (ed.), *Reading Rodney King, Reading Urban Uprising* (London: Routledge, 1993), pp. 15–22.

43. Quoted in Hultkrans, 'Interview', p. 80.

44. This is a theme of many essays in Sophie Watson and Katherine Gibson (eds), *Postmodern Cities and Spaces* (Oxford: Blackwell, 1995).

45. Kevin Robins, *Into the Image* (London: Routledge, 1996), pp. 138–40.

46. Jane Jacobs, *The Death and Life of Great American Cities* (New York: Random House, 1961), p. 35.

Once Upon a Time in America

It is widely argued that as well as changing common perceptions and uses of space postmodern urbanism is producing a new sense of place and locality. Here is a not untypical assessment, by Nan Ellin:

The importance of place has diminished as global flows of people, ideas, capital, mass media, and other products have accelerated. And the walking city has evolved into a less legible landscape where the erstwhile distinctions between city, suburb, and countryside no longer abide. The most common ways to describe this shift – both geographical and perceptual – are de-territorialisation and placelessness. A by-product of this shift is a profound sense of loss.[1]

As the city becomes less 'legible', in Ellin's view, a search ensues for 'urbanity, a centre, community, roots'.[2] Ellin is not wrong about this sense of loss – as we shall see, it shadows the discourse of urban decline in many narratives – but it is a much more conflicting and contradictory structure of feeling than her commentary suggests. A key issue here is how and to what ends the city, and more especially places within the city, function both as *imago mundi*, imaginary worlds accessible only through memory, and as material sites of memory work. Memory becomes an important resource in the spatial production of new moorings (individual and collective, private and public) amidst the displacements of postmodern urbanism. Whether it takes the form of commodified nostalgia or of a cultural counter-force to the dominant urban imaginary, it links time and space in complex and unstable ways. In certain modes and representations memory may seem to represent escapism from contemporary urbanism, but all memory work is variably conditioned by the effects of the present.

Urban spaces have long been understood and used as theatres of

memory. While the *ars memoria* of the pre-modern past may no longer be practised, modern city dwellers have learned arts of memory anew in both 'official' and 'vernacular' forms, through museums, theme-parks, festivals, parades and through everyday acts of movement and looking which allow us to read the past off built space, investing it with desire or yearning for what is no longer there. While these practices are open to many influences, we should note that postmodern urbanism has in part been characterised by an increasing aestheticisation and commodification of urban spaces as sites of memory, often designated as such within civic or touristic discourses. Certain sites of ethnic or racial memory have become valorised as sites of 'cultural interest', forms of symbolic capital which take on value within the broader urban political economy.[3] The 'authenticity' of cultural identity in the memorialisation of the urban past is often a hostage to competing values and priorities. It is tempting to select between authentic and inauthentic spaces and practises of memory, but the question of authenticity in itself is often misleading and unhelpful. Individuals and groups have varied and complex reasons for strong, affective associations with urban spaces; imagination and emotions, which course strongly in these associations, are not necessarily rooted in the authenticity of place understood either in material or historical terms. There is a good deal of contemporary critical interest in memory as an affective agency of self-definition and resource of critical perspectives on dominant forms of historical consciousness.[4] However, memory should not be too casually privileged as a counter-hegemonic force, for it is always socially constructed; it both transforms and is transformed by history. Moreover, when memory is a motivated or strategic act – of cultural maintenance or community-building, for example – it threatens to prescriptively memorialise the past and essentialise the cultural identities it inscribes. Memory can support dialogue and interaction, it can also support new tribalisms and competing nationalisms. It is not the privileged preserve of one cultural group and its very instability and claim on emotions make it a volatile ground for competing reclamations of the urban past.

With these reservations in mind about the more public mobilisations and interpretations of memory, where it often approaches the character of myth, we need also to be cognisant of the instabilities of memory in more private forms of association between subjectivity and urban space. Memory is profoundly spatial, compressing and displacing the co-ordinates of time measured as history, compromising the temporal structure of duration with the spatial dismemberment

of condensation. Memory not only responds to the city as material environment but as psychic space; a space of repetitions, regressions and deferrals that resonates with unconscious impulses. In many literary narratives urban spaces become archeological or topological sites combining dream work and cultural semiosis, proffering opaque, buried connections between urban past and present. Such associations can be readily romanticised but they can nevertheless establish the 'real' of memory work in which the present reinvents the past in order to explain the present. Memory holds some promise for writers seeking to understand the opacity of urban space; it offers to deepen the legibility of the city by exposing the foundations of impulses to recover or maintain imagined communities of urban relationships. The literature under examination in this chapter brings us close to these emotional and psychic workings of memory while exploring their historical contexts in particular urban places.

LIEUX DE MÉMOIRE: ROOTS AND ROUTES OF URBAN LITERATURES

Since the 1970s, memory has become a significant issue of representation in American literature, with many writers 'reclaiming' or 'retelling' the American past from distinctly ethnic and racial perspectives.[5] This preoccupation with the past is not new, but it has never been so plural nor so politicised in the history of American literature. What is at issue in much of this writing is the formation and inscription of cultural identities in the act of narrative remembrance. Writers have sought to interrogate and revitalise the histories of their ethnic and racial groups and show how cultural identities in the present are shaped by narratives of the past. I want to consider some of the historical and ideological contexts of this literary turn to memory and more particularly its consequences for remembering the urban past.

The memory work of urban representation is inflected by the volatile cultural pluralism that has characterised the fragmentation of coherent political and cultural publics in the United States over the last thirty years. With the disintegration of the postwar ideological consensus in the mid 1960s, as Frederick Buell observes,

cultural pluralism emerged as a powerful public issue and force. On the one hand, this represented an extension of the ideologically sacred concept of the United States as a nation of immigrants, a nation of nations; on the other hand, it ruptured these traditions, as analyses of American racism and the

failure of the melting pot were supplemented by advocacy of oppositional and revolutionary forms of cultural nationalism. In race relations, in ethnic affairs, and in management of internal borders generally, the boundaries of American identity were being transgressed and shattered.[6]

Although the 'boundaries of American identity' were never securely fixed in an unchanging national ideology they were deeply encoded in the concept of the American Creed as civil religion and in its master narrative of exceptionalist ethnogenesis. This narrative did not simply dissolve in the 1960s but it lost its power to describe a collective, national experience and evoke a shared historical consciousness. Since this period Euro-American traditions have struggled to authorise the meanings of American identity. New patterns of cultural existence, immigration and migration, and ethnic and racial boundary-marking have accentuated these decentring tendencies, fragmenting and dislocating the 'common culture' of reference. This is another way of stating what we observed above as a decentring of the culture of the core in postmodern urbanism and the concomitant emergence of a discourse of urban decline.

The importance of memory in this decentring cannot be underestimated, though it takes diverse forms and has no singular political impetus. As totalising historical consciousness gives way to a multiplicity of micro histories and vernacular memories American writers have had to question notions of cultural origin, agency and continuity, even as they take account of the role memory can play in constituting meaningful cultural and historical bearings. The writers' self-conscious efforts to 'recover' the past, a willed remembering set against diverse forces of historical amnesia, creates what Pierre Nora terms *lieux de mémoire*, 'sites of memory'. As Nora explains, *lieux de mémoire* exist:

where memory crystallizes and secretes itself at a particular historical moment, a turning point where consciousness of a break with the past is bound up with the sense that memory has been torn – but torn in such a way as to pose the problem of the embodiment of memory in certain sites where a sense of historical continuity exists.[7]

Lieux de mémoire are products of the dynamic interaction of history and memory, unstable signs of the past that are invested with cultural significance in the present. They may be places, or people, or objects, or events; they may be real or imagined.

American city spaces constitute key *lieux de mémoire* in the narratives of many writers. They are not exclusive to any particular

cultural group or mode of writing. As such, it would be possible, though too demanding here, to compare and contrast a very wide range of literary representations. I have chosen to focus here, in the first instance, on some general features of literary memory work, and more fully and analytically on selected urban novels by Irish-American and African-American authors which address 'the problem of the embodiment of memory' Nora refers to.

'One of the central themes in the culture of the 1970s', Marshall Berman has observed, 'was the rehabilitation of ethnic memory and history as a vital part of personal identity'.[8] In general terms Berman is right, but we need to go beyond his unquestioning description of this 'rehabilitation' to consider how and why it came about and what the implications were for white ethnic writing on the city. The 'rehabilitation' he refers to began in the 1960s as America's immigrant past was celebrated anew and the term 'ethnic' shed its alien emphasis. While not only conditioned by the activities and achievements of the black Civil Rights Movement, there is little doubt among historians that in some large part this ethnic revivalism was a response to the public recognition and legislative gains of African-Americans in the period. One result of this revivalism, as Colin Greer has pointed out, was that a 'public ethnicity' emerged which identified the ethnic with the 'image of the self-reliant and community-supported newcomers on their way up'; the 'historic immigrant was known as the heroic base from which contemporary Americans took their identity'.[9] One consequence of this was that symbols and narratives emerged which fixed the 'ethnic passage' from immigrant to American in the popular imagination as a linear, achieved story. *The* ethnic story was one of immigrant arrival and successful economic struggle, and this story was encoded in different cultural forms as a key trope of ethnic revivalism in the late 1960s and 1970s. A distinctive feature of this changing conceptualisation of 'ethnic' is that it both celebrates and negates cultural pluralism by accommodating ethnic difference within a national ideology of exceptionalism. (This is perhaps a somewhat posthumous accommodation given the 1960s splintering of the national imaginary, but a powerful one nonetheless and an influence upon the prevailing sense of loss in discourses of urban decline.) What is just as important, and we shall have cause to return to this, the ethnic/national story is encoded as a white narrative: 'coming to America' and 'up from poverty' are stories that implicitly exclude (having no time or space for) non-white minority claims to American identity.

It is important to note that this revalorisation of white ethnicity

occurred during a period when white ethnics were widely perceived to have all but completed their symbolic movement from the central cities to the suburbs. Now they were being reassured that this movement was part of a progressive narrative of American identity formation that allowed them to celebrate their central city 'roots' from the purview of the suburbs. This spatial relocating, literal and imaginary, of ethnic identity is a fascinating story in itself and one that has received little direct critical analysis. My concern here, though, is to ask: what did the social dislocation and dispersal of cultural communities and the public re-orientation of the significance of ethnicity mean for white ethnic writers? If the history of the ethnic group was popularised as a completed or contained history (within the ideological parameters of 'American' identity) and white ethnic identity is robbed of its traditional cultural resources and material contexts of experience and reference, then what is left to write about?

In the last thirty years white ethnic writing has become both more dependent upon and more self-conscious about narrative remembrance of the urban past. This dependency is a more complex issue than it may appear. It results in part due to processes of cultural dispersal and dislocation noted above – put much too simply, the movement from ghetto to suburb – processes which seem to fit neatly with the common assumption that white ethnics have been assimilated into the normative centre of American identity to now constitute the dominant (white) ethnoculture in the United States. But this assumption needs to be historicised if we are to recognise that assimilation is neither a seamless nor transparent process for many white ethnic writers, nor is it the tidy ideological end product of uneven patterns of dispersal and dislocation. What is the cultural work of memory when the associations between ethnicity and place are historically and geographically distanced? In some instances it may be a fairly straightforward narrative act of nostalgic reconstruction of 'lost' spaces of the urban past, uncritically inflected though nonetheless conditioned by the urban present – the examples are legion, especially in the mode of autobiography. Or it may be that white ethnic writers will invoke the urban past of their memories to support critique of contemporary urban conditions – a literary version of the cry 'there goes the neighbourhood'. This is not uncommon among white ethnic journalists who, as Carlo Rotella points out,

form an influential subset of those urban intellectuals who position themselves on the ground of 'the old neighborhood', that mythic space derived from the urban village. From that vantage, deep among the postindustrial

city's industrial roots, they claim authoritative insight into contemporary urbanism.[10]

Yet other writers have less readily assumed a secure position from which to remember or claim authoritative insight on the relationship between urbanisms past and present. Such writers recognise that white ethnic identities are not closed narratives in the history of the United States even if they have been more comprehensively and centrally incorporated into that history than those of other groups. The dissolution of traditional resources of ethnic identity has meant the emergence of new ones and of critical inquiry into the meanings of the deeply mythologised 'ethnic passage' from immigrant to American. White ethnic writers have played an important part in analysing both the emergent and the residual meanings of ethnicity which challenge the dominant narrative of assimilation (in which, for example, class differences and conflicts are all too easily erased or ignored by a motivated forgetting).

Such a range of uneven investments in urban memory is evident, for example, in Jewish-American representations of the city. Early twentieth-century representations of New York City tended to depict it from localised and vernacular perspectives; it is a conglomeration of 'urban villages', of ethnic cities within the metropolitan mass which have their own distinct communities, customs, religions and languages. There is an intense identification with the everyday culture of family and street life and the urban iconography becomes a mirror of self-development. By mid century, though, elder first and second generation Jewish-American writers were beginning to look back at the urban village of settlement with a sense of loss. Alfred Kazin, in his autobiographical *A Walker in the City* (1951), condenses the 'home' of Jewish Brooklyn into sensory metaphor as he remembers:

there would arise from behind the great flaming oil drums and the pushcarts loaded with their separate mounds of shoelaces, corsets, pots and pans, stockings, kosher kitchen soap, memorial candles in their wax-filled tumblers . . . that deep and good odor of lox, of salami, of herrings and half-sour pickles, that told me I was truly home.[11]

Since the 1950s, ambivalent responses to the city are commonly present in the work of writers who are more historically distant from the culture of the immigrants. Writers such as Saul Bellow (more focused on Chicago), E. L. Doctorow, Grace Paley and Sandra Schor have produced psychological studies of the hyphenated state of

being Jewish-American, both drawn to and repelled by the culture and traditions of the ancestors and yet struggling to define their meanings in contemporary contexts. It is striking how often in the work of these and other Jewish-American writers the presence of black characters elicits the writer's views (or dramatisation of the narrator's views) on urbanisation. Saul Bellow's increasingly jaundiced ruminations on city life turn the discourse of urban decline into a grand metaphor for the decline of Western civilisation and there is in his work a strong association of this decline with racial populating of central cities. Grace Paley, on the other hand, eschews lament and frequently writes to understand the racialised relations between old and new centre city inhabitants, focusing on everyday encounters in differentiated neighbourhoods.[12] With all these writers, whatever their variant perspectives on urbanisation, ethnicity is very much a discourse of foundations or origins, and memory and imagination are heavily relied upon to generate a continuous process of ethnic interpretation.

If the story of ethnic passage as a core myth of national identity is troubling for many white ethnic writers it is almost entirely alien to most African-American writers. The progressive urban narrative of immigrant arrival, ghetto communalisation and suburban assimilation has relatively little historical or imaginary relevance to the lives of African-Americans. The black urban experience in the twentieth century is one largely founded on migration and (the growth of a suburbanised black middle class notwithstanding) continues to be significantly defined as a central city experience. Since the Great Migration of the early twentieth century when many thousands of Southern blacks moved northwards to cities such as Detroit, Chicago, Philadelphia and New York, urban experiences have crucially transformed African-American cultural identity and made the city a key site of collective memory within the broader diasporic consciousness. African-American writers have recorded, interrogated and contributed to this transformation. There is no singular, unified representation of this transformation in black literature. A utopian/dystopian dialectic operates within and across black city texts, dramatising the urban maps of possibility and prohibition for African-American subjects. The city is a space of refuge, recommunalisation and individual agency; but it is also a space of terror, segregation and environmental determinism. James Baldwin, in *Go Tell It On the Mountain* (1953) famously combines archetypal images of heaven and hell as his black protagonist John Grimes surveys the skyline of New York while standing on a hill in Central Park:

there arose in him an exultation and a sense of power . . . he would live in
this shining city which his ancestors had seen with longing from far
away. . . . And still, on the summit of that hill he paused. He remembered the
people he had seen in that city, whose eyes held no love for him. . . . Then
he remembered his father and his mother, and all the arms stretched out to
hold him back, to save him from this city where, they said, his soul would
find perdition. . . . It was the roar of the damned that filled Broadway.[13]

Ironically symbolising New York as the 'shining city' of Puritan
vision, Baldwin underlines his protagonist's sense of exclusion from
this crucible of American democracy. For African-American writers
of recent years representations of the city continue to portray such
doubleness or ambivalence, though often within a more self-con-
sciously historical framework as writers such as Gloria Naylor, John
Edgar Wideman, Toni Morrison and Walter Mosley seek to rewrite
the urban black past within the context of continued economic and
social immiseration for urban blacks in the United States.

Before analysing some of these contemporary authors' representa-
tions of the urban past, though, we need to consider some of the
contexts and concerns which differentiate their writings from those
of white ethnic authors. Like white ethnic writers, African-American
writers have had to negotiate the relations of physical and imagina-
tive emplacement in the reconstruction of the urban past. But these
narrative practices are not identical (even though they may share
certain formal features). If we look again to the late 1960s and 1970s
we should note that black consciousness raising must be distin-
guished from ethnic revivalism. African-American literature of this
period was deeply influenced by very public and collective black
consciousness raising and this proved a formative context for many
who sought to produce historical narratives which contested public
memories of the American past. The most prominent narrative treat-
ments of black history in this period – among them, Margaret Walker's
Jubilee (1965), Malcolm X's *Autobiography* (1965), Ernest Gaines'
The Autobiography of Miss Jane Pitman (1971), Alex Haley's *Roots*
(1976), and Toni Morrison's *Song of Solomon* (1978) – produced
searching treatments of the American past and were intimately
attuned to the tensions between history and memory in the context
of the present period of writing.

Notably, with the possible exception of Malcolm X's text, urbanism
was not a central concern of these writings, either as spur to or sub-
ject of memory within the narrative. As with many African-American
texts before them – even the classic urban novels such as Richard
Wright's *Native Son* (1940) and Ralph Ellison's *Invisible Man*

(1952) – it is what is most often remembered as a largely rural South which is the focus of memory. This is not surprising if we consider that the image of a rural South has retained a potent role as a symbolic 'home' even in the most densely urbanised and long established of Northern settlements. Writing in the early 1960s Amiri Baraka noted that while the South represents 'the incredible fabric of guilt and servitude identified graphically within the Negro consciousness', it also signifies home:

It was the place that Negroes knew, and given the natural attachment of man to the land, even loved. The North was to be beaten, there was room for attack. No such room had been possible in the South, but it was still what could be called home.[14]

Baraka makes a striking use of spatial metaphors here to distinguish between 'the room' available physically and psychologically in the North and the South, and we shall return to similar uses of metaphor in analysis of more recent black writings. Whether the South still has the resonance in relation to Northern urban struggles Baraka attributes to it may by now be questioned, but there is no doubt that the South very often plays an important role as an imaginary homeplace in African-American literature with a primary Northern urban setting.[15]

We need to keep in mind the symbolic significance of the migratory passage from South to North when we turn to contemporary black narratives of the urban past, and remember that while the classic 'rites of assent' in American culture could be made over as the rites of ethnic passage they have never been made over as the rites of black migration. The significance of that story has largely fallen to black writers and musicians to tell, often within the colloquial forms from within which it was experienced and learned. While this story may be black-centred, though, it often either touches or parallels elements of the story of ethnic passage. The memory of a Southern homeplace in African-American writing, for example, has suggestive narrative parallels with the relation to the homeplace of immigrant urban settlement apparent in white ethnic writing, though it is very different in spatial and ideological terms. Beyond such parallels but also oddly enriching them are the diffused national imaginaries which also infiltrate into the workings of narrative memory (African or Caribbean for some writers, Irish or Jewish for others). The differences of passage may be paramount, but they are not necessarily exclusive of each other; as we shall see, roots are tangled and routes intersect.

The African-American passage from South to North is not the

exclusively privileged story of memory in the narratives we will look at, for writers have also delved into the black settlement histories following migration to ask what remains are to be found for understanding what John Edgar Wideman terms the 'miasma' of urbanisation in the present. Black writers in the 1980s and 1990s who explore the urban past tend to do so with an eye on pressing socio-economic and cultural forces of urban discrimination and segregation as they perceive them in the present time of writing. In doing this they either implicitly or explicitly intend their writings as narrative interventions in public memory of the black urban past. These writers tend to assume that community and collective memory are not simply givens of their cultural group, but must actively be reinvented and conserved. Through their writings they seek a usable past which will have resonance in the urban present; this is also to say they write with a sense of urgency and with a heightened consciousness of their own positionality in relation to contemporary urban issues – conditions of authorship rarely present in white ethnic writing.

Cities of Exile: *Ironweed* and *This Side of Brightness*

Irish-American writers have a distinctive imaginative investment in the American city. The first Irish immigrants who fled the famine in the mid nineteenth century and those who followed through the early years of the twentieth century largely settled in urban environments, in part because of their harrowing experiences of rural life in Ireland. Throughout the twentieth century, urban experiences have significantly defined Irish-American politics and culture and have been central to literary representations of the ethnic group. From Finley Peter Dunne's satirical sketches of Irish life in Chicago at the turn of the century, through James T. Farrell's extensive narratives on the ghetto Irish of Chicago in the 1930s and 1940s, to Mary Gordon's stories of Irish-American suburbanites in New York today, a history of the Irish-American urban experience has been documented and imagined.[16]

There is no single theme dominating this literature, though several have been adumbrated as prominent and recurring, among them: the everyday domestic life of families, often controlled by powerful patriarchs or matriarchs; the repressions and guilts of emotional life, frequently under the sway of Catholicism; and the acculturations of the ethnic group from immigrant outsiders to American insiders. In

urban fictions such themes have commonly meditated the meanings of geographical and historical displacements (from Ireland to America, from the city to the suburb). This literary history of the Irish-American experience is far from continuous, though, and registers many political and ideological shifts, including the new cultural pluralism outlined above. Charles Fanning has argued that 'the decade of the 1960s' was crucial to the reshaping of Irish-American literature:

Shaping events for Irish America in those turbulent times included the Second Vatican Council, the civil rights and sexual revolutions, the ascendancy and tragedies of the Kennedy clan, the breakup of Irish ethnic ghettoes and the old Catholic fortress identity, upward social and economic mobility, and the related move to the suburbs. This change and energy are reflected in the perspective of liberating doubleness that characterises much Irish American literature since the 1960s.[17]

Such changes can certainly be detected in much post-1960s Irish-American writing. The 'liberating doubleness' Fanning posits as a key characteristic of this writing refers, in his view, to a 'more balanced rendering of ethnicity' than had hitherto been the case, 'a movement from stifling emotional stasis into communication and understanding'.[18] However, while Fanning is not wrong to claim a new emotional and communicative maturity in Irish-American writing, this must be set against and understood in relation to both the new securities of assimilated status and the new insecurities of an ethnic identity struggling to hold onto meaningful markers of the group's boundary-formations.

Fanning finds an exemplary narrative of this 'liberating doubleness' in Elizabeth Cullinan's story 'Commuting' (1983). The story tells of the narrator's experiences and thoughts as she travels from a university in the Bronx, where she grew up, to Manhattan, where she now lives. She exits the campus 'into a daunting scene of urban decay – though I remember these surroundings as comfortable, middle-class New York'. Her bus route 'opens up another rich seam of the past' as the urban landscape triggers memories – of her sister's wedding reception at the Boulevard Grand Hotel, and of her father's stories 'of hardship and happiness' in turn of the century Harlem. As she nears her stop in Manhattan the story ends with an epiphanic insight:

Riding that last half-mile, my head swam with relief, my heart sang – they do every week, as this realization comes over me: I've reenacted, in spirit,

the journey that has given my life its substance and shape, color and brightness. I've escaped![19]

In Fanning's view this story 'is a paradigm of chosen migration and a metaphor for ethnic consciousness in our time'; it tells us 'that the doubleness of ethnic consciousness is enriching and clarifying... and that a refusal to decide between the poles of ethnic community and cosmopolitan individuality can mark the beginning of a rich, varied life'.[20] Indeed it can, but it can also mark the security of an assimilated life, wherein 'chosen migration' signifies the diminution of material ties to the history of ethnic passage which is symbolically summarised in the bus ride Cullinan's protagonist takes. The closing cry of 'I've escaped' is ambiguous at best; it might be interpreted as the triumphantly transcendent position of one who can view sedimented ethnic and racial relations in the built space of the city as a travelling spectator. This is not to denigrate Fanning's attraction to the metaphor of commuting – 'literally going back and forth between two parts of life' – as a figure of ethnicity, for it is a highly suggestive figure and one to which we shall return.[21] While there is undoubtedly a 'liberating doubleness' at work here, Fanning glosses the issue of who is being liberated from what and ignores how doubleness can function as a privileged position of white ethnic ambivalence or ambiguity. While recognising doubleness, we need also to be more attentive to the spatial relations of memory and difference in representations of the urban past.

Another form of doubleness commonly present in Irish-American literature is that composed of sentimental and critical forms of memory work. (Cullinan's story has the virtue of being a more pointed and self-conscious treatment of ethnic memory than many.) Not surprisingly, memory has become a crucial reflex and resource in post-1960s Irish-American identity formation. It has played an important role in sustaining a national imaginary, partly through sentimental attachments to the 'old country' (apparent in ethnic celebrations and song, and in tourism) and partly through a more politically charged attachment to the recent violent history of Northern Ireland. While such attachments no doubt have strong historical roots they all too readily romanticise relations between the United States and the national homeland of immigrant origin. Shaun O'Connell warns of the 'mist of sentiment' or 'green fog' that hangs over 'the Irish-American dream', defining the ethnocentrism present in Irish-Americans' 'determined self-affirmation and self-projection'.[22] Representations of this green fog abound in Irish-American literature and culture, but

they are not my focus here. Rather, I want to look at how memory takes on a more critical function in selected writings which have neither simply embraced nor eschewed the assimilated status of Irish-Americans but sought to interrogate its historical foundations and critically dramatise the meanings of ethnic (and at certain points racial) identity formation in urban contexts.

I begin with the author William Kennedy, whose work is intensely concerned with ethnic memory and city life. Of the Irish-American writers at work today it is Kennedy who has made the most extensive efforts to interrogate critically the meanings of Irish-Americanness as a historical and intrinsically urban legacy. He has written a cycle of historical novels that constitute a richly imaginative and shrewdly revisionist history of Irish-American urban experiences. He has situated all his narratives in Albany, New York, documenting and expanding genealogies from novel to novel, constructing an intimate fictional and historical tableau of ethnic life in the city. The novels closely tie historical memory to place and foreground the roles of reminiscence and anecdote, of what Kennedy terms 'memory and hearsay', in the retelling of the ethnic past.[23] With this focus on vernacular memories, in particular, Kennedy illuminates the everyday encodings of ethnic identity and distinctiveness and explores the cultural myths of the ethnic group. Believing that Albany's past is 'always-shifting' he seeks to show how Irish-Americans use (select and interpret) history and reinvent the past in the process of self-definition.[24] In doing this he questions his own group's deeply mythologised story of immigrant success and ethnic passage, and shows considerable empathy for those who do not fit neatly into this story.

Irish-American reinvention of an ethnic identity and an idealised past is a central feature of *Ironweed* (1983). The narrative opens, fittingly enough, in an Albany graveyard where Francis Phelan has taken a few days work digging graves. Francis has returned to the city after twenty-two years 'on the bum', a life of seemingly self-induced 'exile' sustained by the guilt he feels about the deaths of a scab he felled during a strike and of his thirteen-day-old son Gerald, whom he accidentally dropped and killed. In the graveyard and in his movements through the streets of the city he begins to confront the ghosts of his past and re-examine the memories he has carried with him for many years. His movements are contained within a tightly structured and highly symbolic time frame. It is Halloween 1938, and the narrative opens on All Souls Day and closes on All Saints Day, underlining the themes of sin and redemption and the idea of communication between the living and the dead that further particularise

the author's ethnic perspective. Francis' personal dilemma is not consumed by abstractions though, for Kennedy works to historicise it by showing how it is bound up with the Irish-American community's interpretation of its past. Francis re-enters Albany as a ghostly figure voided of a historical self by the mythological status he has been accorded by the community and which he has long internalised. For Irish-Americans he is a heroic figure for his action in killing the strikebreaker, an action written into a popular play which depicts him as a 'Divine Warrior' furthering the cause of immigrant struggle. The popular narrative conforms to the 'up from below' symbolism so important to white ethnic views of the past which build upon immigrant heroism. In this context Francis' return to Albany takes on a potent symbolism, for he returns as a bum, a historical reality at odds with his mythical identity. He is at once a living signifier of the harsh socio-economic realities of the Depression and a ghost of the ethnic past, the harsh realities of which have been sentimentalised or 'forgotten'.

Francis' ghost-like existence also symbolises the sense of social exclusion he experiences in being designated a 'bum'. Early in the narrative, while digging graves in the Albany cemetery, he comments to his co-digger, 'I never knew a bum yet had a gravestone'.[25] The recognition of social invisibility takes on a particular ethnic significance in the context of the author's comments on the cemetery and the memories it stirs in his protagonist. When Francis muses that 'being dead here [the cemetery] would situate a man in place and time. It would give a man neighbours' (p. 13), he responds to striking encodings of Irish-American history in this landscape of the dead. Scanning the cemetery he notices that the dead 'settled down in neighborhoods', from the rich and powerful Irish-Americans 'vaulted in great tombs built like heavenly safe deposit boxes', to 'the flowing masses, row upon row of them under simple headstones and simpler crosses' (p. 12). The cemetery not only encodes class differentiation (a form of social differentiation that is largely obscured by imperatives of ethnic struggle), but also offers an intriguing spatial figure of the passage from immigrant to ethnic. While the names on the oldest headstones at the foot of the cemetery hill have weathered away,

the progeny of those growing nameless at the foot of the hill were ensured a more durable memory. Their new, and heavier, marble stones higher up on the slope had been cut doubly deep so their names would remain visible for an eternity, at least. (p. 13)

Francis is implicitly identified with the 'nameless' at the bottom of the hill, the virtually erased immigrant identity that has been displaced and incorporated by that of the ethnic. Denied the security of location 'in place and time' this Divine Warrior/bum haunts the Irish-American present, straddling and blurring the realms of history and myth.

In *Ironweed* the Irish-American past is always under construction, its reinvention important to the patterning of social relations in the present. This reinvention is neither a stable nor an easily controlled process, suggesting that ethnicity is no simple matter of group assimilation or socialisation. Because ethnicity is a dynamic process of identity formation, its reinvention requires repeated revelations and repressions that are experienced both privately and publicly.[26] An important function of memory in *Ironweed* is to express an ethnic anxiety about the past that characterises the protagonist's struggle clearly to define and locate his identity. Possession by the past is shown to be harmful, promoting a self-lacerating sense of guilt in Francis: 'In the deepest part of himself that could draw an unutterable conclusion ... [Francis] told himself: My guilt is all that I have left. If I lose it, I have stood for nothing, done nothing, been nothing' (p. 216). His return to Albany initiates a flood of memories and before long he is 'conjuring memories against his will' (p. 96). His task is to reinterpret their meanings for him in the present, and Kennedy explicitly notes the therapeutic promise: if Francis 'can remember this stuff out in the open' he can 'finally start to forget about it' (p. 19). Throughout the narrative the process of remembering 'out in the open' is activated by the ghosts who challenge him to reassess the causes and consequences of his violent past. This self-analysis disrupts Francis' deep psychological investment in the narrative of heroic exile. He begins to consider that the strike was 'simply the insanity of the Irish, poor against poor, a race, a class divided against itself', and that the strikebreaker he killed was an itinerant like himself, seeking 'to survive hostility in ... strange cities' (p. 207).

Needing 'to believe in simple solutions', Francis finds that he is more and more confused by 'his own repetitive and fallible memory' (p. 223). However, if repetition signifies an ethnic anxiety, it also allows Francis to begin to come to terms with his violent past and with his vacated roles of husband and father. When he visits his family toward the end of the novel nothing is clearly resolved, though initial resentment and emotional conflicts slowly give way to a family dialogue about the past and present. The novel climaxes not in the family home but in yet another symbolic environment, an

encampment of bums and hoboes which constitutes an alternative 'city of essential transiency' (p. 208), and also a 'primal scene' (p. 209) in which Francis reenacts his personal traumas. The first reenactment is imaginative, as he tells others for the first time the story of how he accidentally killed his son. The second is physically violent as he kills one of a group of American Legion raiders who attack the encampment. The dramatic interactions of private and public actions and of ethnic and class politics are played out again. For Francis, this ritualistic return of the past leads to no ready release from his sense of guilt. The novel closes on an ambiguous note, a hallucinatory fantasy of Francis' return to his family. The meaning of this fantasy is not clear. Is Francis now about to 'reenter history' (p. 169), and locate himself 'in place and time'? The author refuses to tell us, and in the irresolution of this ending boldly reemphasises the tensions between history, memory and desire in the construction of an ethnic identity.

In *O, Albany!* (1983), his non-fiction 'urban biography' of the city, Kennedy proposes that Albany is 'a magical place where the past becomes visible'.[27] In *Ironweed* this magical element is the activity of memory as it responds to charged associations with the past in everyday urban scenes and events of the present. The Albany streets in particular appear surfeited with echoes of past lives:

Francis saw the street that lay before him: Pearl Street, the central vessel of this city, city once his, city lost. The commerce along with its walls jarred him; so much new, stores gone out of business he never even heard of. Some things remained: Whitney's, Myer's, the Old First Church, which rose over Clinton Square, the Pruyn Library. As he walked, the cobblestones turned to granite, houses became stores, life aged, died, renewed itself. (pp. 63–4)

There are echoes here and elsewhere in the novel of a modernist nostalgia, a melancholic romancing of the past, but Kennedy is not simply motivated by a sense of the loss of the ethnic past. In representing city spaces as *lieux de mémoire* and source of material and imaginary traces of the past in the present he asks readers to recognise the 'always-shifting' nature of ethnic history and identity as these depend upon interpretations of that past. Kennedy concentrates on both the internal mechanisms of ethnic identity formation and its historical conditions, aware that he is himself playing a part in the reinvention of the Irish-American past. The 'liberating doubleness' Fanning detects in contemporary Irish-American writing is certainly present in Kennedy's work, though in a complex fashion. His protagonist's efforts to move from 'emotional stasis into communication

and understanding' are never clearly achieved or drawn as a form of redemption or resolution. Of course, as I suggest above, the depiction of such ambiguity or ambivalence may be a relative luxury for the assimilated white ethnic writer. Yet, Kennedy offers more than epiphanic glimpses of the meanings of urban ethnicity as a form of 'commuting'. He digs deep into the buried emotional life of his cultural group to see what the dominant Irish-American narrative of progress, assimilation and power has obscured in Irish-American urban experience.

I do not mean Kennedy's narrative to stand as an exemplary treatment of the urban past in Irish-American writing.[28] With the novel we turn to now, Colum McCann's *This Side of Brightness* (1998), we find curious echoes of key themes and formal procedures of *Ironweed*, but also a narrative more centrally focused on issues of racial difference and identity, and more directly addressing issues of contemporary urbanism. Like Kennedy, McCann interweaves history, myth and memory to produce a complex narrative in which time is porous and disjointed, though it has a violently determining force. *This Side of Brightness* resists simple synopsis for the narrative craftily plays plot off against story, asking the reader to put together what at first seem unlinked characters and events split by time. The narrative begins in 1991 with the story of a homeless man, known for much of the novel as Treefrog, who resides in a subway catwalk beneath Riverside Park in Manhattan. This story alternates with that of Nathan Walker, beginning in 1916 when Nathan, a black man from Georgia, has migrated to New York to work as a 'sandhog' digging subway tunnels beneath Manhattan. As the first story moves us back in time through the memories of Treefrog, the second story moves us forward through the more realistic narrative descriptions of Nathan's working life, the tragedies that befall him and his family, and his physical and mental demise. The stories finally converge for the reader as we come to realise that Treefrog is Nathan's grandson, but before they converge in narrative time there falls between them a violent and haunting history of ethnic, racial and class differences bound to the building of the city. Treefrog's efforts to deal with legacies of this history take us beyond the point of convergence into a space of trauma from which he struggles to emerge.

In a novel rich in symbolic events, perhaps the most significant is a bizarre and horrifying accident which befalls Nathan and his co-workers in 1916. Nathan works at the front of the tunnel alongside men who have migrated or immigrated from diverse places and who find a muted camaraderie as sandhogs, freed from some of the

prescriptions and prejudices of the city world above their heads. The accident occurs when a 'tiny hole' appears in the tunnel wall: 'At first the weak spot is the size of a fist, then a head' as the compressed air in the tunnel escapes.[29] Nathan and his three co-workers are sucked into the hole, Nathan at first trapped in it like a cork 'with a million years of riverbed in his mouth and his shovel above his head in an act of ascension' (p. 14), and then with the others is pushed upwards through the riverbed and the water:

And then all three of them erupt through the surface of the East River, heads just missing the floes of ice, shooting out into the air with only their overalls and boots on, their chests contracting and expanding madly now, spewing water and muck from their mouths, gulping down oxygen, feeling their brains thump. . . . The three sandhogs somersault in the air above the river. The water suspends them for a moment between Brooklyn and Manhattan, a moment that the men will never lose in their memories – they have been blown upwards like gods. (pp. 16–17)

This near miraculous act of ascension has its immediate tragedy in the death of Con O'Leary, an Irish immigrant worker Nathan was close to, though the others survive and form an especially intimate bond following the accident. Though this accident is based on a real event it is of particular symbolic import to McCann. The survival of Nathan and the death of his friend are intertwined in genealogy as Nathan slowly falls in love with O'Leary's daughter Eleanor and marries her.

Despite discrimination Nathan and Eleanor have a long and loving marriage before tragedy strikes with the violent deaths of both Eleanor and their son Clarence. Following these deaths Nathan retreats into himself, talking to the dead in his memories. He tries and fails to protect Clarence's wife Louisa from drug abuse, but carefully nurtures his grandson Clarence Nathan who eventually becomes his minder and only point of focus and hope for the future. A man who exulted in the fierce strength and suppleness of his labouring body Nathan can now only contemplate its 'disappearing landscape' and consider 'pain . . . his companion' as it donates 'a necessary order to the hours, to the routine, to the watching of the street' (p. 179). His growing decrepitude is measured in part by the changing landscape of the city: 'The view from the window has changed in recent years – the sunlight is blocked out by large housing projects that step their way across the city' (p. 166). Nathan's decline, physical and mental, is also mapped against changing socio-economic infrastructures of the

city as New York shifts from a place of rapid physical growth, where manual skills were required, to a place where blue-collar work has been greatly displaced by service work. His story would seem to provide yet another narrative of urban decline, though this one is focused on particular intersections of race and class. It tells of the demise of the labouring class as an important faction in the socio-economic making of the city and as a culture filled with all kinds of prejudices but also open to new connections between workers from disparate ethnic and racial backgrounds.

In the context of this decline, the early (in historical time) part of Clarence Nathan's story seems to promise something better, perhaps a reascension of his father's labouring spirit. The boy is gifted with a sense of balance almost supernatural in its effects. 'Balance is the boy's inheritance' (p. 170), as is his grandfather's passion for building – he combines them not in tunnel digging though but in skyscraper building. Fulfilled in this work and happily married with a young child, it seems tragedy may have been lifted in the third generation of the family of Nathan Walker. It returns again though when Nathan is killed – all too symbolically crushed by a subway train in one of the tunnels he had laboured in and perversely, near death, demands Clarence Nathan lead him through. Nathan may well have been seeking death in the tunnel, but for his grandson, who watches him die even as he attempts to pull him to safety, this is a trauma that utterly transforms his life. As his grandfather had done before him, he draws into himself, but with a more dysfunctional effect on both himself and his family. Unable to communicate with his family and sacked from his job his balance becomes an obsessional practice of trying to correct fantasised disequilibrium in the small objects and landscapes around him. In a confusing period of guilt and shame he reaches to his daughter, claiming he sees his grandfather in her. His gestures to his daughter, the facts of which are never clearly described, are interpreted as abuse by his wife who leaves him and takes their daughter to Chicago. Already on the edge of sanity Clarence Nathan jumps off the common social world into the tunnel and into a darkness of guilt and troubled self-analysis for several years.

In Clarence Nathan's story we find striking echoes of Francis Phelan's in *Ironweed*. We recall that Francis became a homeless bum following the accidental killing of his child and moves in a half-world of history and memory, consumed by guilt; displaced from immediate family connections, he yearns for 'a place in time' to which he might return. This pattern of exile and guilt is mimicked in *This*

Side of Brightness, as is a focus on the history of labouring men. Exiled from family and the city Clarence Nathan, again like Francis, begins to yearn to locate himself again in the world above his head. Stirred out of his retreat into the subway tunnel by his attraction to a homeless woman, Angela, he violently defends her against her abusive boyfriend. The episode triggers the catharsis Clarence Nathan needs and for the first time he tells his story, ostensibly to Angela but mostly to himself and the reader. As in *Ironweed* the confessional telling of the story of trauma is anticlimactic for the listener in the novel, but it is cathartic for the teller who feels he has 'emptied himself of history' (p. 240) and now begins to see Treefrog as a ghostly figure with a separate existence in the tunnel. At the novel's end Clarence Nathan prepares to leave the tunnel, a symbolic 'resurrection' (p. 244) that uncannily echoes the image of the ascending 'Walker on a geyser of water' (p. 244) seventy-five years earlier.

McCann's most evident theme in *This Side of Brightness*, the outcasting of those who have manually built the city, is intertwined with the personal histories and memories of those outcast. Among the bums of Albany, Kennedy finds a 'city of essential transiency', while McCann finds among the homeless of New York City an underground city of the damaged and dispossessed. Neither author romanticises these subjects as alternative communities, though they portray particular social hierarchies and conducts at work. While both writers treat their respective cities as *lieux de mémoire*, Kennedy tends to prefer the metaphor of archeology while McCann prefers that of darkness. The metaphor of darkness runs throughout *This Side of Brightness* in too many ways to enumerate here, but its most significant tenor is the theme of racial separation and invisibility conditioned by the historical blindness and prejudice of city life. Clarence Nathan's early gift of balance depends upon 'forget[ting] your body even exists' (p. 163), it denotes a knowledge of one's self in relation to one's spatial surroundings. But it is a limited and precariously grounded knowledge, a racial knowledge which is not simply chosen or learned but a 'gift of blood' (p. 247) and a complex historical legacy. It is knowledge that preconditions a fall, in Clarence Nathan's case from supreme spatial control working on the skyscrapers to extreme spatial dislocation living in the tunnel. It is also a fall from light into darkness, into a space where 'to be blind means ... that nothing announces its approach except memory' (p. 247). (Memory, as Francis Phelan came to understand, can be a prisonhouse of the self; it is the space of the tunnel as a site of memory to which Walker is regressively drawn and dies within.) Interred

in memory, Clarence Nathan comes to think about the world he has left from 'this side of brightness'.

McCann's use of metaphors of darkness and invisibility should put us in mind of yet another suggestive intertext, Ralph Ellison's *Invisible Man* (1952). Like Ellison's protagonist, Clarence Nathan becomes an 'underground man' retreating from the social world above ground. To be sure, there are very different reasons for their retreats, but there are echoes in many details. In both texts, for example, the underground protagonists illicitly channel electricity from official sources to light their recesses, both symbolically burn papers they had gathered as markers of identity, and the texts end on irresolution tempered by intent as the protagonists prepare to re-enter history though we do not know what happens next. Perhaps the most suggestive link between these novels though is a more complexly intertextual one, invoking national literatures as well as ethnic and racial ones. In *Invisible Man* Ellison signifies on James Joyce's *A Portrait of the Artist as a Young Man*, appropriating and recontextualising Stephen Dedalus' commitment to 'silence, exile and cunning' as a critical response to his alienation from home and nation.[30] Ellison metaphorises his protagonist's alienation as a racialised invisibility and illuminates the signifying absence of race in constructions of modern urbanism and urban modernism. It may be that with *This Side of Brightness* McCann repays the (ironic) compliment of intertextual appropriation – an Irish author recasting modernist thematics of African-American identity within frameworks of postmodern urbanism and postcolonial identification.

This Side of Brightness lacks the depth of cultural detail which Kennedy and Ellison lend their characters and their distinctively coded environments; nor does McCann display the superior writerly powers of these writers, lacking their finesse in use of metaphor and symbol. Yet, his novel has its own powers. An ambitious tale of family, race and (possible) redemption, it does not fall foul of the more vacuous mode of 'ethnic telling' evident in the immigrant saga novels common in white ethnic writing. It stretches out from ethnic insiderism to imagine relations between white ethnic passage and black migrant passage. It may be pertinent to note that McCann writes from a different ethnic position than Kennedy. A much younger writer, he was born in Ireland and educated in the United States, and lives in both countries. He does not have Kennedy's rootedness in a singular locale, but he brings a fresh perspective to questions of ethnic and racial interaction in urban contexts, perhaps in an effort to understand something of the perplexing history of connections

and disconnections between Irish-Americans and African-Americans in the United States.

Perhaps because he is less constrained by attachment to place McCann's novel offers a form of 'liberating doubleness' that differs from much Irish-American literature. We recall the question posed of Cullinan's urban narrative of ethnic remembering, figured as 'commuting': from what position and to what end does the writer remember? The question needs posing given the conflicts over identity which have subtended the volatile cultural pluralism in the United States discussed at the beginning of this chapter. Historically, as many commentators have shown, the Irish in the United States 'became white' in large part to avoid the discriminations experienced by black (and Chinese) workers. This adherence to the racial category of 'whiteness', some now argue, compromises Irish-American references to a history of discrimination. David Lloyd argues that given the history of this adherence 'it is surely impossible now for Irish-Americans to invoke the memory of their experience of discrimination as some kind of ethical hedge against their access to what is still the privilege of whiteness'.[31] I agree with Lloyd, but his charge against the memory work of Irish-Americans is too harshly and sweepingly articulated. He implicitly recognises this himself when he goes on to urge Irish-Americans 'to open up the other histories that are less often invoked difficult as that may be', that is, historical narratives other than those 'of successful immigration and assimilation'.[32] This, I hope to have shown above, is what Kennedy and McCann do in their writings, exposing and examining silences around class and race in dominant imaginaries of ethnic passage. Some of the linkages encountered – across space and time, race and ethnicity, white writing and black writing – doubtless require a fuller critical inquiry than I am able to offer here. What I have wanted to draw attention to are some of the ways in which differently rooted and routed forms of urban passage find form in narrative memory, both within lines of the cultural group's boundary-formation and crossing over into the imaginaries of others.

FREEDOM CITIES: *JAZZ* AND *PHILADELPHIA FIRE*

Of all the city spaces which symbolise the 'modern' African-American experience it is Harlem that has been most powerfully and prodigiously mythologised. The movement of blacks into Harlem from 1915 onward represented not only a significant demographic shift

but also the emergence of a 'race capital' in the United States. As Harlem began to take this emergent form in the 1920s black writers were quick to interpret and advance the symbolic impetus. In *The New Negro* (1925) Alain Locke famously presented his vision of a new black identity:

Here in Manhattan is not merely the largest Negro community in the world, but the first concentration in history of so many diverse elements of Negro life. It has attracted the African, the West Indian, the Negro American; it has brought together the Negro of the city and the man from the town and village. . . . Proscription and prejudice have thrown these dissimilar elements into a common area of contact and interaction. Within this area, race sympathy and unity have determined a further fusing of sentiment and experience. . . . In Harlem, Negro life is seizing upon its first chances for group expression and self-determination. It is – or promises to be – a race capital.[33]

Locke's vision was widely taken up in the period and has been seen as a central statement of the Harlem Renaissance, though his views were disputed then and since by writers who perceived it to be an elitist discourse of Americanist renewal which ignored the realities of black working-class life in the city and of continuing racist discriminations. Locke's utopian vision is mediated through more ambivalent black representations of Harlem in the work of Langston Hughes and Nella Larsen in the 1920s, and of Ann Petry, Ralph Ellison, and James Baldwin in the mid-century.[34] In his essay 'Harlem is Nowhere' (1948) Ralph Ellison emphasised the extreme psychological and cultural impact of the transition from rural to urban, from pre-modern to modern, symbolised in the black peopling of Harlem. He argues that this transition epitomised the African-American's sense of instability as 'a "displaced person" of American democracy'. For Ellison, the 'nowhere' of Harlem is the symbolic 'scene of the folk-Negro's death agony' and of 'his transcendence'.[35] Writing forty-five years after Ellison, Toni Morrison picks up these themes of psychological instability and cultural transition in her novel *Jazz* (1993), a historical romance of Harlem lives in the 1920s.

 In *Jazz* Morrison presents a Harlem that is more expressively imagined than it is historically documented. It is a Harlem of the mind, a symbolic locus of black memory and a primal scene of African-American modernity. Morrison writes with an intimate knowledge of the mythological and fictional signifiers that convey 'Harlem' in the black imagination. Her aim is not to uncover the 'real', historical Harlem, but to tease out the meanings of the cultural transition

Ellison refers to above. In doing this, she reworks her own abiding interest in the dialectics of remembering and forgetting in African-American culture. Though Morrison is certainly not the first black writer to view memory as a key site of racial consciousness, few have more deliberately and consistently sought to 'fret the pieces and fragments of memory' in black life. For Morrison the reconstruction of the past is a form of narrative 'archeology': narrative remembrance, she observes, is 'a journey to a site to see what remains have been left behind and to reconstruct the world that these remains imply'. In this process she blends memory and imagination to enter into the 'interior lives' of black Americans: 'I'm looking to find and expose the truth about the interior life of people who didn't write it'.[36] The truth of her characters' interior lives is not only the social facts of their daily experiences but also their unconscious or semi-conscious desires, anxieties and yearnings. It is in this psychological territory that Morrison digs deep into individual and collective memories.

The relationship of the city to African-American memory is not a new concern for Morrison. In earlier novels and in several essays she has expressed an ambivalent attitude to the patterns of displacement and adjustment in urban spaces. Her second novel *Sula* (1973) begins: 'In that place, where they tore the nightshade and blackberry patches from their roots to make room for the Medallian City Golf Course, there was once a neighborhood. . . . It is called the suburbs now, but when black people lived there it was called the Bottom'.[37] The novel tells of the formation and the collapse of the black neighbourhood under the pressures of white suburbanisation and commodity capitalism, and indirectly chastises the 'young ones [who] kept talking about the community, but they left the hills to the poor, the old, the stubborn – and the rich white folks'.[38] In the novel the loss of 'a place' has a damaging impact on black culture and the sense of imminent or real loss of African-American experiences of localised community is one that underlies much of Morrison's writing. In her essay 'City Limits, Village Values: Concepts of Neighborhood in Black Fiction' (1981), she argues that 'the affection' black writers display for the city is usually limited to 'the village within it: the neighborhoods and the population of those neighborhoods'. In Morrison's view the key figure of this village community is that of 'the ancestor' who 'values racial connection, racial memory over individual commitment'. It is this memorial parent who provides the possibility of recommunalisation in the city based on 'village values'.[39] In *Jazz* this theme of urban amnesia is picked up again as Morrison makes more explicit her concern that the American city 'seduces' black people

into forgetting the experiences of pre-urban black life in the United States. Even as she makes this explicit, though, she also subtly revises her earlier views to provide a complex meditation on the meanings of 'freedom' for African-Americans in the urban village of Harlem in the 1920s.

The unidentified first-person narrator of *Jazz* is self-confidently speculative about the lives narrated in the novel: 'Risky, I'd say, trying to figure out anybody's state of mind. But worth the trouble if you're like me – curious, inventive and well-informed'.[40] The narrator is all of these things but also only a partial witness to the life stories narrated and is notably seduced by the dynamism and aesthetics of city life. At the beginning of the novel the narrator speaks as a somewhat ironic proselytiser of the new:

I'm crazy about this City. A city like this one makes me dream tall and feel in on things. Hep . . . I'm strong. Alone, yes, but top-notch and indestructible – like the City in 1926 when all the wars are over and there will never be another one. The people down there in the shadow are happy about that. At last, at last, everything's ahead. The smart ones say so and people listening to them and reading what they write down agree: Here comes the new. Look out. There goes the sad stuff. The bad stuff. The things-nobody-could-help stuff. The way everybody was then and there. Forget that. History is over, you all, and everything's ahead at last. (p. 7)

This vision of the city is characterised by its aesthetic distance, echoing the (predominantly white) modernist perspectives on New York as a future-oriented city. It also echoes the bullish vision of Alain Locke (perhaps one of the 'smart ones' referred to above), an ideological championing of the black metropolis which will uplift the race. For the narrator, the city is a space of possibility and pleasure in which black people see and experience each other in new ways, such as 'how men accommodate themselves to tall buildings and wee porches, what a woman looks like moving in a crowd, or how shocking her profile is against the backdrop of the East River' (p. 34). The city 'pump[s] desire' into human relations, displacing love and inducing forgetfulness; it deceives people into feeling 'more like themselves, more like the people they always believed they were' (pp. 34–5). Black people are involved in exercises of individual and collective narcissism. Enduring economic deprivations on arrival in Harlem they nonetheless 'stayed to look at their number, hear themselves in an audience, feel themselves moving down the street among hundreds of others who moved the way they did' (pp. 32–3).

The narrator's exuberant representation of the city as 'back and

frame' (p. 9) for the characters' lives is a richly expressive feature of the novel. But it also signals what the narrator finally admits is an error of vision and interpretation:

It was loving the City that distracted me and gave me ideas. Made me think I could speak its loud voice and make that sound sound human. I missed the people altogether...I believed I saw everything important [the main characters] did, and based on what I saw I could imagine what I didn't: how exotic they were, how driven. Like dangerous children. (pp. 220–1)

The narrator errs in predicting the desires and actions of the main characters having imagined them as 'exotic', 'driven' beings who are ignorant of the workings of history and prisoners of their passions and traumas. The narrator's self-censure and late admissions of unreliability are not intended to dissolve the lives narrated into arbitrary fictions or to diminish the reader's interest in them. On the contrary, the reflexivity of the novel draws attention to those elements of the characters' 'interior lives' that exceed the point of view of the narrator. What is absent, what is not seen or said, has a powerful narrative presence, motivating memory and desire in these interior lives. What the narrator 'misses' (and the reader is invited to reflect upon) is the significance of the workings of memory and desire – of loss, displacement, abandonment, and mourning – on the lives of the characters.

Essential elements of the plot of *Jazz* are narrated in the first few lines of the book:

Sth, I know that woman. She used to live with a flock of birds on Lenox Avenue. Know her husband, too. He fell for an eighteen-year-old girl with one of those deepdown, spooky loves that made him so sad and happy he shot her just to keep the feeling going. When the woman, her name is Violet, went to the funeral to see the girl and to cut her dead face they threw her to the floor and out of the church. (p. 3)

The economy of this opening is deliberate and striking. In a few lines we are introduced to the garrulous narrator, to the three main characters – Joe Trace (the murderer), Violet (his wife), and Dorcas (the murdered girl) – and to key themes of obsessive love, betrayal and death. This plot and the attendant themes are the stuff of popular romance, though it is clear that Morrison views them as a representative subject of urban blues or jazz music. The plot, she has observed, is intended as 'the melody' of the text that the narrative departs from and circles around.[41] The bare plot of *Jazz* is itself a

narrative improvisation based upon a photograph in James Van der Zee's *Harlem Book of the Dead* of an eighteen-year-old girl lying in her coffin.[42] Morrison constructs her digressive narrative around this image, positing the death of Dorcas as an allegory of desire in the estranged lives of Joe and Violet.

Clues as to how to interpret this allegory are scattered throughout the text, and as we follow the 'crooked line of mourning' (p. 17), which follows on Dorcas' death, we are led back in time to the Southern past. Joe, Violet and Dorcas are all orphaned migrants, haunted by the loss of parents and in particular the loss of mothers. Joe was rejected by his mother at birth and takes his enigmatic surname at an early age when he is told his parents had 'disappeared without a trace' (p. 45). Violet's mother committed suicide, jumping down a well in rural Virginia. Dorcas' mother is burned alive in her house in East St Louis during the riots of 1917, only five days after her father's murder. The novel moves unevenly back in time to give us the stories of Joe and Violet's childhoods and of their meeting in Palestine, Virginia, and even further back, the story of Joe's mother, Wild, and of Golden Gray, a white man (with a black father) whom Violet's grandmother raised. The stories are 'pieces and fragments of memory' which resist coherent narrative development, yet collectively constitute a distinctive genealogical legacy of loss and dispossession that shapes the memories and desires of the characters in the present.

As the disjointed narrative slowly begins to fill in details of Joe's and Violet's past lives we learn that they have emotionally grown away from each other, retreating into numbing consideration of their own lives. The death of Dorcas heightens their estrangement but also propels them into newly self-conscious investigations of prefiguring traumas. Violet becomes obsessed with Dorcas, and obtains a photograph of the dead girl that she places on the mantelpiece of their apartment. As 'a dead girl's face [becomes] a necessary thing for their nights' Joe and Violet in turn rise from bed to gaze at 'what seems like the only living presence in the house' (pp. 11–12). Joe sees a 'calm, generous' face absent of accusation or judgement. Violet sees a 'greedy, haughty' face that only 'sees its own self' (p. 12). The photograph becomes a focus for their diverse desires, reconfiguring other losses and absences in their memories. For Joe, Dorcas doubles for the mother he has lost and is haunted by. He discovered at the age of eighteen that his mother is a wild woman who lives in the woods and he searches for her on several occasions, at once ashamed and fascinated by the 'traces of her sloven unhousebroken self all over the county' (p. 178). For Violet, Dorcas' deathly presence in her life has

distinctive if confused meanings. Even before the girl's death 'cracks' had begun to develop in Violet's consciousness, 'dark fissures in the globe light of the day' (p. 22), and as she 'stumbles onto these cracks' (p. 23) she becomes dissociated from the everyday course of her urban life. A major cause of this stumbling is her memory of her mother's death and her (too late) desire for a child. She is immured in 'mother-hunger' (p. 112) and as she gives herself to the memory of Dorcas it is clear that the dead girl becomes a substitute for the child she and Joe never had. Violet finds that 'not only is she losing Joe to a dead girl, but also she wonders if she isn't falling in love with her too' (p. 111). She further wonders: 'Who lay there asleep in that coffin? Who posed there awake in the photograph? . . . Was she the woman who took the man, or the daughter who fled the womb?' (p. 109).

As memories and desires are constructed around Dorcas we find that the identities of the main characters are complexly split between the past and present, between the rural South and the urban North. A damaging psychological pattern of dispossessions fashions the 'crooked line of mourning' that binds Joe and Violet despite their estrangement. Violet comes to wonder if the originating moment of love between Joe and her was a form of displacement in which each stood in for the other's figure of desire: 'Which means from the very beginning I was a substitute and so was he' (p. 97). The allegory of desire that is Dorcas' death repeats this patterning of substitutions and the narrator is confident that Joe and Violet will compulsively repeat their traumas. When Felice, a young friend of Dorcas', enters the lives of Joe and Violet to produce a 'scandalizing threesome' (p. 6), the narrator views their relationship as a 'mirror image' of that involving Dorcas and predicts that 'one would kill the other' (p. 220). But the narrator is wrong and the patterns of the past are broken as Joe and Violet settle into a relationship of loving fulfilment at the end of the novel. The narrator ruefully expresses surprise:

I was sure one would kill the other. I waited for it so I could describe it. I was so sure it would happen. That the past was an abused record with no choice but to repeat itself at the crack and no power on earth could lift the arm that held the needle. (p. 220)

How is it that the characters have stalled or defeated the metonymic drive of unfulfilled desires? The narrator does not tell us, indeed claims ignorance and suggests that there is something 'missing' or 'rogue' in the telling of the life stories (p. 228).

While Morrison refuses simply to explain Joe and Violet's loving resolution, she does work to suggest that it occurs as a result of their preparedness to confront the past so that they can find release from it. This confrontation and release, as much as the determining forces of history and desire, illuminates what I take to be Morrison's key concern in *Jazz*, to investigate the meanings of urban 'freedom' for African-Americans. The narrator represents the city as a space of desire and forgetfulness, while Morrison works to suggest that it is not only this but also a space of love and memory. The latter possibilities have to be struggled for against the seductive powers of the former and it is this struggle which defines the agency of her characters and their connection not only to the rural South but also to the past of slavery. In interview Morrison states that she was 'fascinated by the thought of what the city must have meant to ... second and third generation ex-slaves, to rural people living there in their own number. ... How did people love one another? What did they think was free?'.[43] The significance of these questions about love and freedom is put into historical context by Morrison's observation in *Beloved* that 'not to need permission for desire – well now, *that* was freedom'.[44] In *Jazz* the city is the space of such freedom only imagined by the slaves and ex-slaves in the earlier novel who are forced to 'love small' or not at all. Dorcas (the symbolic descendant of Beloved) embodies an overwhelming desire that was not available to the ex-slaves and their children. For Morrison, there are profound questions of human agency bound up in her black characters' 'ownership' of their own bodies and emotions. The narrator of *Jazz* seems aware of this, believing it made urban blacks 'dangerous children' unable to understand or responsibly act upon their new urban freedoms. Joe and Violet confound this view, however, registering responsibility for their actions, signifying their ability to change on their own terms, and transmuting desire into love.

In *Playing in the Dark: Whiteness and the Literary Imagination* (1992) Morrison critically examines the American romance genre of the nineteenth century to argue that it most compellingly tells of 'the terror of human freedom – the thing [Americans] coveted most of all'.[45] In *Jazz*, her own historical romance, the 'terror of human freedom' is less a metaphysical force than a historical legacy of slavery. The discourse of 'freedom' in the novel is present in many registers, cutting across private and public realms of black lives and conjoining past and present. In the private lives of the characters it is most commonly reiterated in their references to 'choice' in deciding how to lead their lives and whom to love. Such choices can be delusory,

representing the franchised 'freedom' on offer in an urban consumer culture. Morrison portrays such delusions in *Jazz* but also looks to deeper emotional meanings of human agency in the need of her characters to live an 'unslaved life'. The common dilemma for her characters is one that she has acutely posed for herself as an African-American writer: the need 'to find some way to hold on to the useful past without blocking off the possibilities of the future'.[46] She knows this is a delicate critical act of balancing the demands of remembering against those of forgetting. She also posits it as a cultural necessity for her African-American contemporaries.

The idea of identifying and holding onto a usable past, particularly as the need to do this is defined by contemporary urban contexts, is a central theme of John Edgar Wideman's writings. Also in common with Morrison, he has an interest in the legacies of freedom which connect the urban present to a pre-urbanised African-American history. Both writers are aware that the American city acts as a totalising gauge of social and political progress and have sought to provide their own forms of assessment of the effects of urbanism on African-American experience and identity. Wideman's treatment of black urban life differs from Morrison's, though, in his more direct focus on contemporary urbanism and in the intense self-analysis in his narratives which asks searching questions about the role of the African-American writer as witness to and reporter of black urban experience. In *Philadelphia Fire* (1990), a 'novel' that incorporates elements of the autobiographical essay and journalism in style and content, he lends brilliant and troubled expression to these questions. At the core of this complex narrative is a horrific event, the 1985 bombing by police of a row house containing an Afrocentric cult known as MOVE, resulting in the deaths of eleven people and the destruction of over fifty houses. Around this event Wideman circles his thinking on the 'miasma' of urbanisation in the contemporary United States and its historical roots. Much of the narrative is compelled by grief and rage, including Wideman's outrage that this event seems to be quickly receding from public memory:

The concerted, ruthless campaign of a city government – ironically, a city government under the control of a black mayor – to destroy difference is one of the most important public events that I've observed. It was particularly important because it was buried. A whole city is afflicted by amnesia. In the press it got a little play for a while, but then it was forgotten.[47]

In the act of writing, he seeks to counter such amnesia: 'I'm trying to

make myself stop, look, listen, and think about what's happening to us'.[48]

This effort to revoke or challenge cultural amnesia is not new in Wideman's work, but *Philadelphia Fire* moves it into a more political framework of representation than his earlier urban fictions (and in doing so very deliberately echoes the protest tradition and apocalyptic imagery of James Baldwin's *The Fire Next Time*). In the early 1980s Wideman published a trilogy of novels – *Damballah* (1981), *Hiding Place* (1981) and *Sent for You Yesterday* (1983) – set in Homewood, a predominantly black Pittsburgh neighbourhood where he was born. In these novels, as well as several related short stories and non-fictional writings, he created a representation of place that has been described as 'an archetypal psychic map of African-American experience'.[49] Not unlike William Kennedy, he constructed a detailed family and community history spanning over one hundred and fifty years of neighbourhood life. Memory is central to the construction and maintenance of family and community in the writings. In the preface to *Sent for You Yesterday*, he writes:

Past lives live in us, through us. Each of us harbors the spirits of people who walked the earth before we did, and those spirits depend on us for continuing existence, just as we depend on their presence to live our lives to the fullest.[50]

Echoing the contemporaneous writings of Toni Morrison (and many other black authors) he draws on an Africanist sense of an archeomythology, linking memory and place to a diasporic history which he argues through his narratives must be remembered or recovered to sustain the blighted neighbourhood of Homewood with a sense of community. This call to memory is also a key to explaining his often complex narrative style, plied as it is through digressive and concentric narratives which remain rooted to place. It is an ethos as much as a style, in his own description his writing is 'an endless process of backward and forward and overlap and self-echoing and recapitulation that is a career, that is an evolution of a way of seeing, especially of a vision'.[51]

While formal features of this style remain in place in *Philadelphia Fire*, the ethos it commonly gives expression to in his work becomes fractured and uncertain. In moving from a Homewood he is intimate with to a Philadelphia he knows but can barely understand Wideman loses the securities of place which so richly dimension the lives of his Homewood characters. *Philadelphia Fire* is marked by isolated, displaced characters adrift in an urban milieu all but voided of family

and community connections. The narrative is split between voices and perspectives that reflect as well as reflect upon the discordant urban environment. As Jan Clausen observes, the narrative affects 'a layering of voices that represents not an organic community, rooted in the past, but a community of strangers, transfixed by a common despair and outrage'.[52] The most central voice is that of Cudjoe, a Philadelphia writer who exiled himself from the United States for ten years, escaping his past and commitments to wife and children. There is also the counterpointing first-person voice of the author (for whom Cudjoe is clearly a persona), plus the voices of Timbo, an old friend of Cudjoe's, J. B., a homeless man, and of street children among others.

The narrative begins with Cudjoe's return to Philadelphia, leaving his aimless life on a Greek Island to confront the changes in the city he left and examine his own relationship to it. He also returns in order to take up an obsessional search for a boy who was seen running from the carnage of the bombing and who is said to be 'the only survivor of the holocaust on Osage Avenue'.[53] Cudjoe never finds the boy and his search provides no clear insight into the meanings of the fire. This irresolution is reflected in his uncertainty about his role as a writer. He is reluctant to add fiction to the bare facts he knows about the fire: 'Cudjoe reminds himself he was not there and has no right to add details. No sound affects' (p. 9). At one point he 'decides he will think of himself as a reporter covering a story in a foreign country. Stay on his toes, take nothing for granted' (p. 45). At another point he considers: 'maybe this is a detective story.... Out there the fabled city of hard knocks and exciting possibilities. You could get wasted out there and lots did. His job sleaze control' (p. 46). The shifting perceptions of his role as a writer find a textual corollary in his use of metaphors to describe the city. Here are two striking examples:

If the city is a man, a giant sprawled for miles on his back, rough contours of his body smothering the rolling landscape ... a derelict in a terminal stupor, too exhausted, too wasted to move, rotting in the sun, then Cudjoe is deep within the giant's stomach, in a subway-surface car shuddering through stinking loops of gut, tunnels carved out of decaying flesh, a prisoner of rumbling innards that scream when trolleys pass over rails embedded in flesh.... Same filthy-windowed PTC trolley car carries you above and below ground, in and out of flesh, like a needle suturing a wound. (pp. 20–1)

Wasn't a city millions of eyes that are windows opening on scenes invisible till the eyes construct them, till the eyes remember and set in meticulous

detail the city that was there before they closed for sleep? Wasn't the city one vast window covered by a million mini-blinds and every morning every blind snaps open, quickly, like you peel a dressing from a wound. . . . Weren't countless pairs of eyes, eyes like his, needed to create the cityscape? Were they the mind animating the city's body? (pp. 53–4)

These are remarkably suggestive metaphors which resonate through-out the text (the conceit of the city as a derelict man being set alight, for example, later becomes a reality for the homeless man J. B.). In the knowing, reflexive presentation of his metaphors as figurative language Wideman is also drawing our attention to the work of metaphor itself in describing urban experience. He is experimenting with the explanatory power of language, testing out the resources of literature to explain the 'miasma' of urbanisation and provoking the reader to 'stop . . . and think about what's happening to us'.

As noted in the introduction to this study, Wideman parodies the (post)modern desire for urban legibility, the desire to know the city as a whole, to render it visible and readable. He is suspicious of the will to transparency that will reveal the 'truth' of the city. At one point Cudjoe imagines it might be possible, through representation, to 'arrange the building blocks' of the city 'into some semblance of order, of reality' (p. 157), but finds it impossible to do this without 'distortion' (p. 157) of his subject. This desire for order and legibility has a particular historical import in the city of Philadelphia, as we see when Cudjoe surveys the vista of the city from a hilltop:

He is sighting down a line of lighted fountains that guide his eye to City Hall. This is how the city was meant to be viewed. Broad avenues bright spokes of a wheel radiating from a glowing center. No buildings higher than Billy Penn's hat atop City Hall. Scale and pattern fixed forever. Clarity, balance, a perfect understanding between the parts . . . I belong to you, the city says. This is what I was meant to be. You can grasp the pattern. Make sense of me. Connect the dots. I was constructed for you. . . . The city could fool you easy. And he wonders if that's why he is back. To be caught up in the old trick bag again. (p. 44)

Cudjoe senses the rigorous planning and design that once charac-terised Philadelphia as the new nation's ideal enlightenment city. He also senses that the alluring cityscape of republican democracy is a figure of power that does not 'belong' to him, whatever its open appeal. This is one of many intimations in the text that this city already has an order – 'Everybody had zones' (p. 45) – in which rights of citizenship are demarcated along lines of race and class.

Wideman is also drawing attention to the historical symbolism of Philadelphia within national imaginaries of freedom and democracy. This is symbolic territory he had already addressed in a short story titled 'Fever', published a year before *Philadelphia Fire*. The story, set in the summer of 1793 in Philadelphia, tells of the yellow fever which gripped the city and the deterioration of urban life: 'Busy streets deserted, commerce halted, members of families shunning one another, the sick abandoned to suffer and die alone. Fear ruled'.[54] In this climate of fear African-Americans are doubly discriminated against, first treated as cause of the fever, then enrolled 'to nurse the sick and bury the dead' (p. 141) as though immune to the fever's effects. The story has an allegorical function, for Wideman posits the fever as a cultural metaphor for the human horrors of slavery and segregation. Fear, he writes, 'grows in the secret places of our hearts, planted there when one of us decided to sell one of us to another' (p. 133). The allegorical treatment of fever has apocalyptic overtones that associate it with Philadelphia in the 1980s – 'Fires burn on street corners. Gunshots explode within wooden houses' (p. 150) – and at the end of the story the author explicitly connects with contemporary Philadelphia and the aftermath of the bombing: 'The Mayor proclaims a new day. Says let's put the past behind us. . . . Of the eleven who died in the fire he said extreme measures were necessary as we cleansed ourselves of disruptive influences' (p. 161). Through this story Wideman situates the bombing in relation to a history of fear and violent discrimination within the city and challenges the imperative to 'put the past behind us'. Fever and fire are productive metaphors used to link past and present conditions of urban life in Philadelphia. While there are no explicit references to the fever of the short story in *Philadelphia Fire*, it resonates in what Wideman terms the 'miasma, this fever of shakes and jitters, of self-defeating selfishness called urbanization' (p. 157). It is also signified by the disconnected voices that represent 'a community of strangers' who lack an ethos of place to locate human continuity and community.

As well as fever and fire, another metaphor in *Philadelphia Fire* draws attention to the relationship between urban past and present, that of urban removal. As Cudjoe visits places of his youth he finds that the city has been radically redeveloped in his absence. Meeting his old friend Timbo, cultural attaché to the mayor, he comments: 'I have places, almost like stage sets, in my mind. I've been trying to find them since I've been back but they're gone. Buildings, streets, trees. Stores I used to shop, bars where we partied' (p. 85). Timbo tells him the places have been 'urban-removed' (p. 85). Urban removal

is a powerful metaphor in Wideman's usage for the public amnesia surrounding the bombing in particular (he describes the levelling of the row-houses after the fire) and broader forms of erasure, imaginative and material, which are changing the fabric of the city and social relations within it. Timbo is eager to support the current redevelopment that is producing a 'University City' area: 'When redevelopment's finished, a nice, uncluttered view of the art museum. That's the idea. Open the view . . . what we're trying to create here is our little version of Athens, you dig? . . . Modern urban living in the midst of certified culture' (p. 78). The redevelopment valorises the historical city image and casts out those who have no place within the image. In Timbo's words: 'Can't argue with progress. At the same time over in the north and in the west where people from here forced to move, what's growing is garbage dumps' (p. 79).

Timbo's support of redevelopment occurs within his broader disquisition on the African-American experience of post-Civil Rights urban politics. He looks back with some cynicism at the idealism he and Cudjoe shared in their youth in the 1960s: 'This city gon be Camelot, right? Our black Camelot. We're in the driver's seat, watch us go, world. . . . Seemed like we might have half a chance to do our thing here, do it our way' (p. 77). Now he believes their mistake was 'believing things spozed to change for the better' and supports a black mayor who is 'realistic about power and politics and deals and compromise and doing his jig inside the system' (p. 80). In detailing Timbo's explanation of his and the mayor's realism Wideman recognises the compromises many black politicians have felt compelled to make in roles of urban leadership in the 1970s and 1980s. He also broadens the canvas of his subject to position the fire in relation to large and complex changes in the infrastructures of urban order in American cities. But Timbo's explanation is not sympathetically portrayed, nor is his rationalisation of the bombing: 'How the mayor spozed to stand up and talk to white folks when he can't control his own people?' (p. 81). Against Timbo's talk of 'progress' Wideman draws his reader's attention to the 'waste' that is produced in the form of people such as the homeless man J. B. who scavenges in dumpsters for food.

While Timbo's 'realism' appears unattractive to Cudjoe (and Wideman) it nonetheless shows up the uncertainty and inaction of Cudjoe. As Timbo bluntly puts it to Cudjoe: 'Where you been hiding all this time? Could have used a few more good shoulders at the wheel. You copped the education and ran, man' (p. 81). This statement draws attention to the issue of the social role of the black intellectual –

a perplexing issue for Cudjoe and for Wideman his author. Cudjoe recalls his plan in the late 1960s to produce and direct a performance of *The Tempest* with a cast of black school children. He imagines the performance as a form of 'guerilla theater' (p. 143) and his 'gift to the community' (p. 132). The play is never produced and the intellectual activism Cudjoe's plan symbolises is portrayed as an inadequate response to urban realities. In parodying this plan Wideman implicitly rejects the idea of the black intellectual as an agent of redemption for the black masses. At the same time, Cudjoe's frustrated sense of impotent disconnection from the masses is placed under analysis by the author as an issue he must himself engage with as a black intellectual. This may explain in part his awkward relation to his narrator: 'Why this Cudjoe, then? This airy other floating into the shape of my story. Why am I him when I tell certain parts? Why am I hiding from myself? Is he mirror or black hole?' (p. 122). Wideman has discussed in interviews and elsewhere his troubled sense of his early voluntary exile (through education) from aspects of black culture, and his efforts to put together the 'two pieces' of his life, 'the life of the black kid growing up in a predominantly black neighbourhood in Pittsburgh, the life of a middle-class academic in a white world'.[55] Highly self-conscious about this division and its attendant conflicts in his life he does not take for granted his own space of autonomy as a writer. Acknowledging the distance between the writer and the 'street people' (p. 192) in *Philadelphia Fire*, and the dangers of writing 'clever, irresponsible, fanciful accounts of what never happened' (p. 172), he writes a provocative meditation on the spatial divisions – between self and other, author and subject – which haunt many forms of writing dealing with black urban experience. He does not presume to bridge the gap between the academy and the ghetto through the example of his own writing.

The irresolution of his narrative as well as its discordant play of voices and modes of writing signify Wideman's difficulties in expressing a social purpose for his prose. This is not to say that he eschews a social role for literature, but he stresses his writing is 'an expressive activity ... not simply instrumental. ... Writing for me is a way of opening up, a way of sharing, a way of making sense of the world'.[56] In particular, he values the memory work of narrative: 'stories are a way of keeping people alive' and 'break[ing] down our ordinary ways of conceptualizing reality ... so that we suddenly realize that past and future are not different. That living and dead are kind of arbitrary categories'.[57] This memory work remains a key function of writing in *Philadelphia Fire* despite its author's near despair

about the possibilities of communicating with or adequately representing the lives of those he writes about. It is evident in his efforts to provide forms of momentary definition and insight – a provisional legibility – that will illuminate historical and psychological components of what he terms the 'miasma' of urbanisation. The irresolution of the narrative mirrors the condition of urbanisation he examines. Like the fever in his short story, 'miasma' refers to 'the unresolved question of slavery, the unresolved question of racism, the unresolved question of majority rule that leads to majority domination and oppression'.[58] Separation and segregation characterise the urban condition he describes and these are not to be dramatically denied or resolved through the act of narration. At the end of the novel, though, Wideman does allow Cudjoe a muted affirmation as his private recollections are tied to public memory during a memorial service for the victims of the bombing which takes place in Independence Square. Imagining the ghosts of those who had filled this square in the past, 'Cudjoe hears footsteps behind him. A mob howling his name. . . . Words come to him. . . . He'd known them all his life. *Never again. Never again.* He turns to face whatever is rumbling over the stones of Independence Square' (p. 199). This visionary conclusion is ambiguous (and echoes again the apocalyptic overtones of the narrative), yet contains a note of resolution which certifies Cudjoe's commitment to an ethos of place which has been fractured and obscured by the miasma of urbanisation.

In representing urban spaces as *lieux de mémoire* Wideman, like the other authors examined here, recognises the fundamental instability of memory in the formation and maintenance of cultural identities. All of these writers bear imaginative witness to changing configurations of urban space though they narrativise different forms of urban passage and exhibit different motivations and aims in retelling the past. Taken together these writings testify both to the uneven developments of white ethnic and black experiences of urbanisation and the common need to establish a usable past which will have resonance in the urban present. They illuminate some of the ways in which the 'making of Americans' as an urban process has been and continues to be a powerfully motivated process of remembering and forgetting, of inclusion and exclusion. If Wideman is more pessimistic than the others about the powers of memory work to reclaim or maintain alternative urban imaginaries this is due in large part to his more immediately engaged response to contemporary urbanism and his doubts about the role of the urban intellectual. It is this pessimism, though, which compels him to press the most urgent

claims on his readers, black and white, to imagine 'the ashes of this city we share' (p. 120).

Notes

1. Nan Ellin, *Postmodern Urbanism* (Oxford: Blackwell, 1996), p. 1.
2. Ibid.
3. See Sharon Zukin, *The Cultures of Cities* (Oxford: Blackwell, 1996); M. Christine Boyer, *The City of Collective Memory* (Cambridge, MA: MIT Press, 1994); and Dolores Hayden, *The Power of Place: Urban Landscapes as Public History* (Cambridge, MA: MIT Press, 1994).
4. There is a growing body of critical work on memory in the fields of American cultural history and literary studies. See, for example, George Lipsitz, *Time Passages: Collective Memory and American Popular Culture* (Minneapolis, MN: University of Minnesota Press, 1990); John Bodnar, *Remaking America: Memory, Commemoration, and Patriotism in the Twentieth Century* (Princeton, NJ: Princeton, 1992); David Thelen (ed.), *Memory and American History* (Bloomington, IN: Indiana University Press, 1994); Genevieve Fabre and Robert O'Meally (eds), *History and Memory in African-American Culture* (New York: Oxford University Press, 1994), Amritjit Singh, Joseph T. Skerrett, Jr., and Robert E. Hogan (eds), *Memory and Cultural Politics: New Approaches to American Ethnic Literatures* (Boston, MA: Northeastern University Press, 1996).
5. See 'Introduction' in Singh et al., *Memory and Cultural Politics*, pp. 3–18.
6. Frederick Buell, *National Culture and the New Global System* (Baltimore, MD: Johns Hopkins University Press, 1994), p. 144.
7. Pierre Nora, 'Between Memory and History: Les *Lieux de Mémoire*', *Representations* 26 (Spring 1989), p. 7.
8. Marshall Berman, *All That is Solid Melts into Air: The Experience of Modernity* (London: Verso, 1983), p. 333.
9. Colin Greer, 'The Ethnic Question', in Sohnya Sayres, Anders Stephanson and Fredric Jameson (eds), *The Sixties Without Apology* (Minneapolis, MN: University of Minnesota Press, 1984), pp. 119–20.
10. Carlo Rotella, *October Cities: The Redevelopment of Urban Literature* (Berkeley, CA: University of California Press, 1998), p. 103. Rotella suggests Chicagoan Mike Royko was 'the dean of America's white-ethnic urban newspaper columnists' from the early 1970s until his death in 1997. He provides an astute critical analysis of how Royko narrativised the emergence of postindustrial Chicago for a wide readership. Closely attending Royko's deanship in this period were the New York columnists Jimmy Breslin and Pete Hammill, also positioning themselves as 'regular guys' and moral guardians of the urban past. As noted in the Introduction to this study, Mike Davis adopts a similar stance (albeit it with very different moral and political convictions) in his writings on Los Angeles.
11. Alfred Kazin, *A Walker in the City* (New York: Harcourt, Brace, 1951), pp. 31–2.

12. See, for example, Saul Bellow, *Mr Sammler's Planet* (1969) and Grace
 Paley, 'The Long-Distance Runner', *Enormous Changes at the Last Minute*
 (London: Virago Press, 1979), pp. 177–98. For an African-American per-
 spective on Bellow's treatment of black characters, see Brent Staples,
 Growing Up in Black and White (New York: Pantheon Books, 1994).
13. James Baldwin, *Go Tell It On The Mountain* (New York: Dell, 1985),
 pp. 33–4.
14. Amiri Baraka, *Blues People* (New York: Morrow and Co., 1963), p. 105.
15. Gloria Naylor provides a rich representation of this role in her novel
 Mama Day (1989). As we shall see in Chapter 4, Walter Mosely's detective
 fictions also presents the South as imaginary homeplace for black migrant
 settlers in postwar Los Angeles.
16. See, for example, Finley Peter Dunne, *Mr Dooley in Peace and in War*
 (1898), James T. Farrell, *Young Lonigan* (1932), and Mary Gordon, *The
 Other Side* (1989). The most comprehensive study of Irish-American lit-
 erature to date is Charles Fanning, *The Irish Voice in America: Irish-
 American Fiction from the 1760s to the 1980s* (Lexington, KY: University
 of Kentucky, 1990).
17. Charles Fanning, 'The Heart's Speech No Longer Stifled: New York Irish
 Writing Since the 1960s', in Ronald H. Bayor and Timothy J. Meagher
 (eds), *The New York Irish* (Baltimore, MD: Johns Hopkins University
 Press, 1995), p. 511.
18. Ibid., p. 517.
19. Elizabeth Cullinan, 'Commuting', *Irish Literary Supplement* 2/1 (Spring
 1983), pp. 34–5.
20. Fanning, 'The Heart's Speech', p. 530.
21. Ibid., pp. 530–1.
22. Shaun O'Connell, 'Boggy Ways: Notes on Irish-American Culture',
 Massachusetts Review 26/2-3 (1985), pp. 393–4, p. 380.
23. William Kennedy, *O, Albany!* (New York: Viking Penguin, 1983), p. 371.
24. Ibid., p. 7.
25. William Kennedy, *Ironweed* (Harmondsworth: Penguin, 1986), p. 12. All
 further references are given in the text.
26. On ethnicity as 'a deeply rooted emotional component of identity', see
 Michael M. J. Fischer, 'Ethnicity and the Post-Modern Arts of Memory', in
 James Clifford and George E. Marcus (eds), *Writing Culture: The Poetics
 and Politics of Ethnography* (Berkeley, CA: University of California Press,
 1986), pp. 194–233.
27. Kennedy, *O, Albany!*, p. 7.
28. For example, Mary Gordon and Phyllis Burke draw attention to important
 issues of gender and sexual politics in the Irish-American urban experi-
 ence that Kennedy barely touches upon. See Gordon, *The Other Side*
 (1989) and Burke, *Atomic Candy* (1989).
29. Colum McCann, *This Side of Brightness* (London: Pheonix, 1998), p. 12.
30. James Joyce, *A Portrait of the Artist as a Young Man* (London: Panther,
 1977), p. 222.
31. David Lloyd, ' "Living in America": Politics and the Irish Immigrant', in
 Ishmael Reed (ed.), *MultiAmerica: Essays on Cultural Wars and Cultural
 Peace* (New York: Penguin, 1997), p. 184.
32. Ibid.
33. Alain Locke, 'Introduction', in Alaine Locke (ed.), *The New Negro: An
 Interpretation* (New York: Athenaeum, 1925, 2nd edn, 1968), p. 5.

34. See, for example, Nella Larsen, *Quicksand* (1928), Ann Petry, *The Street* (1946), and Ralph Ellison, *Invisible Man* (1952).
35. Ralph Ellison, 'Harlem is Nowhere', in *Shadow and Act* (New York: Vintage, 1948, 1972), pp. 294–302.
36. Toni Morrison, 'The Site of Memory', in Russell Ferguson, Martha Gever, Trinh T. Mihn-ha and Cornel West (eds), *Out There: Marginalization and Contemporary Cultures* (Cambridge, MA: MIT Press, 1990), pp. 302–3.
37. Toni Morrison, *Sula* (London: Triad Grafton, 1973, 1982), p. 11.
38. Ibid., p. 148.
39. Toni Morrison, 'City Limits, Village Values: Concepts of Neighborhood in Black Fiction', in Michael C. Jaye and Ann Chalmers Watts (eds), *Literature and the American Urban Experience* (Manchester: Manchester University Press, 1981), pp. 35–43.
40. Toni Morrison, *Jazz* (London: Picador, 1993), p. 137. All further references are given in the text.
41. 'Interview: Toni Morrison with Elissa Schappell', *Paris Review* 35 (Fall 1993), p. 118.
42. See Deborah A. McDowell, 'Harlem Nocturne', *The Women's Review of Books* 9/9 (June 1992), p. 1, pp. 3–5.
43. 'Interview', p. 120.
44. Toni Morrison, *Beloved* (London: Picador, 1988), p. 146.
45. Toni Morrison, *Playing in the Dark: Whiteness and the Literary Imagination* (Cambridge, MA: Harvard University Press, 1992), p. 57.
46. Toni Morrison, 'Rediscovering Black History', *New York Times Magazine*, 11 August 1974, p. 15.
47. Charles H. Rowell, 'An Interview with John Edgar Wideman', in Bonnie TuSmith (ed.), *Conversations with John Edgar Wideman* (Jackson, MI: University Press of Mississippi, 1998), pp. 99–100.
48. Rowell, ibid., p. 100.
49. Bill Mullen, 'Looking Back', *Partisan Review* (Fall 1990), pp. 529–30.
50. John Edgar Wideman, *Sent for You Yesterday* (London: Allison and Busby, 1985), p. vii.
51. Quoted in Mullen, 'Looking Back', p. 530.
52. Jan Clausen, 'Native Fathers', *Kenyon Review* 14/2 (1992), p. 50.
53. John Edgar Wideman, *Philadelphia Fire* (New York: Vintage, 1991), pp. 7–8.
54. John Edgar Wideman, 'Fever', *Fever: Twelve Stories* (Harmondsworth: Penguin, 1990), p. 129.
55. Rowell, 'An Interview', p. 92.
56. Ibid., p. 93. Madhu Dubey provides an insightful analysis of ways in which *Philadelphia Fire* functions as 'a novel about the problems of writing and reading urban fiction' and draws particular attention to Wideman's eschewal of black nationalist aesthetics. Madhu Dubey, 'Literature and Urban Crisis: John Edgar Wideman's *Philadelphia Fire*', *African American Review* 32/4 (1998), pp. 579–95.
57. Judith Rosen, 'John Edgar Wideman', in Bonnie TuSmith (ed.), *Conversations with John Edgar Wideman* (Jackson, MI: University Press of Mississippi, 1998), pp. 82–3.
58. Rowell, 'An Interview', p. 100.

Between Pathology and Redemption

As the cores of American cities have been radically transformed in the last twenty years, the postindustrial ghetto has emerged as a highly visible signifier of urban decline, a scene of social and economic devastation peopled by an ominous urban 'underclass'. The concept of the underclass has been widely used as a metaphor for the socio-spatial restructuring of American cities in the 1980s and 1990s: it refers to the deindustrialisation and decentralisation of economic enterprise, the intense concentration of poverty in increasingly iso-lated inner-city areas, the deproletarianisation of the urban poor, and the privatisation and militarisation of public space. The underclass is also a compelling myth of behavioural deficiencies, combining common assumptions about poverty and race. It generates stock representations of delinquent and aberrant behaviour as signifiers of urban 'blackness'; as a term of racial categorisation it posits urban black poverty as a 'a tangle of pathology'.[1] In this chapter I will com-ment on some general features of the myth of the underclass and examine how it has been treated as an issue of representation in selected texts.

The myth of the underclass is a cultural and political construct that has a distinct historical emergence and development in public discourse. It began to take distinctive shape in the wake of late 1960s representations of 'urban crisis' which focused on riots, disorder and decay in African-American urban centres. In March 1968 the Kerner Commission, reporting on the cause of urban riots, famously warned that the United States was 'moving toward two societies, one black, one white – separate and unequal'. While the Commission's recommendations for 'ghetto enrichment' and racial integration were

largely ignored its image of 'the racial ghetto [as] a destructive envi-
ronment totally unknown to most white Americans' is one that
emerged in more detailed and negative profile in 1970s and 1980s
discourses on the underclass.[2] These discourses developed in social
analysis and then more publicly in the national media toward the
end of the 1970s. One notable instance of the latter is a *Time* cover
story of August 1977 which stated: 'Behind [the ghetto's] crumbling
walls lives a large group of people who are more intractable, more
socially alien and more hostile than almost anyone had imagined.
They are the unreachables: the American underclass'.[3] This state-
ment represents the underclass as a distinctly separate group, all but
invisible to white America, and implicitly responsible for its mem-
bers' separation and immiseration – they are not only alien, but
intractably so, rendering themselves unreachable. There is in this
language an intimation of what have become common assumptions
about the underclass: that it is outside normative (white American)
considerations of what constitutes citizenship and that its members
have little prospect of overcoming this isolation.

Such assumptions became hardened within a political ideology of
the underclass in the 1980s, an ideology in tune with the national
government's withdrawal of social expenditure programmes and the
Reaganite engineering of a more hierarchical society. While liberal
analysts such as William Julius Wilson sought to identify class dif-
ferentiation and economic restructuring as causes of the underclass
condition, conservative America found more polemical and com-
pelling evidence in the work of Charles Murray, Lawrence Mead
and others who criticised liberal welfare policies and advanced
behavioural models to explain the existence of a separate poor black
population in American cities.[4] The behavioural explanation (echoing
the 'culture of poverty' argument of the 1960s) both focuses and
rejects the black poor as a social 'problem' by arguing that the indi-
vidual not social conditions is responsible for membership of the
underclass.

In the mid 1980s 'underclass' came to be used primarily as a
behavioural term, widely used to describe what was perceived as
aberrant or anti-social lifestyles and outlooks. This discourse (echoing
nineteenth-century perspectives of the 'undeserving poor') rearticu-
lated the crude dualism of 'two societies', but now with a powerful
moralising emphasis. It worked to transform the social problem of
poverty into the moral problem of behaviour. Moralising commen-
tary on the urban black poor has tended to accentuate the pathological
difference of the underclass as a form of social degeneration signifying

an essential loss or lack of social wholeness – individual, familial, and communal. The underclass is said to lack moral values and incentives; it is said to have lost role models due to the absence of a black middle class. This formulation of fundamental behavioural deficiencies valorises a 'middle-class morality' which is absent from ghetto cultures and focuses attention on the dysfunctional nature of family structures, gender relations and reproduction among ghetto inhabitants. As images of teenage mothers and one-parent families became commonplace images of underclass life, 'behaviour' was readily taken to connote attitudes, motivations and values that are only rarely studied in detail.[5]

The underclass discourse has produced peculiar mystifications about race and class, and about behaviour and values, which have reinforced a sense of intractable difference and distance surrounding the ghetto poor. Throughout the 1980s and 1990s the separateness and pathologies of the underclass became thoroughly naturalised in public discourse. The outpourings of sociological and journalistic commentary on the topic only served to aggrandise rather than demystify its mythical appeal. The myth developed potent symbolic power despite, or better because of, the inconsistencies of its categorical indices. Commentators have made confusing claims as to who exactly constitutes membership of the underclass, yet the inconsistency of focus and definition has not hindered popular dissemination of the myth. Nor is its appeal dented by mere empirical evidence – as rates of teenage motherhood actually declined, American media popularised images of 'babies having babies'. The transcendent appeal of the underclass myth is such that, as Adolph Reed notes, 'its resonance has far out-paced its empirical content, and it has thrived as a concept in search of its object'.[6] In other words, the underclass both functions and appeals as an over-determined metaphor because it symbolically inscribes common assumptions about race and poverty.

If the underclass myth was originally propelled into public consciousness by the writings of sociologists and journalists it took on a fresh impetus and even greater resonance through visualisation in television and cinema. By the late 1980s images of unmarried ghetto mothers, crack users and homeless people were common on American television, and it was television news and documentary programmes which began to feed alarmist images to the public of 'babies having babies'. These forms of programming encoded black urban poverty as distinctively separate from the worlds of the viewing audience and contributed to the pathologisation of the poor inherent in the

underclass myth.[7] Issues of visuality and visibility are crucial to understanding representations of black urban poverty, especially as these take on recognisable spatial components. The framing of the postindustrial ghetto as the space of the black underclass has given rise to stock images of people positioned in a *mise-en-scène* of urban wasteland streets, concrete playgrounds, project housing and derelict buildings. The ghetto appears as a carceral space, confining its inhabitants as both visible and exotic, subjected to the distanced gaze of the viewer.

The emergence and dissemination of the myth of the underclass is inextricably linked to ideological issues of race and representation. It has been subject to many modes and mediums of representation: journalism, television, documentary film, narrative film, photography, mural art, autobiography, fiction and popular music. In this chapter, I will focus on selected texts of journalism, photography and film that have proved to be influential representations of black ghetto life in the 1990s. The texts offer well-intentioned, meliorist efforts to inform and demystify, to produce fresh understandings of urban black poverty, yet, as we shall see, they also reproduce as well as challenge common assumptions about the underclass.

HOW THE OTHER HALF SURVIVES: *THERE ARE NO CHILDREN HERE*

American journalists have been venturing into the inner city to record 'how the other half lives' for over one hundred years, and sociologists have followed a similar path for almost as long. Their representations of the urban poor have evolved over time, both responding to contemporary social conditions and drawing on established codes and conventions of documentation and reportage. The result has been a distinctive if varied literature of ghetto ethnography that has played an important role in defining urban poverty for a readership outside that world. The underclass writings of the 1990s have significant methodological and stylistic roots in 1960s journalism and sociology. They build on the traditions of 'new journalism' which melded fictional techniques with traditional forms of reporting in analysis of American subcultures and countercultures, and mimic the fieldwork aspect of progressive sociologists who immersed themselves in the cultures of the urban poor. The underclass ethnography of the 1990s is in certain ways more sophisticated and self-conscious regarding the positionality of authorship, yet continues to valorise

the role of the writer as participant observer, a first-hand witness to the experiences of the urban poor.

The text which most influentially opened the way for indepth reporting on the black underclass in the 1990s is Alex Kotlowitz's *There Are No Children Here: The Story of Two Boys Growing Up in the Other America*, published in 1991. Kotlowitz's book had its origins in a series of articles he wrote for the *Wall Street Journal* in 1987 on black children living in a public housing project in Chicago. The articles were well received (one of them won the Robert F. Kennedy Journalism Award) and Kotlowitz returned to Chicago to closely chronicle the lives of two brothers in the Henry Horner Homes over a period of three years. The resulting book quickly became a best seller and established its author as an expert on ghetto poverty and education. Throughout the 1990s many writers have followed Kotlowitz into the lives of black people in public housing. A large number have shared his focus on children, and notably popular have been texts which analyse the expressive culture of young black males through sport. Others have focused on drug culture and related aspects of predatory street life.[8] A common element in these works is a concern to represent the psychological and cultural damage caused by inner-city poverty. They offer personalised accounts which engage readers very immediately with the experiences of the black urban poor and offer to understand the collective 'condition' of the underclass through close attention to the daily routines and thoughts of selected individuals.

There Are No Children Here tells the story of Lafayette and Pharoah Rivers across a period of three years, producing a very intimate chronicle of their home lives, their schooling, their relationships with their extended family (with particular emphasis on the role of their mother LaJoe) and their responses to the poverty and violence which surrounds them. In 'A Note on Reporting Methods' which follows the main narrative text Kotlowitz emphasises the diligence of his approach to his subject:

In reporting this book, I spent a good deal of time just hanging out with Pharoah and Lafayette, sometimes as much as four to five days a week. . . . LaJoe was like a second pair of eyes and ears for me. She relayed incidents involving her children that I would talk about with them at a later date. . . . I interviewed over a hundred other people, including the boy's friends and neighbors, police, schoolteachers, judges, attorneys, Chicago Housing Authority officials, and local politicians. . . . Of the numerous scenes in the book, I witnessed nearly half. . . . Those events at which I wasn't present I recreated from interviews with people who were. . . . In those instances

where dialogue was re-created, it was based on the memory of at least one of the participants, and often on the memory of two or three.[9]

This explication of reporting methods underlines the veracity and authenticity of Kotlowitz's chronicle. We cannot doubt that he has been a dedicated and conscientious observer of the boys' lives. However, this commentary on his methods, as much as the narrative it follows, begs many questions about his participation in and mediation of their lives.

While Kotlowitz appears to have been omnipresent, ever-documenting the lives of Lafayette and Pharoah, he renders himself invisible in the main narrative which is told in the third person by an omniscient voice which blends the perspectives of the key participants with social and historical information. In this manner Kotlowitz seeks to draw us into the lives of the boys (and of their mother) by opening up their interior worlds, the subjective spheres of hopes, dreams, anxieties and fears. The effect is dramatic, as common feelings unfold in uncommon contexts we are taken into a world of everyday poverty and violence through the perspective of those who cannot be held responsible for this environment. As a narrative strategy this is an effective means of appealing to a readership that might have little direct interest in issues of urban poverty and education. However, it is also a strategy that sets the boys lives within particular ideological and narrative frameworks the author has selected. While Kotlowitz seeks through interiorisation to provide points of empathy for his readers it is never clear to what degree the children and their mother have expressed their emotional lives to him and to what degree he imaginatively constructs subjectivity. Although this is impossible to clarify we can recognise that he uses particular modes of emplotment, focalisation and metaphorisation to dramatise his chronicle.

The narrative begins with a coming-of-age episode (a stock device of countless fictional and autobiographical treatments of childhood) in which the boys and their friends visit railroad tracks near their home to hunt for garter snakes in the undergrowth alongside the tracks. Their 'urban safari' fails to uncover any snakes but just as boredom sets in 'a commuter train approaching from downtown' (p. 6) startles the boys. As the boys frantically hide themselves their fear is explained by the narrator:

The youngsters had heard that the suburb-bound commuters, from behind the tinted train windows, would shoot at them for trespassing on the tracks. . . . Some of the commuters had heard similar rumors about the neighborhood children and worried that . . . they might be the targets of

talented snipers. Indeed, some sat away from the windows as the train passed through Chicago's blighted core. For both the boys and the commuters, the unknown was the enemy. (p. 7)

The incongruity of unconventional setting (ghetto pastoral) and conventional motif (the machine in the garden) establishes key thematics of the narrative and signals its implied reader. The thematics – the relations between space and knowledge, innocence and experience, and self and other – are archetypal but will take on the particulars of the boys' environment and experiences as the narrative unfolds. The implied reader is correlated with the commuter in the suburban bound train who recoils in fear from the denizens of the city's 'blighted core'. Playing the points of view of the boys and the commuters against each other Kotlowitz reassures his reader that 'the unknown was the enemy' and implicitly asks his reader to open their minds to what lies beyond rumours about the ghetto poor.

This introductory chapter also begins the characterisation of Lafayette and Pharoah. The older Lafayette is portrayed as impulsive and impatient; 'almost twelve', he is on the edge of adulthood and tugs at the responsibilities of looking after his younger brother. As he grows older he becomes apprehensive about close relationships as friends die at a horrific rate and he struggles with the role of his mother's confidant in place of his father who has left the family. By the end of the narrative he has become a morose young man whose 'face seemed incapable of expression' (p. 280) and whose expressions of tiredness to his mother worry her that 'he was just tired of being' (p. 260). It is Pharoah, though, whose interior world is more fully dramatised by the author and strikes the most empathic chords with the reader. Nine years old at the opening of the narrative, he is portrayed as a sensitive child given to private reveries who seems 'in awe of the world' (p. 4). In the opening chapter he marvels at the downtown skyline:

With the late afternoon sun reflecting off the glass and steel skyscrapers, downtown Chicago glowed in the distance. As he looked south a few blocks, he glimpsed the top floors of his home, a red brick, seven story building. It appeared dull and dirty even in the brilliant sun. (p. 4)

The sense of socio-economic disjunction is for the readers' eyes only, though, for Pharoah finds the view 'pretty great' (p. 4). This sense of wonder at the surfaces of life is used by the author to transmit the perspective of childhood, further enhanced by Pharoah's attachment

to the natural world. As the other boys play around him he is distracted by butterflies and wildflowers, 'lost in his thoughts, thoughts so private and fanciful that he would have had trouble articulating them to others' (p. 7). As his narrative develops he is depicted as yearning for a 'sanctuary' to protect his childhood: 'Pharoah clutched his childhood with the vigor of a tiger gripping his meat. He wouldn't let go. Nobody, nothing would take it away from him' (p. 15).

The struggle to protect childhood lends the book its moral core. Kotlowitz shows us that the innocence associated with childhood is under extreme pressures in the projects environment and as he details the decay and danger that surrounds the boys we are led to feel concern for their very mortality as much as for their emotional and intellectual development. The author frequently draws our attention to the social and historical contexts of their imperilled childhoods. For much of the narrative he does this almost seamlessly, impelling the reader to look over the shoulder of the children at issues beyond their articulation (as in his depiction of Pharoah's view of the city above). As the children experience random shootings in their neighbourhood he moves to present information on gang activities and policing; at another point the children's presence at a basketball stadium, where they seek to park cars safely for a fee, allows him to provide an insightful historical sketch of the politics of policing surrounding the stadium which is on the edge of the projects. At times, though, the narrative moves awkwardly between the children's perspectives and the broader social issues of project life Kotlowitz wants to comment upon. His commentary on the criminal activities of a gang leader and his eventual conviction stretches across several chapters and reads like a journalistic aside to the main narrative. The sometimes awkward transitions in narrative focalisation and tempo render apparent the tensions between the moral thrust of his chronicle and his nascent efforts to identify causes and responsibilities for the boys' immiserated childhoods.

In the figure of LaJoe, the boys' mother, Kotlowitz means to broaden his purview of family relationships and pose questions about adult values and responsibilities. LaJoe is described as the key 'guidepost' (p. 9) in the lives of the boys at the beginning of the narrative, though it is a position she struggles to maintain. Via her memories the author documents the development of Henry Horner Homes from a place of utopian hopes in the mid 1950s when LaJoe arrived there with her parents to a place where she 'and her neighbors felt abandoned' (p. 12) by the late 1980s. Kotlowitz accentuates this sense of abandonment through his descriptions of the physical decay of her immediate

environment – her apartment and her building which lack mainte-
nance – and of the neighbourhood that lacks public spaces for safe
recreation or communal activities. This physical decay is linked time
and again in the narrative to forms of individual, familial and com-
munal decline. From La Joe's perspective, '[i]t wasn't just her home
that was crumbling; the neighborhood was too. It was all the perfect
metaphor, LaJoe thought, for what was happening to her spirit'
(p. 241). The metaphor is too perfect, though, to hold together the
manifold issues of poverty and parenting the larger narrative places
before us. Earlier we are told that LaJoe 'could not separate' her
family and the physical ruin of the neighbourhood: 'Sometimes she
blamed her children's problems on the neighbourhood; at other
times, she attributed the neighborhood's decline to the change in
people, to the influx of drugs and violence' (p. 13). This seesawing
perspective works fine to dramatise LaJoe's insecurities and sense of
despair, but it also reflects the author's own elisions of critical
inquiry (as he works to sustain the illusion of the invisible, omniscient
chronicler who simply reports what he hears and sees) and mystifies
social and economic relations.

Whereas Kotlowitz emphasises LaJoe's embattled but essential
humanity, he depicts her largely absent husband Paul in pathological
terms, as a junkie who has failed the family. Having promised Lafayette
'he would move the family out of Horner to a quieter neighborhood'
(p. 167), his failure to keep this promise appears central to the family's
'decay': '[Paul] had not only welshed on his promises, but he was too
dejected to be of much support for the kids' (p. 168). The reader is
not told what changed Paul from an employed father to a depressed
junkie, simply that his 'habit overtook him' (p. 167). He remains a
shadowy figure in the narrative – we do not share his point of view
as we do that of the children and their mother. This may be due in
some part to the author's limited access to Paul but the result is a
skewing of the narrative to suggest that the absent, delinquent father
is largely responsible for the family's plight. This reflects Kotlowitz's
broader treatment of male role models in the book. He draws attention
to the paucity of employed black men in the boys lives, pointing out
that 'only a handful' of their schoolteachers are men and noting the
allure of gang leaders as surrogate fathers. However, issues of male
parenting roles remain largely pathological in presentation, sum-
marised as the common occurrence of absence in 'a neighborhood
where men fathered children and then disappeared into the gangs
and the street corners and death' (p. 82). The focus on behavioural
deficiencies stands in for analysis of motivations and values and we

learn little about the impact of the urban political economy on the role of male parenting.

The 'disappearance' of the fathers is a common stereotype in mass-media portraits of black poverty and Kotlowitz does nothing to further readers' understanding of the trajectories or emotional complexities of adult black male life in the ghetto. One of the most troubling aspects of his narrative in this respect is his dissociated treatment of his own presence in the lives of the children. For all his references to conscientious 'reporting methods' he retains complete, omniscient authorial control of the narrative. His stress on his closeness to the boys might lead readers to wonder just what effect he had as a role model while 'hanging out' with them (especially as the epilogue hints that he has acted as both benefactor and mentor). Narratologically, at least, he is another absent father, lending their lives shape and meaning at a distance. Kotlowitz's omniscience is troubling also in its effort to provide a corrective vision of the underclass condition through empathy and recognition of a common humanity based on 'our' responses to children. The immediacy and strong emotional tones of the narrative convey a sense of urgency and foster both horror and pity in the reader. However, this liberal effort to evoke compassion relies on assumptions about the universality of child-hood – its immanence and innocence – which deflect understanding of the very differences – of race and poverty – which make them fit-ting subjects for liberal empathy. In his preface Kotlowitz stresses that 'despite all they have seen and done, [Lafayette and Pharoah] are – and we must constantly remind ourselves of this – still children' (p. xi). *There Are No Children Here* is a reminder of this, but it also allows 'us' to forget the material conditions of difference and segre-gation in favour of the imaginary citizenship of empathy.

HOW THE OTHER HALF STRIVES: *HOOP DREAMS*

Documentary filmmaking has long been established as a medium of representation that offers to reveal and interpret hidden or obscured cultures, promising the viewer knowledge of the 'real' based on the illusion of direct, unmediated engagement with the world of others. This illusion can be powerfully affective, feeding on the viewer's desire to know and using staple techniques and devices – talking head interviews, fly-on-the-wall footage, *verité* camerawork, and voice-over narration – to render transparent what appears to be the inherent drama of the filmed subject. In its treatment of its subject it

is akin to literary journalism due to their shared epistemological basis, but documentary film must be distinguished as a visual ethnography – it relies on the hegemony of vision to certify the real and uses the camera to insistently place the viewer as witness to or voyeur in the world of others.[10] When applied to worlds of urban poverty documentary film has taken many forms, including populist voyeurism (true crime television programming), liberal investigation (ethnographic treatments of ghetto life), and the radically vernacular (residents' filming of their own conditions of poverty). It is liberal ethnography I am concerned with here, specifically as it is represented by the film *Hoop Dreams* which is by far the most highly acclaimed documentary film treating black poverty in recent years.

Hoop Dreams earned astonishing box office success and wide critical praise on its release in 1994. It is an independently funded film made principally by three young white filmmakers – Steve James, Peter Gilbert and Fred Marx – who began in 1987 to put together a half-hour documentary about high-school basketball in Chicago. In 1994 it was released as a three-hour 'epic' that won the Audience Award at the Sundance Festival, made the top ten of just about every film critic's list in the United States, and caused a media frenzy when it was snubbed for an Oscar. Within a year it had grossed more than eight million dollars and the filmmakers and their filmed subjects, two young black basketball players from the Cabrini Green projects, Arthur Agee and William Gates, had become celebrities. The filmmakers were signed up by Spike Lee to assist in a fictional version of the film, while Agee and Gates were widely interviewed in the mass media and feted for photocalls by President Clinton. As several critics have noted, the success of the film has a reflexive connection to its content premised on the dream of upward mobility, the movement from margin to mainstream.[11] However, such success for a documentary film could not have been foreseen and we must look more closely at the film to consider the appeal of a three-hour documentary on inner-city black basketball players, and more particularly to analyse its representation of ghetto life.

From the point of view of the filmmakers, *Hoop Dreams* was originally intended to be an expose of the manipulation and exploitation of young black athletes from the ghetto by agents, coaches, high schools and universities; it was meant to feed the audience's desire to know through its illumination and critique of the making of sports celebrity. In many ways it achieves this aim, showing us how a white suburban high schools poaches black basketball talent from the ghetto with little regard for educative potential, or how Nike manages

a basketball summer school for such talent which is known as a 'meat market'. However, a more potent narrative force subsumes the critique: the story of two poor boys chasing the American Dream. Between intended critique and resulting narrative reside ambiguities and contradictions that the narrative momentum of the film barely allows us to reflect upon as we watch.

The powerful narrative momentum does not come from traditional documentary resources, though the filmmakers imply otherwise. Over five years, as they followed the lives of Agee and Gates, they accumulated over 250 hours of film. In interviews the director Steve James comments on both the slow pace of their enterprise and the rawness of their practice (they had only one camera, shot directly onto Beta video, and used natural lighting when possible) to emphasise that they were three years into the project before they understood what the film was about and realised '[y]ou write the screenplay in the editing'.[12] This is disingenuous as an explanation of the narrative form as it replays the stock documentarist view that the subject assumes its own dramatic form – the drama of the real. In fact, the momentum of the film draws heavily on narrative film tropes and devices, particularly those of the sports movie, which has tradition-ally featured narratives of impoverished athletes triumphing over great odds in pursuit of an American Dream. It is this genre of narrative film which *Hoop Dreams* appropriates to provide the dramatic force of the film, even using formulaic themes and iconography of the genre, such as the big game finale and the slow motion treatment of a ball play which carries the drama of success/failure in its arc. In the shaping of its material for dramatic effect *Hoop Dreams* ultimately invests in the pleasures of success. It is the narrative of upward mobility – eerily iconicised in the image of William slowly rising skyward with a ball in film advertising – that reviewers fixated on.[13]

While the dramatic focus on the Dream ultimately overwhelms the filmmakers' overt critical intentions, they do succeed in offering a fascinating portrait of ghetto life for at least half of the film's running time before the drama of success/failure becomes almost exclusively tied to court play. The first half of the film is densely textured, cross-cutting between diverse individuals and environments and building a complex web of social and personal relations. Family dynamics receive a good deal of attention, although they mostly revolve around the dreams of the boys. The roles of the mothers, particularly Sheila Agee, are positively presented to show them as caring and supportive of their families in general and the boys in particular. At one point Sheila asks the filmmakers: 'Do you ever ask yourself how I get by on

268 dollars a month and keep this house and feed these children? Do you ever ask yourself that question?'. Articulate and intelligent, Sheila also pursues her own dream of becoming a nurse and the film finds one of its few emotional highlights outside of the boys lives when she passes her exam. Although a secondary character in the narrative, the portrait of Sheila effectively challenges common stereotypes of 'welfare mothers' which were prevalent at the time of the film's making and release. Unfortunately, there is no similar challenge to stereotypes in the portraits of adult black males in the film. Indeed, there is a clear echo of Kotlowitz's narrative in the film's representation of Arthur Agee's father Bo as an unemployed drug addict who deserts his family. Once again, pathology and dysfunction characterise the role of the black male adult without any interrogation of the conditions or circumstances of individual failings. Although we learn that both Bo and William's brother Curtis have previously held employed work but now have difficulty finding jobs there is no suggestion that they may be victims of deindustrialisation. Rather they are portrayed as victims of their own failings, defeated men now living out what is left of their aspirations through son and brother respectively.

Sheila's direct address to the filmmakers is the only direct reference to poverty in the film, which, unlike *There Are No Children Here*, eschews critical examination of the socio-economic conditions it portrays. As a result we have only very limited understanding of why (as the film would have us believe) a longing to play basketball consumes all desire in the lives of young black men in the ghetto. 'Basketball is my ticket from the ghetto' William asserts, articulating the transcendent promise of the Hoop Dream. Some commentators have sought to explore why this belief is held by many young black males in ghetto poverty, and produced varied explanations: the street credibility of this route to success; the relative access to this sport within ghetto environments; the celebration of black athletes as role models; an alternative to unfulfilling wage labour.[14] *Hoop Dreams* does not explore such issues, it simply relies on the assumption that a desire to escape the ghetto is a natural aspiration. A telling scene in this respect is one in which the young Arthur comes face to face with his hero Isiah Thomas who has visited his high school alma mater where Arthur and William are now enrolled. For Arthur, whom we observe watching Thomas on television at the beginning of the film, the man before him is the Dream incarnate, holding the ticket from the ghetto. We watch Arthur and Thomas play a quick one-on-one in which the latter feints and leaps past the awe-struck boy, and as the camera focuses on Arthur's expression of wonder we sense how

potent is his identification with this heroic figure who leaps past him, out of the film and back into the world of mythical sports celebrity. It is, as with many moments in this film, poignant and self-sufficient. At no point with this scene do the filmmakers attempt to provide the more critical forms of interrogation they bring to the workings of the high-school coach or the Nike training camp. There is no consideration, for example, of how and why many black basketball stars have come to act as symbolic surrogates for the absent fathers of the ghetto.[15]

Hoop Dreams celebrates the dream of ascension even as it is selectively critical of machinations attendant on this. It simultaneously exploits and elides viewer fascination with the urban environment that constrains and motivates the Dream. The film begins with a panoramic view of downtown Chicago as seen from the projects (echoing the opening of *There Are No Children Here*) and briefly follows the movement of an elevated train before cutting to Arthur and William in their respective homes watching a NBA All-Star game on television. Surrounded by their families the boys whoop with delight as they watch their heroes at play. William is then shown going outside to play ball on a neighbourhood court and the camera catches him in slow motion going for an impressive slam-dunk. While this establishing sequence has some obvious meanings – the boy's fixation on the world of celebrity basketball and relative distance from the rest of Chicago – it also announces an important element of basketball's media appeal and perhaps that of the film as well: the juxtaposition of the dichotomous worlds of the professional basketball arena and the 'street' space of ghetto players. The link between these worlds is widely romanticised in professional basketball and related advertising, with images of ghetto courts and rusting, netless hoops becoming common symbols of the game's 'authenticity'. This is to say that the link is also commodified, as professional basketball exploits the 'street' image of the game. However, this linkage is rarely treated critically in mass-media representations. This may be due, as Gitanjali Maharaj contends, to a reluctance to engage a central paradox of representations of race in the United States:

the same late-capitalist economic practices that led to deindustrialisation and the decline of black urban communities in the post-World War II United States also produced the black basketball star as a commodity and an object of desire for mass consumption; . . . both the 'nightmare' of the urban ghetto and the 'dream' of being a celebrity, professional athlete are manifestations of the economic and cultural workings of late capitalism.[16]

Hoop Dreams allows us to only barely glimpse this paradox and steers clear of engaging its complexities. It reads the difference between street and arena as that between failure and success, suppressing the more ideologically charged connotations of pathology and redemption.

The socio-economic underpinnings of the Hoop Dream point us back to the effects of postindustrial decline on American inner cities, particularly to the transformations in the roles and meanings of labour and recreation among the urban poor. The romance of the ghetto as a space of play (not only in *Hoop Dreams* but also in much corporate advertising) effaces the impact of the urban political economy on recreational space. As Robin Kelley points out: 'Economic restructuring leading to permanent unemployment, the shrinking of city services . . . the decline of parks, youth programs, and public schools, all have altered the terrain of play and creative expression for black youth'. One result of these processes is that 'the pursuit of leisure, pleasure, and creative expression is *labor*' for many young black people in the postindustrial ghetto.[17] *Hoop Dreams* ignores the role of the urban economy in creating new conditions for play-as-labour and encouraging self-commodification among young black males. It only allows one of its protagonists a flickering recognition of how play is turned into labour late in the film when William expresses his disillusionment with the pressures on him to succeed and observes that playing basketball has become a 'job'. At best, this functions as an aspect of the film's fragmented critique of exploitation, but even this is defused as William's increasingly dejected characterisation symbolically associates him with the failed men of the film (Bo and Curtis) and the narrative moves on to focus on the drama of Arthur's more fulsome pursuit of success.

As liberal ethnographies of underclass life, *There Are No Children Here* and *Hoop Dreams* effectively evoke compassion for their subjects. However, they also frame their subjects within ideological and narrative structures that reproduce one of the most common assumptions about the underclass, that it is always already outside normative citizenship. Though they encourage different modes of identification – with narratives of innocence and aspiration – these texts distance the reader/viewer from the material realities of the worlds they represent. While Kotlowitz has a coming-of-age story deflect the differences of race and poverty, the filmmakers allow the driving narrative of the Dream and the spectacle of play – the recurrent imagery of black bodies performing on court, invested with aspirations – to subsume their critical intentions. Moreover, both texts exhibit the ethnographic fallacy of sharply delineating 'the behaviour at close range but

obscure the less proximate and less visible structures and processes that engender and sustain that behaviour'.[18] By ultimately reinforcing a sense of intractable difference and distance surrounding the ghetto poor, they reproduce mystifications about race, class and poverty common to mass-media representations of the underclass. The underclass remains a 'problem of race' in these texts (even as they suggest this problem may be overcome, through the struggle to survive or escape), contained within the other America of the post-industrial ghetto.

URBAN NECROPOLIS: *THE NEW AMERICAN GHETTO*

Urban poverty has long been a favoured subject for photojournalism in the United States. In *How the Other Half Lives* (1890) Jacob Riis included many photographs of poor immigrant neighbourhoods and interior spaces in New York's Lower East Side. These photographs, as many critics have pointed out, all but invented a middle-class view of urban poverty at the turn of the century. Images of crowded tenement rooms and garbage-strewn alleys were shot in ways that accentuated the grime and density of inhabited urban spaces. Throughout the twentieth century American photographers have continued to photograph ghetto poverty within contexts of news reportage or reform imperatives. By the 1970s a mode of 'street photography' was well established in magazines, books and exhibitions. Much of this photography responded to the 'urban crisis' of the late 1960s and early 1970s by documenting the human inhabitants of the 'dark ghetto'. In a post-1960s environment of heightened perceptions regarding issues of representation and image politics, though, this and other forms of photography became widely subject to critical and ethical questioning about the use of the photograph as a form of documentation. Since that period, photography of urban poverty, and especially that focused on black subjects, has had to negotiate a new self-consciousness about issues of voyeurism, aestheticism and colonisation in the relations between photographer and subject.[19]

In the 1980s and 1990s photographs of the urban poor retained a central place in the work of photojournalists and documentary photographers and the new consciousness of an urban underclass was given visual form by many images in magazines and newspapers. While most images were absorbed into general consciousness about urban poverty some proved highly controversial, especially due to

the representation of black subjects. In 1994 Eugene Richards, a distinguished photojournalist with a reputation for 'documenting conditions on the front lines of violence, drug addiction, poverty, racism, and cancer', published *Cocaine True Cocaine Blue*, 'a hellish look at core drug addiction among the urban underclass'.[20] The book, which depicted the use and effects of crack cocaine on predominantly black ghetto dwellers, divided critics and drew vehement criticism from African-American spokespeople in several cities. Richards claimed he wanted to raise consciousness and prompt a national dialogue about drug addiction. However, there was precious little dialogue and it was clear the issue of divided responses was race. Vincent Musi, in *News Photographer*, professed outrage at those who attacked Richards, arguing his book 'follows in the great tradition' of work by Jacob Riis and Walker Evans, 'explanatory journalism exposing great injustice'.[21] Brent Staples, on the other hand, writing in the *New York Times*, presented a careful critique of the book. Staples commends Richards for allowing 'voices of the addicts and their families [to] come through in high fidelity' in accompaniment to the images, but asks:

why are nearly all of the people in these photographs black? . . . why is the white aspect of drug addiction so consistently invisible? . . . Certainly drugs are a scourge in the African-American community. I am not asking for equal-opportunity representation of drug abuse. Nor am I saying that Mr. Richards should have written a different book. The point is larger than that. When the culture focuses on black addiction alone, we miss the breadth of the danger and confine the problem to 'those people' over there.[22]

Staples identifies an issue which haunts much similar photography: the role of race in perceptions of underclass behaviour as pathologically aberrant and separate from the behaviour of those outside the ghetto. Richards responded to Staples' critical questioning by stating 'the last thing I noticed about the pregnant woman smoking crack, the addicts dying after shooting up, young girls prostituting themselves, the drug boys with automatic weapons or the mothers grieving for their dead children, was their skin color'.[23] Richards' litany of abuse, grief and death is clearly intended to rhetorically position his response to what he saw as one of moral concern about human suffering. To claim he had no comprehension of either the race of his subjects or the effects of racism on them is naive at best, though, echoing the humanist ideology of many earlier American photographers of poverty.[24]

In *Cocaine True Cocaine Blue* Richards shows a genius for coldly catching moments of human disconnection as expressed by facial gestures and bodily postures and positioning. One photograph is a close up of a woman's face as she ties up her arm seeking a usable vein and grips a syringe between her teeth; another shows the bodies of two young men slumped forward in their car seats having died after shooting up; and another (the image which drew most criticism) shows a woman with an infant strapped to her back preparing to perform fellatio on a man who stands before her. With many of his photographs, including the last cited, Richards does indeed produce images of universal degradation which few viewers could look at without a sense of horror. However, he shows little understanding of how black bodies lend the environment of the image forms of racial significance. The image of the woman with the infant preparing to perform fellatio is also coded within an ideological matrix of discourses and images about the underclass which links race, gender and poverty in perceptions of familial dysfunction, aberrant female sexuality, and uncontrolled reproduction. Paul A. Rogers, considering a photographic image of black poverty produced in the mid 1960s, argues that photography can function to map poverty onto black bodies in ways which render the relationship natural, and asks 'why must the black body, the black family matrix, become the sole explanation of its social, political, and economic circumstance?'.[25] The question is pertinent in viewing Richards' images, though he offsets the lack of context by including the voices of the addicts. The mother in his most controversial image seems more likely to be 'read' as a site of shame and blame rather than as an explanation of the forces and contexts of urban poverty. Richards' images may not be racist, but they are intensely racialised.

I want to look in more detail at one further example of recent ghetto photography, Camilo José Vergara's *The New American Ghetto* (1997), which, with an accompanying exhibition, received almost universal acclaim for its depiction of the decaying environments of the inner city. Vergara's is an unusual photographic project, though one that reanimates issues concerning representations of race and poverty in urban photography. In 1977 he began photographing ghetto spaces in major American cities – New York City, Newark, Chicago, Gary, Camden, Los Angles and Detroit – with a particular focus on the physical environment: streets, building facades (and occasional interiors), vacant lots, NIMBY structures such as shelters, institutions such as factories, and graphic expressions on building walls. The human inhabitants of these environments are either absent

or distant, only very rarely imaged in close up. This is deliberate, reflecting Vergara's view that 'People are not the ones who are expressing the change that's going on in the cities. *Buildings* are'.[26] This view speaks to the striking methodology he utilises. By varying his point of view (though he has a preference for taking photographs 'from above', often from the roofs of project buildings, sometimes simply from atop a car) and by periodically returning to and re-photographing the same urban site, he aims for 'complete coverage . . . a methodology to capture a monumental urban transformation under way'.[27] The aim is to construct an encompassing and ever-growing 'pictorial network' to which he will add more images, 'filling in new views'. He imagines a future time in which '[t]hose interested in what happened to our cities will ask to see what happened. They will need pictures showing blocks, buildings, streets – the entire urban landscape' (p. xi). He is confident his photographs can serve as 'fragments from which we can imaginatively reconstruct lost neighborhoods' (p. xiii).

The most striking images in the book are those composed in time-lapse sequences. These images lend powerful visual support to Vergara's view that 'history reveals itself in layers of development and redevelopment' (p. 29). An excellent example is the sequence focused on 178th Street and Vyse Avenue in the South Bronx, New York City. Across nine photographs, taken between 1980 and 1994, he records the deterioration, abandonment and demolishment of a grand apartment building, the derelict space it stood on, and the building of townhouses on the site. The first photograph of the sequence shows us children and adults seated on the spacious steps and balustrade and walking in the courtyard of the building. The next three photographs chart the deterioration of the building, show-ing bricked up windows on the ground floor, broken windows on floors above, and a breeze brick wall built on and around the balustrade. The next two photographs show the building disappearing, in the first only a small corner remains, in the second it is gone from view entirely and only some scattered rubble remains as a physical reminder that it had once stood on this site. The next two pho-tographs show the arrival and erection of the predesigned wooden houses. The final photograph shows the town houses in their com-pleted state, with a small lawn in front surrounded by iron fencing. This is a fascinating documentary supplement and challenge to the all too abstract usage and connotations of the term 'redevelopment' in public discourses about the city. Viewed as a sequence these images take on the force of a chronicle, depicting the changes in one

urban place over time while prompting us to question the progressive nature of redevelopment through the discontinuity of the physical spaces we look at.

Other sequences have a similar cumulative power to represent the dynamics of spatial production and deterioration. Many of them do not depict the redevelopment of ghetto spaces but their decay into waste or semi-natural spaces. An effective example is the sequence focused on New Street and Newark Street, Central Ward, Newark. In four photographs, over a period of fourteen years, we move from a depiction of three ill-kempt but seemingly occupied row houses (of the type built for blue-collar workers at the turn of the century) to an empty lot covered in vegetation, surrounded by a chain fence and overhung by a floodlamp. There are many other images in the book of vegetation growing in derelict spaces or abandoned buildings. The presence of vegetation is figured by Vergara as a 'return to wilderness' signifying social forms of neglect. The sequences that culminate in waste or semi-natural space just like those which depict redevelopment have an affective impact as images of loss. With each successive image our eye is drawn to what is absent, to what can no longer be seen but which we can confirm was once there by looking at previous images. Through such sequences Vergara is using photography to prolong that which has been; in other words, he is trying to circumvent the common correspondence of photography with the instant, the fleeting moment. The results are often remarkable in their combinations of reality effect and aesthetic metaphorisation. At one level of connotation the photographic sequences produce a manifest imagery of the ghetto that appears symptomatic of local spatial production; at another level it is more suggestively anamorphic as the representation of absence propels consideration of the spatio-temporal dimensions of urban decline beyond the place in the frame of the photograph.

Because the photographs take on elements of narrative form through temporal sequencing the space between the images in sequence act as invitations (though these are all too frequently troubled by Vergara's intervening text) to the viewer to fill in the narrative in ways that reimagine the urban continuities and contexts of experience now lost. Through its attempt to restore time to representations of the production of ghetto space Vergara's photography brings a fresh visibility to meanings of urban 'decline' as signified by the postindustrial ghetto. By positing traces of historicity in the sequences he shows the viewer that the development of the new American ghetto is not a temporary aberration. As Witold Rybczynski notes in

his review of *The New American Ghetto*, 'Vergara's book forces us to confront the incontrovertible fact of the ghetto, and to recognise its immensity, its pervasiveness, and its longevity'.[28]

A further grouping of images, only a few of which are sequenced, evokes a different structure of feeling – not loss, but fear – as Vergara records ways in which fortification has become a common feature of ghetto building. Echoing Mike Davis, he writes:

Fortification epitomises the ghetto in America today. . . . Buildings grow claws and spikes; their entrances acquire metal plates; their roofs get fenced in and any additional openings are sealed, cutting down on light and ventilation. . . . Neighborhoods are replaced with a random assortment of isolated bunkers, structures that increasingly resemble jails or power stations; their interiors effectively separated from the outside. . . . In brick and cinder block and sharpened metal, inequality takes material form. (p. 102)

Vergara produces many images in support of this analysis. The sequences move from photographs relatively open to an exterior world to photographs of the same building some years later, now sealed off from the exterior. In these sequences and in many single images he draws particular attention to the fortification of 'public' buildings – churches, post offices, libraries, hospitals, family centres, colleges, day-care and senior citizens' centres – and thereby shows us ways in which what might once have been thought of as public space is now divisioned, militarised and defended through an architecture of fear. The photographs of fenced-, wired- and bricked-off spaces not only emphasises feelings of fear and insecurity within the ghetto, but also revises the stereotypical media representation of the postindustrial ghetto as an object of fear for those outside of it.

There are many further rich conjunctions of images in *The New American Ghetto*, including derelict factories, graffitied walls, street dogs, new uses for abandoned bank buildings, street memorials, store front churches, play areas for children and methadone clinics. As noted above, Vergara aims at a 'complete coverage' of urban transformation as it has occurred within the spaces of the postindustrial ghetto. However, this urge to completion betrays a totalising vision of the ghetto that in practice, through his photography, undermines his stated desire to 'promote social change'. Vergara's totalising vision is evident not only through his methodology but through technical and perspectival features of his practice. He comments on technique: 'I have tried to produce photographs storing the maximum possible information. . . . To get clear, readable, and stable images I

use Kodakchrome 64, perspective corrective lenses, high shutter speeds, and avoid dark shadows' (p. xiii). In these ways he presumes not only to produce stable images but images which avoid the distortions of 'dramatic' street photographs which he believes 'shape more than record reality' (p. xv). The result is indeed often one of clarity, but only in the technical sense of composition, lighting and reproduction. Vergara presumes to offer another form of clarity, a clarity of insight and understanding of the conditions of poverty in the ghetto. He expects this clarity to be yet further enhanced by perspective, particularly through his practice of taking photographs from high points in the environment (a practice partly due to his 'concern for security' (p. 38) in ghetto spaces). In his preface he comments, 'This new perspective, from above, helped me in my goal of achieving more complete and clearer documentation' (p. xiii), and later he argues that a 'lofty viewpoint directs our attention to the built environment. Removed from people, their voices and facial expressions, we can concentrate on the form of those communities' (p. 29). This distancing or erasure of the human subject, when considered in relation to the desires for complete coverage and a view from on high, present a clarity of vision which is imperial in relation to its subject matter. Vergara's is a cold, omnipotent eye surveying the 'physical environment of destitution' (p. 7). In his desire for clarity he registers a common urge to make urban space legible, but the photographic results are not nearly as transparent as he would have us believe.

Because we are 'removed from people' in Vergara's photographs he avoids some of the problems dogging photojournalists who focus closely on the embodiment of poverty, especially those that focus issues of behaviour and social dysfunctionality. However, the absence or distanced presence of the human subject in his photographs introduces fresh problems concerning race, poverty and representation in photographing ghetto spaces. In a photograph titled 'Cooling Off', shot at street level, children play in the water gushing from a hydrant outside the Robert Taylor Homes in Chicago. While the play of the children and the title caption might suggest some element of pleasure the photograph more powerfully draws our eye to the looming, alienating project high-rises which are in the background of the image yet fill most of it. Above the children stands an arcing streetlight further bounding their space in the image, dwarfing them in the limited foreground of the frame. Another photograph of children playing is titled 'Cement, graffiti, and bundled-up children' and the setting is a school in the south Bronx. This photograph is taken from above the

playground and works to suggest a metonymic relationship between the titled elements. With facial features distanced and bodies truncated by perspective the children can only appear as 'bundled-up' forms; set against and within the framing ground of cement and graffiti they are abstracted as a palette of colours. These photographs, like so many that do not include human subjects, accentuate the physical forms of the environment in ways which leave no room (unlike some of the time-lapse sequences) for the viewer to imagine community or the lived experience of place.

When Vergara tells his reader he wants to record 'the experience of living on the other side' of the ghetto boundaries we have to pause to wonder what constitutes 'experience' in the absence of subjectivity? More pointedly, we can ask: what is the role of race in this recording of experience. One of the most remarkable features of Vergara's text is its near silence on issues of race, even as he depicts black bodies at a distance or shows us images of recognisably black ghetto culture (such as church store fronts, or murals). The black ghetto inhabitants are rendered either invisible or marginal in their own social spaces; they are not shown as social beings, while their environment is shown to lack 'normal' services, amenities and accoutrements. To be sure, Vergara is to the point in telling the reader his work is directed 'to those unfamiliar with the ghetto' (p. 9), but at no point does he recognise this unfamiliarity as a racial issue. The black inhabitants of the ghetto are bracketed off from history even as Vergara works to effect recognition on the part of the viewer of historical change over time in the fabric of the environment. It is race as well as poverty that structures and informs the absences between photographs in the time-lapse sequences, but Vergara prefers only to draw our attention to the latter. Black people can only appear in his photographs as passive metonyms of an asocial lumpenisation: the underclass.

Vergara's fascination with the ghetto as a space of decay and ruin is evident throughout his book. At one level this interest is allied with his efforts at consciousness-raising as he believes that the ruined physical environment of the ghetto is both a repository of memory for those who live(d) there and a mirror of memory for a nation which 'leads the world in urban ruins' (p. 201) but refuses to acknowledge their historical meanings and consequences. Vergara's views on the myopic American approach to urban ruins offer some stimulating thoughts on the meaning of urban decline as physical decay:

Increasingly, ruins herald the coming of the post-urban era. The world economy has by-passed many American cities. Contradicting a long-held

vision of our country as a place of endless progress, ruins were unforeseen and then often denied, but surely they are here to stay and spread, leaving us with the question of what things mean when they are no longer used. (p. 205)

This is indeed an increasingly urgent question, but perhaps even more urgent is the question of what *people* mean when they are no longer used. Vergara may be said to be trying to re-enchant ghetto spaces (as sites of memory and ruin) through his photography, but he does so at the expense of the people who inhabit them. Absence, abandonment, dereliction, waste, decay, ruin – these are the metaphorical motivations of re-enchantment his photographs evince. Human poverty is represented as environmental decay.

We recall that the metaphor of decay appears in Alex Kotlowitz's *There Are No Children Here* where the author occasionally allows it to stand in place of social analysis, as with the following passage:

Sometimes at Henry Horner you can almost smell the arrival of death. It is the odor of foot-deep pools of water that, formed from draining fire hydrants, became fetid in the summer sun. It is the stink of urine puddles in the stairwell corners and of soiled diapers dumped in the grass. It is the stench of a maggot-infested cat carcass lying in a vacant apartment and the rotting food in the overturned trash bins. It is, in short, the collected scents of summer. (p. 45)

Despite the ironic lyricism of his ghetto pastoral motif, Kotlowitz echoes the metaphorisation of urban decay that already widely represents the underclass condition in stereotypical terms. In *The New American Ghetto* decay becomes an over-determined metaphor for underclass life. The barely visible black bodies occupying the ruins of the ghetto are ultimately dehistoricised, locked out of history by Vergara's photographic practice. Decay connotes a natural environmental process that even his sequencing is unable to temporalise as a historical and social one. The move from culture to nature (quite literally in many photographs of vegetation) is emblematic of Vergara's propensity to elide human subjectivity in his images and ignore the ontological and experiential dimensions of black subjectivity in particular.

Vergara's vision of the new American ghetto is not only imperial it is also romantic and aesthetic. Toward the end of the book he comments: 'America does not share Europe's respect for ruins. From a distance they are perceived as messengers of bad news' (p. 197), and later muses that 'it will be a long time before we can look upon [ghetto]

ruins with anything resembling appreciation' (p. 205). But 'apprecia-
tion' is precisely the category of aesthetic apprehension Vergara dis-
plays toward the ghetto in his photographs. His 'clarity' of vision
finds the 'picturesque' (p. 216) in ravaged urban forms, while his
sense of loss suffuses his images and text with melancholic rumina-
tions on ruin. This melancholia is a form of modernist nostalgia,
which is further signified by his appreciation of the photograph as a
'fragment' of a lost wholeness, and his effort to restore time to the
image. Both the melancholia and the mastery of vision in Vergara's
photographs signal his modernist sensibility. The totalising ambition
of his project sets it apart from much contemporary urban photography,
yet also relocates it within high modernist aesthetics. His gaze is not
predatory nor invasive in the way much street photography is, but it
is nonetheless colonising, a form of surveillance which makes the
ghetto legible to those beyond its boundaries.

Vergara's nostalgia for ruins is nowhere more evident, nor more
absurd, than in the proposal he puts forward at the end of his book.
Contemplating the intensive physical deterioration of Detroit's
downtown area, and especially its pre-Depression skyscrapers, he
writes: 'I propose that as a tonic for our imaginations, as a call for
renewal, as a place within our national memory, a dozen city blocks
of pre-Depression skyscrapers should be left standing as ruins: an
American Acropolis' (p. 215). He adds: 'we could transform the
nearly one hundred troubled buildings into a grand national historic
park of play and wonder, an urban Monument Valley' (p. 220). The
proposal is clearly intended to elicit discussion if not outrage – not
surprisingly, it received a good deal of negative reporting in Detroit.
Even in his text Vergara comments on several negative views on this
proposal before the book was published, but puts these aside to insist
that 'a memorial to a disappearing urban civilization is a realistic
alternative' (pp. 223–4) to rasing the skyscrapers. I believe his pro-
posal is seriously intended for it is entirely consonant with the
nostalgia and romanticism of his photographic practice. The proposal
also signals another twist in his confused treatment of race, poverty
and the physical environment of the ghetto. Once again people are
rendered invisible in this museum of ruins, but now the space of the
ghetto has been displaced onto a whole downtown area that is not
conventionally understood as a ghetto space. This symbolic dis-
placement casually conflates race and abandonment as key signifiers
of contemporary Detroit (a city economically and socially devastated
by capital withdrawal and white flight) to imply that the city is
one huge ghetto space. This conflation echoes with other aspects of

Vergara's troubled representation of race and urban space and leads us to ask: who, as well as what, is being memorialised through his photographs? The pre-Depression skyscrapers, like the buildings referred to above in the sequences set in the Bronx and Newark, were built by and for white capital and labour. They are now occupied or associated with black lack of capital and labour. Who and what have been/is lost in and through Vergara's photography? Are the photographs and the Detroit proposal memorialising the black spaces of the present or a lost urban civilization of the white past? Whose memory can re-enchant and redeem the spaces of the contemporary ghetto?

I doubt Vergara knows the answers to these questions, so deeply muddled are his romantic and social visions. In some compelling ways his photographs do challenge mass media representations of the postindustrial ghetto (especially through his use of time-lapse sequences where we are at least encouraged to bring time and history into a conventionally dehistoricised space). But his aesthetic valorisation of ruin and decay ultimately presents the ghetto as a 'pictorial network' of singular images that allow sensations of wonder and loss to diminish the urge to social action he periodically calls for. One reviewer of *The New American Ghetto* commends Vergara for avoiding 'photojournalistic cliche' and comments: 'In all, it's an unlikely coffee-table book'.[29] Vergara does indeed avoid some of the cliches of street photography, but he replaces them with cliches of modernist aestheticism and produces a text which in lavish design, layout, and compelling images of ruin in the world of others is very much a coffee-table book. While there is the promise in *The New American Ghetto* of a public chronicle of urban change, the result is a work of art.

THE NEW GHETTO CINEMA: *BOYZ N THE HOOD* AND *JUST ANOTHER GIRL ON THE IRT*

As we have seen, visual representations of the black poor are not innocent mirrors of reality, but rather selective frameworks of interpretation formed by ideological premises and drawing on established codes and conventions of representation. In turning to analysis of cinematic treatments of the postindustrial ghetto by black filmmakers we encounter representations which exist in critical tension with the long-established 'grammar of race' in American cinema. This grammar most generally functions to represent black people as a 'problem' and race relations as a sphere of conflict. More specifically, Manthia

Diawara argues, Hollywood cinema has developed this grammar to fix 'Black people within certain spaces . . . on the screen'.[30] He refers to the visual association of black people with selected private and public spaces, their restricted repertoire of activities within these, and their positioning as secondary or supporting characters within the film text. Black filmmakers have long sought to present alternative representations of blackness, which are not defined by this grammar. For many years the most challenging and innovative black filmmaking has been in independent cinema, perhaps not surprisingly given the lack of opportunity in Hollywood for black filmmakers. In the last ten years, though, there has been an extraordinary growth of black-directed films within the Hollywood system, with many of these focused on black ghetto life. While the very centring of black ghetto culture in film narrative does signify a challenge to the dominant Hollywood system of racial representation it has also been subject to critical debate as a focal point for issues of gender, class and nationalism within black popular culture.

The debate has been most heated around the representation of black culture in the 'ghettocentric' films of the 'new black wave', which emerged in the early 1990s. This cinema – most notably represented by *Boyz N the Hood* (1991), *Straight Out of Brooklyn* (1991), *New Jack City* (1991), *Juice* (1992) and *Menace II Society* (1993) – both responded to contemporary contexts and issues of black inner-city life and struggled to articulate an image of blackness not conducive to stereotyped understanding by white audiences. The directors of these films regularly spoke of their intent to address social ills (an aim often signified within the films by the use of documentary aesthetics) and challenge mass media representations of black culture. As many critics noted, though, this cinema greatly favoured representation of urban poverty in tandem with images of crime, delinquency and violent masculinity. Some commentators attacked it as an irresponsible treatment of black urban life, arguing it nurtured black nihilism, reinforced white resentment and 'corroborate[d] rather than critique[d] mainstream mass media'.[31] However, such attacks greatly simplify the representational politics involved in the production and viewing of these films and ignore ways in which film acts as a site for not only the reproduction but also the contestation and transformation of racial meaning. These films deliver conflicted and complicated meanings about the postindustrial ghetto experiences of African-Americans. Whatever the intentions of their makers the films are, as Ed Guerrero proposes, 'vehicles through which society's racial contradictions, injustices, and failed policies are mediated'.[32]

The ghettocentric films emerged precisely at the time when the myth of the underclass was becoming widely popularised and the postindustrial ghetto was taking on familiar features in the mass media. For Hollywood, the black inner city and its stereotyped inhabitants became a prime site for exploitation within a new black cinema with 'cross-over' appeal. As a source of voyeuristic pleasures within conventional generic structures – most commonly those utilising action and coming-of-age scenarios – the ghetto could stimulate white fascination with black street culture without making the white audience uneasy. The imperatives of crossover appeal meant that black filmmakers had to map a ghetto imaginary attractive to black and white audiences. At the same time, though, black filmmakers working within the Hollywood system of representation were concerned to register forms of critical inquiry in their films about the socio-economic conditions of ghetto existence for African-Americans. Black filmmakers (not for the first time) had to balance issues of integrity and representation, aesthetic and economic imperatives, in relation to their ghetto subject matter within an institutional system of cinematic production they did not control. The resulting tensions are evident in the films, as efforts to critique racism are blurred by spectacular displays of black-on-black violence or other forms of autodestruction. A curious admixture of pleasure and pathology attends some of these films which are rarely unified in their visions of postindustrial ghetto life.

As well as having a strong narrative focus on the dislocated lives of young black (usually male) inhabitants of the ghetto, these films also have common geographic and spatial features that characterise the boundaries and environment of the 'hood'. The hood of these films tends to denote a particular geographical setting – often Harlem or Brooklyn in New York, South Central or Watts in Los Angeles – and an imaginary environment of black cultural difference. The hood is also a spatial construct of power and knowledge and the spatiality of social relations and of character psychology is often symbolised by the pressures of confinement and the desires to escape the ghetto. In their elaboration of the ghetto as a carceral space (imaging the disciplining effects of this on black bodies and minds) these films foreground generative relations of space and identity which reflect both physical and psychological forms of containment. The redemptive urge to escape the ghetto is a common narrative device, triggering many tensions and often violence between characters in the films. Within these tensions the films often generate confused messages about issues of choice or responsibility facing their characters, and

about the relationship of the individual to family and community. For the purposes of analysis here I want to look in a little detail at two films which engage many of the issues above but do so with different aims, emphases and results. The first, *Boyz N the Hood*, directed by John Singleton, is centred on black male experiences and set in South Central Los Angeles. The second, *Just Another Girl on the IRT* (1992), directed by Leslie Harris, is centred on black female experiences and set in Brooklyn, New York.[33]

Boyz N the Hood is framed as a realist narrative of the life experiences of young black males in South Central. Like many contemporary black films it makes overt reference to sociological realities. The film begins with the statement: 'One out of every twenty-one black American males will be murdered in their lifetime. Most will die at the hands of another black male'. This statement stands as a disturbing preface to the film narrative, which will provide some insight into the urban realities underlying the statistics. *Boyz N the Hood* is a coming-of-age drama depicting the lives of three young black males as they encounter a range of social pressures. Friendship, sexuality and parenting are key indices of their growth into manhood in the context of a black neighbourhood exposed to internal and external forces of violence. At the centre of the narrative is Tre Styles who at the beginning of the film is a young boy living with his mother. Fearing the results of Tre's continued exposure to violence Tre's mother takes him to live with his father Furious Styles, telling Furious 'I can't teach him how to be a man, that's your job'. The greater part of the film is taken up with the later teenage years of Tre and two friends, the half-brothers Ricky and Doughboy.

Utilising a fairly conventional rite-of-passage narrative structure *Boyz N the Hood* embeds this in a culturally detailed black urban milieu and uses it as a vehicle for pointed commentary on oppressive conditions of inner-city life. One of the most notable features of the film is its close attention to the iconography and boundaries of urban spaces. The sense of psychic oppression felt by the characters is reflected in the signs of urban surveillance and confinement that recur within the film. (One of the most obvious signs is the noise of police helicopters heard throughout the film although they are never seen.) The struggle for control of the hood dramatises not only the violence but also the micropolitics of racial formation in urban space. The opening scenes of the film offer a distinctive treatment of relations between space, power and knowledge. As the children walk along the street we notice the effusion of signs around them – Stop, One Way, LAPD, Police Line Do Not Cross – all directing or

prohibiting movement. As they cross the police line at the scene of a murder this is clearly symbolised as a transgressive act. At one level of connotation this is the common act of children keen to see what they are not supposed to see, but the universality of this act is rendered racially specific by the location, the image of violent death and the responses of the children. We realise that this is not an uncommon sight for children growing up in this neighbourhood and what we are witnessing is a scene of everyday street education for these children (this is reinforced by the cut which moves us from this scene to the children's schoolroom). It is, moreover, a lesson in ghetto living which is symbolically associated with the exterior power of an oppressive white world, as the bullet-riddled poster of President Reagan overlooking the scene of violent death suggests. What these opening scenes highlight with a striking visual economy is the encoding of epistemological registers of racial identity in urban space. The children are learning to 'know their (racial) place' in a manner that is doubly determined: knowledge of geographic location *and* of social positioning.[34]

The idea of knowing one's place is also fashioned as a trope of male authority in the film. Tre's father Furious is a model of black male parenting, combining discipline, knowledge and compassion in his treatment of Tre. Furious counsels his son on sexuality, violence, drugs and racial conflict, and sets an example with his powerful sense of self-possession and self-respect. While this model of fatherhood is primarily focused on educating Tre for survival in the neighbourhood it also teaches him how to best know his place in a racist society and develop a sense of responsibility to the black community. Perhaps the most didactic example of this teaching is Furious' set-piece speech on the threats of real estate appropriation of black neighbourhood spaces. Furious, who is a financial adviser within the neighbourhood, drives the three teenagers to Compton, an even more deeply immiserated black area than the one in which they live. Pointing to a sign advertising 'Cash for your home' he states 'It's the nineties and this is gentrification. That's what happens when the property value of a certain place is brought down. [They] buy the land at a lower price, move all the people out and raise the property values'. He goes on to give further examples of how the ghetto is controlled from without and concludes 'keep everything black in our neighbourhoods'. The didacticism of Furious' speech may jar the realist illusion of the film but it is nonetheless congruent with its overall emphasis on the struggle for control of black neighbourhoods and lives. Perhaps a deeper irony in the presentation of Furious' ideological commitment

to the neighbourhood is that his teachings better prepare Tre for leaving the ghetto space his father is so committed to defending. The questions of responsibility he introduces are glossed by Tre's preparation to leave for university in Atlanta at the end of the film.

As many critics have noted, its privileging of male authority skews *Boyz N the Hood's* representation of black parenting. Director John Singleton has made his intentions clear in several interviews, describing his film as a plea for 'African American men to take more responsibility for raising their children, especially the boys'.[35] Black film critics have expressed divergent opinions on the merits of this plea. Michael E. Dyson congratulates Singleton on presenting 'a stunning vision of black male pain and possibility in a catastrophic community'.[36] Michele Wallace, on the other hand, charges that the film confirms 'hegemonic family values' and demonises 'black single mothers'.[37] Such difference of view and emphasis in black film criticism is in many ways a necessary one, opening up debate not only on such films as *Boyz N the Hood* but on the social conditions the film represents. Its sexual politics notwithstanding *Boyz N the Hood* has an original force in its demythologisation of conventional images of life in South Central and its detailed and complex portrait of black male experiences.

Black womanhood rather than manhood is director Leslie Harris' focus in *Just Another Girl on the IRT*. Harris is very conscious of the marginality of black women in black films and cites this as a motivating force in making *Just Another Girl on the IRT*. She says:

I hadn't seen realistic images of myself in film. There have been films made from an African American male perspective about African American males coming of age. The women in those films are just hanging off some guy's arm. I wanted to make a film from the perspective of a 17-year-old at the crossroads. I'd see these teenage women on the subway and I'd want to follow them home and show them as they are – with all their energy and all their faults and flaws.[38]

As these comments suggest *Just Another Girl on the IRT* is a coming-of-age film with a strong realist impulse. The same might be said of *Boyz N the Hood*, of course, but there are significant differences between these films, differences in style, sexual politics and interpretations of urban blackness.

Just Another Girl on the IRT tells the story of 17-year-old Chantel who lives in the Brooklyn projects. Chantel has intelligence and attitude to burn (Ariyan Johnson portrays her with terrific energy on

screen) and boldly states her determination to finish high school early, go to college and become a doctor. Her plans are seriously threatened when she becomes pregnant. Deeply confused by her pregnancy and unable to make decisions about abortion and adoption she becomes estranged from her boyfriend Ty and conceals her pregnancy from family and friends. At the end of the film, as she meets Ty again, she gives birth prematurely. Terrified, she instructs Ty to hide her baby in a rubbish bin. Ty initially does this but changes his mind and brings the baby back to Chantel. The film closes on a scene depicting Chantel with her infant one year later walking around a community college.

The sociological subtext of the film is readily apparent. It clearly addresses the subject of black teenage pregnancy in the ghetto. More particularly the film responds to contemporary interest in media stories of 'babies having babies' and reports of newborns found in garbage.[39] *Just Another Girl on the IRT* counters such stories by showing us how a young black woman might reach the point of rejecting her child. But the film is not only demythologising in this way and not simply addressed to a white audience. Harris wants to tell a story that will reach black teenage women and her film contains messages very clearly directed at them. The most obvious of these, and the most didactic, are contained in scenes that show Chantel visiting a clinic and then a welfare office. In the clinic Chantel talks to a counsellor (Paula):

C: What about an abortion?
P: We're a federally funded clinic, I can't give out that information.
C: I want to find out about an abortion, it's my decision, not the fucking government's.
P: I think you should have the right to but I'm breaking the rules just talking about it.

In the welfare office Chantel is dealt with much more brusquely and simply informed 'Your household income is too much, you can't get welfare'. In these scenes Harris is very directly sending information to teenage black women in her audience.

The mixed messages of the film tied to the image of an intelligent and ambitious young black woman brought a good deal of criticism. The film was widely described as 'inconsistent', 'didactic' and 'unbelievable'. Some have seen it as a grossly simplistic morality tale while others have charged that it insults the intelligence of lower-class black women.[40] Such criticisms strikingly delimit readings of the film.

The didacticism of *Just Another Girl on the IRT* does not overwhelm Chantel's narrative nor necessarily define what it says about racial identity. We can support this by returning to the opening scenes of the film. What these scenes evidence is that, as in *Boyz N the Hood*, racial identity is bound up with space and place. The sassy self-confidence of Chantel's character is underlined for us by her rapid movement through urban spaces: from the projects, onto the train, and along the streets of West Side Manhattan to the shop in which she works part time. Her mobility signifies a degree of autonomy and freedom both within and beyond her neighbourhood. She is not defined or confined by her neighbourhood nor deeply alienated from the world beyond the projects; she is both a tough 'Brooklyn girl' and a worker and consumer in other urban spaces. To be sure, part of the film's critical function is to challenge Chantel's sense of autonomy when she becomes pregnant. In some respects she fails to meet this challenge as she goes into deep denial about her condition. However, this denial does not render her sense of autonomy a useless illusion even as it does challenge her capacity for self-invention. Chantel's trauma, as much as the pleasures and desires we see depicted in the opening scenes, is socially formed in response to multiple registers of black identity and self-knowledge. Her learning process does not end with giving birth. In the final shot of the film, as she walks around the college with her infant, she looks straight to camera and says 'we're getting our shit together'.

Just Another Girl on the IRT, like *Boyz N the Hood*, is about knowing one's racial place, a coming-of-age story which links knowledge, space and empowerment as a complex network of forces in racial identity formation. Where the films most significantly differ is in their representation of sexual politics and their treatment of the spatial and epistemological boundaries of black identity. The black post-nationalism of *Boyz N the Hood*, most potently imaged in Furious Styles' patriarchal authority, privileges a specific location – the hood – as the essential site of blackness. In contrast *Just Another Girl on the IRT* focuses attention on how a black identity is negotiated between and across locations and is not fixed by concepts of family or community. This is not to say that the film ignores issues of family and community but it emphasises what Paul Gilroy has described as 'a view of identity as an ongoing process of self-making' and refuses to posit an essential black subject.[41]

I do not mean to privilege one film over the other, only to highlight varied forms of representation *within* black film treatments of post-industrial ghetto life (and attendant criticisms of them). Both films

attest to the diversity, not the homogeneity, of urban black experience and challenge naturalised Hollywood (and wider media) representations of this experience. Moreover, both films do this in provocative ways; they are not content with only challenging stereotypes or with depicting 'positive images' as a sop to white viewers. They allude to the failings of public institutions, such as schooling, healthcare and policing as factors delimiting opportunities for black youth. They present black ghetto life as a culture in which familial, sexual and gender relations are not 'a tangle of pathology' but formative social processes shaped by material and intellectual location. These processes may be at a point of crisis today – many black intellectuals argue that they are – and filmic representations will continue to play a role in defining the meanings of this crisis. Black filmmaking constitutes only one small part of the larger system of media representations of ghetto spaces, but it exists in a productive critical tension with this system, both reproducing and transforming visual relations between race and the city.

Though new wave black filmmakers produce mixed messages about underclass life they work with the knowledge that the postindustrial ghetto has become an important site in struggles over representations and meanings of race in the 1990s. The ghetto may be economically marginal, but it is culturally central in popular representations of American urbanism. While the black ghetto may be 'repudiated as a site of abjection', Gitanjali Maharaj argues, 'it is also commodified as a locus of authentic blackness and consumer desire'.[42] White fascination with a street culture associated with the black ghetto suggests both the appeal of the myth of the underclass and the complexities of its relationship to issues of African-American culture and agency. At the same time, producers of black popular culture are uneasily aware of exploiting the imagery of postindustrial ghetto life as symbolic capital and sensitive to criticisms that they may adversely reinforce common perceptions of underclass pathologies. The question of authenticity is a thorny one for black filmmakers – some of whom claim cultural insiderism, while others challenge black essentialism – as is its flip side, the question of responsibility.[43] We will return to these questions in the next chapter in examination of Spike Lee's film *Clockers*.

Questions of authenticity and responsibility shadow all of the texts examined in this chapter, often channelled through the use of documentary modes of representation, which promise an intimate knowledge of the 'real'. None of the texts examined here are definitive representations of the postindustrial ghetto though they all respond

to a new social awareness of its occupants, the black underclass. They seek to provide corrective visions of ghetto life yet remain entangled within broader systems of representation, which powerfully encode common assumptions about correspondences between race, poverty and urban space.

Notes

1. Daniel Moynihan famously described urban black poverty as 'a tangle of pathology'. See Lee Rainwater and William L. Yancey, *The Moynihan Report and the Politics of Controversy* (Cambridge, MA: MIT Press, 1967), pp. 39–125.
2. US National Advisory Commission on Civil Disorders, *The Kerner Report* (New York: Pantheon Books, 1988), pp. 1–2.
3. 'The American Underclass', *Time*, 29 August 1977, p. 4.
4. See William Julius Wilson, *The Truly Disadvantaged: The Inner City, the Underclass, and Public Policy* (Chicago, IL: University of Chicago Press, 1987); Charles Murray, *Losing Ground: American Social Policy, 1950–1980* (New York: Basic Books, 1984); and Lawrence Mead, *Beyond Entitlement: The Social Obligations of Citizenship* (New York: Free Press, 1985).
5. For an incisive critique of the focus of behaviour in discussions of the underclass, see Adolph Reed, Jr., 'The Underclass as Myth and Symbol: The Poverty of Discourse About Poverty', *Radical America* 24 (January 1992), pp. 21–40.
6. Ibid., p. 28.
7. In American television news and documentary representations of the urban black poor there is recurrence of staple images and visual frames which signify social deviancy and dangers. See Herman Gray, *Watching Race: Television and the Struggle for 'Blackness'* (Minneapolis, MN: University of Minnesota Press, 1995).
8. Acclaimed examples include: Daniel Coyle, *Hardball: A Season in the Projects* (New York: Harper, 1995), which tells of the author's experiences coaching a Little League team in the Cabrini Green projects in Chicago; Darcy Frey, *The Last Shot: City Streets, Basketball Dreams* (New York: Houghton Mifflin, 1994), observes the lives of young basketball players in projects in Coney Island; Leon Dash, *Rosa Lee* (New York: Basic Books, 1996) records his intimate observances of the addictions of a black mother of eight children in Washington; and Philippe Bourgeois, *In Search of Respect: Selling Crack in El Barrio* (New York: Cambridge University Press, 1996) is based on the five years the author spent closely observing drug dealers in East Harlem.
9. Alex Kotlowitz, *There Are No Children Here: The Story of Two Boys Growing Up in the Other America* (New York: Doubleday, 1991), p. 307. All further references are given in the text.

10. See Bill Nichols, *Representing Reality: Issues and Concepts in Documentary* (Bloomington, IN: Indiana University Press, 1991).
11. See, for example, Paul Arthur and Janet Cutler, 'On the Rebound: *Hoop Dreams* and Its Discontents', *Cineaste* 21/3 (1995), pp. 22–4.
12. Jack Ketch, 'Beyond the Camera: The Untold Story Behind the Making of *Hoop Dreams*', *The World & I* (October 1995), p. 139.
13. Heralded by *Newsweek* as a 'spellbinding American epic', reviewers treated it as a national story. 'Battered Dreams of Glory', *Newsweek*, 7 October 1994, p. 80. By the time of the film's appearance on video this had become common wisdom, eagerly reflected in the description accompanying the video:

 They have nothing – except talent and a dream – and in this tough Chicago neighborhood, dreams are all they can count on. *Hoop Dreams* is the critically acclaimed true-life story of Arthur Agee and William Gates and the unforgettable five year experience that turns them into men. You will come to know them and root for them as if they were your friends, your family, as against all odds, these boys prove that with faith, talent and a little luck, anyone can achieve the American Dream.

 The description retains traces of documentary's epistemological allure – 'true-life story', '[y]ou will come to know them' – but foregrounds the drama and pleasurable identification of narrative that will be afforded the audience through vicarious pursuit of the Dream.
14. See Darcy Frey, *The Last Shot*, for a journalistic treatment of these issues. For a penetrating academic analysis of transformed meanings of 'play' and 'leisure' in the postindustrial ghetto, see Robin D. G. Kelley, 'Playing For Keeps: Pleasure and Profit on the Postindustrial Playground', in Wahneema Lubiano (ed.), *The House That Race Built* (New York: Random House, 1997), pp. 195–231.
15. On the efforts of the National Basketball Association to display black players as model citizens and surrogate parents, see Gitanjali Maharaj, 'Talking Trash: Late Capitalism, Black (Re)Productivity, and Professional Basketball', *Social Text* 50 (Spring 1997), p. 163.
16. Ibid., p. 159.
17. Kelley, 'Playing for Keeps', p. 198.
18. Stephen Steinberg, quoted in Micaela di Leonardo, *Exotics at Home: Anthropologies, Others, American Modernity* (Chicago, IL: University of Chicago Press, 1998), p. 121.
19. In the early 1970s Susan Sontag produced an influential critique of the act of photography as a powerful appropriation of 'the photographed' that tears it from historical context. Among examples she criticised the work of Walker Evans and other Farm Security Association photographers for composing their share-cropper subjects to support 'their own notions about poverty, despair, exploitation, dignity, light, texture, and space'. Susan Sontag, *On Photography* (London: Penguin, 1979), pp. 30–1. Martha Rosler, in her art as well as her criticism, has explored the murky borders between 'outraged moral sensitivity' and 'slumming spectacle' in photography of the urban poor. Martha Rosler, 'In, Around, and Afterthoughts', in Richard Bolton (ed.), *The Contest of Meaning: Critical Histories of Photography* (Boston, MA: MIT Press, 1989), p. 30.
20. William McGowan, 'Eugene Richards: Social Realist', *CJR* (January/February 1995), p. 43.

21. Vincent Musi, '"Racist" Tag on Richards Won't Hold', *News Photographer* (July 1994), p. 31.
22. Brent Staples, 'Coke Wars', *New York Times Book Review*, 6 February 1994, p. 12.
23. Quoted in Musi, '"Racist" Tag', pp. 30–1.
24. For a trenchant critique of this ideology, see Sontag, *On Photography*, pp. 29–33.
25. Paul A. Rogers, 'Hard Core Poverty', in Deborah Willis (ed.), *Picturing Us: African American Identity in Photography* (New York: The New Press, 1994), p. 161.
26. Rob Walker, 'A Cold Eye', *New York*, 22 April 1996, p. 46.
27. Camilo José Vergara, *The New American Ghetto* (New Brunswick: Rutgers University Press, 1997), p. x.
28. Witold Rybczynski, 'Losers', *The New York Review of Books*, 31 October 1996, p. 35.
29. Walker, 'A Cold Eye', p. 47.
30. Manthia Diawara (ed.), *Black American Cinema* (London: Routledge, 1993), p. 3.
31. Cameron McCarthy, Alicia P. Rodriguez, Ed Buendia, Shuaib Meacham, Stephen David, Heriberto Godina, K. E. Supruja and Carrie Wilson-Brown, 'Danger in the Safety Zone: Notes on Race, Resentment, and the Discourse of Crime, Violence and Suburban Security', *Cultural Studies* 11/2 (1997), pp. 278–90.
32. Ed Guerrero, *Framing Blackness: The African-American Image in Film* (Philadelphia, PA: Temple University Press, 1993), p. 189.
33. There are notable differences between these texts in terms of production: *Boyz N the Hood* is a well-funded Hollywood (Columbia) film; *Just Another Girl on the IRT* is independently produced. However, I do not want to suggest simple binary differences between mainstream and independent sectors. While these are in many ways discreet and recognisable sectors they are not autonomous and there are points of convergent influence and interest. A Hollywood/independent opposition can be very misleading, particularly if it posits a model of dominant/oppositional filmmaking. Unfortunately, it does provide a rough guide to gendered divisions in black filmmaking. While Hollywood opened some doors for black filmmakers in the 1990s the great majority were male. Black female directors have remained more populous in independent cinema.
34. See David Theo Goldberg, '"Polluting the Body Politic": Racist Discourse and Urban Location', in Malcolm Cross and Michael Keith (eds), *Racism, the City and the State* (London: Routledge, 1993), pp. 45–60.
35. Quoted in Mark Kermode's review of *Boyz N the Hood*, *Sight and Sound* 1 (November 1991), pp. 37–8.
36. Michael Eric Dyson, 'Between Apocalypse and Redemption: John Singleton's *Boyz N the Hood*', in Jim Collins, Hilary Radner and Ava Preacher Collins (eds), *Film Theory Goes to the Movies* (London: Routledge, 1993), p. 213. Dyson does not uncritically celebrate the film and acknowledges that Singleton does not really challenge 'the logic that at least implicitly blames single black women for the plight of black children' (p. 221).
37. Michelle Wallace, '*Boyz N the Hood* and *Jungle Fever*', in Gina Dent (ed.), *Black Popular Culture* (Seattle, WA: Bay Press, 1992), pp. 123–5.

38. Quoted in Amy Taubin, 'Girl N' the Hood', *Sight and Sound* 3 (August 1993), pp. 16–17.
39. Ibid.
40. See, for example, Michelle Wallace, 'The Search for the "Good Enough" Mammy: Multiculturalism, Popular Culture, and Psychoanalysis', in David Theo Goldberg (ed.), *Multiculturalism: A Critical Reader* (Oxford: Blackwell, 1994), pp. 265–6; and bell hooks, *Outlaw Culture: Resisting Representations* (London: Routledge, 1994), p. 46.
41. Paul Gilroy, 'It's a Family Affair', in Dent, *Black Popular Culture*, p. 311.
42. Maharaj, 'Talking Trash', p. 158.
43. For commentary on 'the authenticity impasse' surrounding ghetto action films in particular, see S. Craig Watkins, *Representing: Hip Hop Culture and the Production of Black Cinema* (Chicago, IL: University of Chicago Press, 1998), pp. 226–31.

Spatial Justice

Race and criminality have long been intertwined in perceptions of the American city. When media images and narratives of urban crime and violence are fused with race the results are often generic and stereotyped representations, condensing the discourse of urban decline and mystifying the social and economic conditions of urban transformation. Commenting on the racialisation of urban criminality in the context of 'the urban crisis' of the late 1960s, Carlo Rotella argues that the language of crisis compressed and simplified the meanings of criminal violence:

In addition to commanding attention in its own right, explicitly racial violence (like the 'race riot') and racially coded violence (in common usage after about 1960, the figure of 'the mugger' is implicitly assumed to be black or Hispanic) became rubrics under which to reduce the complexity of urban transformation to sharply representable and narratable form.[1]

Racial paranoia concerning criminality has continued since this period to shape representations of and responses to the socio-spatial restructuring of American cities. In the mid 1980s, for example, crime and race were potently fused in national media responses to gang culture and in particular the figure of 'the gangbanger' in Los Angeles. In his critical analysis of the policing and press coverage of LA gangs in this period Mike Davis notes that the 'gang scare' became 'a terrain of pseudo-knowledge and fantasy projection'. An intimidating result, he argues, was the criminalisation of 'successive strata of the community' including not just gang members but whole neighbourhoods.[2] Race was rendered legible as a criminalised blackness (metaphorically condensed within the language of policing and 'the war on drugs') became associated with whole territories within the city. The ideological linkage of crime, race and urban space has been

nurtured by numerous media representations and political discourses, surrounding black and white contact in American cities with paranoia and menace. In this chapter I will examine how selected writers and filmmakers have sought to interrogate this linkage through their treatment of crime genres.

Crime genres – for example, gangster films, hard-boiled detective fiction and their *noir* film equivalents, and true crime reporting – have long served to record transformations of American urbanism and attendant shifts in the ethno-racial composition of the city. Though they have recognisable conventions these genres are never static and in the last twenty years there have been notable shifts within and crossovers between genres in representation of race and urban crime. These include inversions and appropriations as black (and Hispanic) writers and filmmakers have produced what were once conventionally coded as white narratives of criminality or policing. These shifts in genre representation in many ways reflect the changing urban order, especially with regard to the different spatial positions occupied by black and white ethnic groups. As with narratives of memory discussed earlier in this study there are strong imaginary investments in the figures of urban cops and criminals as signifiers of ethnic and racial territoriality.

A fascinating example of this shift in representation is the gangster film. Hollywood cinema has long represented the gangster as a quintessential 'man of the city', a product of the violent energies and drives of the urban political economy.[3] More particularly, the Hollywood gangster from the Warner Brothers films of the early 1930s to the 1970s has been almost exclusively depicted as a white ethnic character – invariably Italian- or Irish-American – whose pursuit of success allegorises core American mythologies of individual enterprise and immigrant acculturation. By the 1970s the conventional formulae of the genre seemed almost hollowed out but received a potent imaginative boost with the work of young Italian-American filmmakers, most notably Francis Ford Coppola and Martin Scorsese.[4] Different as their filmmaking techniques are, these filmmakers provided a fresh representation of white ethnic criminality characterised by a self-consciousness about the gangster genre and a nostalgia for a world that was past or fast passing. In other words these filmmakers confronted their ethnic origins at a time when the central city of immigrant settlement and ethnic passage was largely vacated by their ethnic group. The self-consciousness of the filmmaking is expressive of the doubleness of representation we observed in white ethnic fiction of the period: a sense of working in the 'twilight of ethnicity'

to revalorise dissipated cultural referents of group identity. Even this self-consciousness has receded as an imaginative force in more recent years as the white ethnic gangster has become a subject of parodic or comedic effect.[5]

Even as the white ethnic gangster became a focus for ethnic nostalgia in the early 1970s he was superseded by the black gangster, most notably in the genre of 'Blaxploitation'. In films such as *Shaft* (1971), *Sweet Sweetback's Baadassss Song* (1971) and *Superfly* (1972) the black ghetto is represented as a violent space and black men as heroic figures within that space. For all that is excessive in the representations of violence and masculinity in these texts they also function as critical commentaries on American race relations and more particularly the policing of ghettos at the end of the Civil Rights era. In Melvin Van Peebles' *Sweet Sweetback's Baadassss Song*, one of the most overtly political Blaxploitation films, black nationalist ideology frames the film's representation of the pimp-hero to depict him as the product of an oppressed yet self-validating ghetto community. Black audiences were able to take pleasure in such films that showed black men as violent and heroic agents of action, challenging white powers and taking control of urban space.[6] Limited by its formulaic conventions and only briefly supported by Hollywood as a marketable product Blaxploitation soon peaked in the mid 1970s, but the imagery it advanced of ghetto life has had some continuing influence on black film and on rap culture in the United States.

Since the 1970s the gangster genre has been defamiliarised and reinvented within a broader recontextualisation of American crime films influenced by the racial paranoia concerning urban criminality. On the one hand the genre has been fused with that of the *policier* to foreground the figure of the maverick white cop battling both corrupt police departments and racialised street criminality. On the other hand it has been infused with a fresh point of view to produce a more hybrid depiction of the gangster as a liminal figure. The most potent challenge to the iconic figure of the white ethnic gangster appeared in the (re)emergence in the early 1990s of the black gangster in 'ghettocentric' films such as *New Jack City* (1991), *Menace II Society* (1993) and *Deep Cover* (1994). As we saw in the previous chapter of this study, Hollywood's focus on the racialised gangster reflected broader media fascination with the myth of the black underclass. We might simply view this as a cynical move by Hollywood, cashing in on white paranoia about black criminality, but the resulting films (many of them black directed) offer very self-conscious intertextual treatments of the gangster narrative situated in postindustrial ghetto

spaces of New York City and Los Angeles. These films reinscribe the transgressive nature of the conventional gangster figure to accentuate the ways in which race mediates issues of crime, violence, and justice in the black ghetto and positions its underclass inhabitants outside normative notions of what constitutes citizenship. The films variously use the gangster narrative to explore efforts of black protagonists to escape or transcend the physical and psychological forms of containment which characterise representations of ghetto space. While these films produce different and mixed messages about the black urban underworld they also produce critical perspectives on contemporary mystifications about race, class and poverty common to mass media representations of the postindustrial ghetto.

New forms of hybridity and reflexivity are also apparent in crime writing in this period. Within detective fiction, for example, there has been a fresh questioning of the cultural authority of the lone white male detective and of the more general coding of hard-boiled detective fiction as a 'white' genre. A number of authors – among them, Walter Mosley, Sara Paretsky, James Sallis and Alex Abella – have brought distinctive ethnic and racial perspectives to the detective's task of tracing the hidden structures of urban criminality. They have produced critical representations of relations between spatially divided cultures in the city; often, the movement of the detective within urban space has proved an effective barometer of the fear and paranoia surrounding race and crime. The genre of True Crime writing has also metamorphosed to produce popular 'cop shop' narratives which depict the initiation of reporters on the mean streets of American cities. David Simon's *Homicide: A Year on the Killing Streets* (1991) set the standard for many imitators, blending new journalistic techniques and a hard-boiled tone in his narration of the inner lives of Baltimore homicide detectives.[7] Christopher Wilson has argued that the emergence of these narratives 'registered a reshuffling of the *location* of cultural representations of crime in the Reagan-Bush decades', as True Crime entered 'into social terrain where traditional crime journalism now feared to tread'. A significant feature of this writing, as Wilson convincingly illustrates, is its tendency to 'represent policing as the labour of a dedicated, hard-bitten knight of the city, an everyday, man-in-shirtsleeves servant of the mostly white working class'. In other words, they draw attention to the role of cops as surrogate figures of an aggrieved urban class, registering its 'sense of victimisation and powerlessness'.[8]

These brief examples attest to the flexibility of crime genres, their responsiveness to urban transformation and their inscription of par-

ticular structures of feeling identified with specific cultural groups. The variety of genres and representations is such that I have been very selective here in choosing three examples for closer critical analysis: Walter Mosley's novel *Devil in a Blue Dress*; Richard Price's novel *Clockers*; and the film *Clockers*, directed by Spike Lee. All three are inventive treatments of crime genres: Mosley defamiliarises the hard-boiled narrative from a black perspective; Price blends journalistic realism and the form of the detective narrative; and Lee remakes Price's text as a ghettocentric film. All are self-consciously reflexive narratives, registering the rich intertextuality of crime genres. They are also all fired by progressive tendencies, seeking to critically illuminate the conditions of urban criminality as symbolic ground for the understanding of urban race relations.

BLACK *NOIR*: *DEVIL IN A BLUE DRESS*

The streets were dark with something more than night.
(Raymond Chandler)[9]

Why is hard-boiled detective fiction a white genre? With this question I do not mean to suggest that only white writers have worked in the genre, but rather that hard-boiled fiction's most distinctive narrative codes, conventions and characterisations have traditionally been structured around the consciousness of a white subject. In her *Playing in the Dark: Whiteness and the Literary Imagination* Toni Morrison wonders:

whether the major and championed characteristics of our national literature – individualism, masculinity, social engagement versus historical isolation; acute and ambiguous moral problematics; the thematics of innocence coupled with an obsession with figurations of death and hell – are not in fact responses to a dark, abiding, signing Africanist presence.[10]

I want to comment on some general features of whiteness in hard-boiled detective fiction to argue that the genre has traditionally responded to 'a dark . . . Africanist presence' by adopting a parasitic relationship to blackness. These comments will act as a preliminary to my more detailed study of the distinctively black *noir* that characterises the fiction of the African-American writer Walter Mosley.

The racialised constitution of hard-boiled fiction owes a great deal to the historical period of its emergence and its generic links with Western and adventure genres in the United States. The literary origins

of hard-boiled fiction are diverse, and any extensive study of them would have to plot the emergence and reinvention of key elements across nineteenth-century popular literatures. One significant line of development is centred on the myth of democratic heroism, a structural and ideological feature of the frontier romance which is redeployed in later nineteenth-century adventure stories of crime and detection – most notably in the writings of Alan Pinkerton and the 'red-blooded' dime novels of the last quarter of the century – and re-emerges in the 'pulp' fiction of the early twentieth century. Richard Slotkin has argued that the dime novels of the late nineteenth century constructed a formula fiction which fused the figures of the outlaw and the detective to produce heroic detectives who defend 'the progressive social order, but do so *in the style* of the outlaw, always criticising the costs of progress'.[11] In the post-frontier, rapidly modernising America of the early twentieth century this hybrid figure takes on a more complex ideological cast in the role of the hard-boiled detective who is 'both an agent of law and an outlaw who acts outside the structures of legal authority for the sake of personal definition of justice' and who has no clear class position.[12] This hard-boiled hero is invariably represented as a bastard offspring of modernity and democratic individualism. He is at once a liminal, rootless figure – modernist thematics of alienation, homelessness and melancholia recur in the writings – and a democratic anti-hero, a classless and self-reliant man able to traverse disparate areas of American society. This anti-hero reflected many of the social tensions of the 1920s, serving as a populist critic of capitalist powers but also voicing prejudices and fears about racial 'others' at a time of heightened nativism.[13]

The racialisation of hard-boiled detective fiction is not confined to stereotyping, for the presence of race often has a more subtle function in defining the liminal whiteness of the detective hero. It is often noted that as a proto-modernist form hard-boiled fiction renders universal principles of truth and justice subjective and presages moral inquiry as the detective's singular response to the atomised urban scenes of modernity. It is less often noted that the formulation of moral space in hard-boiled fiction privileges a white subject as autonomous agent while devaluing black subjectivity as extrinsic to rights assertion and agency. This devaluation often takes the form of stereotyping, with race ordering conceptions of self and other and categorically rationalising the 'natural' characteristics of black people. But this devaluation is also important as a sign of the white detective's dependency upon racial others. Race functions as a source of

psychological and social fantasy for many hard-boiled writers, with 'blackness' often signifying an otherness within the white subject which requires control and mastery. Sin, lack of reason and absence of discipline not only confront the white detective but are internalised using race as a topos around which images and discourses are organised. In its most simplified form this appears as a juxtaposition of primitive urge and civilising consciousness, but racial signs are everywhere present.[14]

This appropriation of signs of blackness is particularly striking in the urban imaginary of what is variously termed the 'dark street' or 'mean streets' down which the lone detective walks. Raymond Chandler's 'dark street' is a romantic image, a fantasy sphere in which ideas of justice, morality and heroism can be tested out while the psychological focus remains securely on the liminal white subject. The city streets are the site of degeneracy, disorder, lawlessness, and moral corruption, a universalised and fantastical urbanism that elides questions of racial identity. This elision facilitates the white subject's colonisation of social spaces traditionally associated with 'blackness' in American culture and these degenerate and anarchic spaces expressively heighten the white detective's transgressions, providing voyeuristic pleasures for white readers. In *The Dain Curse* (1929) Hammett's Continental Op follows his investigations to 'a Negro neighborhood, which made the getting of reasonably accurate information twice as unlikely as it always was', and Hammett represents this neighbourhood as a 'darktown' of easy criminality and degraded passions.[15] Chandler's *Farewell, My Lovely* (1940) opens with Philip Marlowe's observation 'It was one of the mixed blocks over on Central Avenue, the blocks that are not yet all Negro'. This observation prefaces Marlowe and Moose Malloy's entry into a black club where Moose assaults the bouncer and kills the club manager.[16] In both instances the white detective transgresses race boundaries into what is depicted as alien and degraded urban spaces, to discover an excessive (passionate, violent) difference in blackness. These transgressions stimulate a white imaginary, for these spaces, though geographically specific, are symbolic repositories of white fears and fantasies.

In turning to the work of Walter Mosley I am particularly concerned with narrative representation of space as a modality through which relations of racial domination and subordination are naturalised. Universal norms of justice and rights are qualified and delimited by spatial categories, setting boundaries on recognition of those who are and are not active participants of the civic polis. As David Goldberg

notes: 'Citizens and strangers are controlled through the spatial con-
fines of divided place. These geometries – the spatial categories
through and in which the lived world is largely mapped, experienced,
and disciplined – impose a set of interiorities and exteriorities'.[17]
Spatial categories have a significant presence in hard-boiled fiction
where relations between inside and outside, and between depth and
surface, interact with the primary dialectic of truth and deception. In
classic hard-boiled writings these relations are structured to privilege
the perspective of the white subject as a private eye in public space.
In the hard-boiled writings of Walter Mosley these relations undergo
connotative defamiliarisation and inversion as he plots the urban
scene around the perspective of a black subject.

To understand the significance of the relationship between race
and urban space in Mosley's fiction we need to consider the geo-
graphical and historical setting of his texts. The five hard-boiled
detective novels he has written to date are set in the Watts area of Los
Angeles in the postwar years, and Mosley has very self-consciously
appropriated hard-boiled conventions in order to write a *noir* history
of black life in the city. Los Angeles is a deeply mythologised city
and its mythologists include detective writers and more broadly
those writers and filmmakers associated with *noir*. The category is
often thought of in filmic terms but it has broader cultural resonances,
for, as Mike Davis has argued, *noir* is a complex corpus of literary and
cinematic production, generally focused on unmasking Los Angeles
as a 'bright, guilty place'. By depicting Los Angeles as 'the nightmare
at the terminus of American history', Davis observes, *noir* dystopi-
anisation of the city has developed as a powerful anti-myth countering
'the accumulated ideological capital of the region's boosters'.[18] Black
writers and filmmakers have not figured large in the construction and
maintenance of this anti-myth, but there are dystopian representations
of the city in black culture.

In the early twentieth century, Los Angeles appealed to many
African-Americans as a locus of opportunity, especially during the
boom years of wartime industry, and a place of escape from Jim Crow.
The idea of opportunity is apparent in W. E. B. Du Bois' confident
statement, made in 1913: 'LA is wonderful. Nowhere in the US is the
Negro so well and beautifully housed. . . . Out here in the matchless
Southern California there would seem to be no limit to your oppor-
tunities, your possibilities'.[19] But for many African-Americans Los
Angeles did not prove to be the melting pot under the sun, as oppor-
tunities and possibilities were eclipsed by a climate of unremitting
deprivation and the luxury of space (highlighted by Du Bois) became

an experience of spatial confinement and surveillance. The African-American writer Chester Himes worked in segregated defence plants in Los Angeles during the Second World War and drew on this experience in writing his first novel *If He Hollers Let Him Go* (1945). The novel details the psychological deterioration of Bob Jones, a skilled shipyard worker, under pressures of white racism. Jones has a utopian wish:

I didn't want to be the biggest Negro who ever lived. . . . Because deep inside of me, where the white folks couldn't see, it didn't mean a thing. If you couldn't swing down Hollywood Boulevard and know that you belonged; if you couldn't make a polite pass at Lana Turner at Ciro's without having the gendarmes beat the black off you for getting out of your place . . . being a great big 'Mister' Nigger didn't mean a thing . . . I'd settle for a leaderman job at Atlas Shipyard – if I could be a man, defined by Webster as a male human being. That's all I'd ever wanted – just to be accepted as a man – without ambition, without distinction, either of race, creed, or colour; just a simple Joe walking down an American street.[20]

This utopian wish is articulated in spatial terms: what he yearns for is the freedom to move through urban spaces with a sense of belonging and without a fear of violent attack. The idea of 'getting out of your place' takes on a double meaning, signifying both geographic location and social prohibition. These meanings converge in the spatial metaphor of 'place'. Himes draws attention to relations between 'knowing one's (racial) place' in the city and the social structures of racial space.[21] These relations inform the tensions and ironies of his narrative; the desire to be 'just a simple Joe walking down an American street' is a desire for an invisibility and ordinariness that is associated with white subjects. Knowing one's place is not only a geographic imperative but a racial(ised) one and ultimately an issue of survival for the black subject in a racist society.

The double meanings of knowing one's place are everywhere evident in Walter Mosley's black *noir*. The protagonist of his five detective novels is Easy Rawlins, a migrant from Houston, Texas, who arrives in Los Angeles shortly after the Second World War in which he served in the United States army. The novels – *Devil in a Blue Dress* (1990), *A Red Death* (1991), *White Butterfly* (1992), *Black Betty* (1994) and A Little Yellow Dog (1996) – follow Easy's life in Los Angeles from 1948 to 1961, and Mosley plans several more novels in the series. The development of the series has a strong historical impetus which Mosley terms 'a migration . . . through time'.[22] He begins in

1948 because it was a period of 'absolute possibility' for the Southern blacks who moved to Los Angeles in great number:

they could go get a good job and buy property and live with some measure of equality. So that was the beginning of a period of transition and hope that didn't quite work out. I want to provide a map through the years of how it didn't.[23]

In mapping this failure of promise Mosley blends history and memory to produce a critical perspective on the development of race relations in Los Angeles. His novels look both backwards and forwards from the present tense of narrative time, situating Easy Rawlins in a continuum of black diaspora experiences while distinguishing the particular locale and psychological complexity of his protagonist. In Mosley's words, 'I wanted to talk about [Easy] as this incredible, complex psyche who comes out of the Deep South into LA with all of these hopes and aspirations and what he can and cannot do for both external and internal reasons'.[24] The external and internal registers of possibility and prohibition are socially formed (if not always consciously recognised) and in Mosley's novels it is the shifting relations between and within these registers which impels the psychological drama of Easy's investigations into the meanings of racial difference and identity in Los Angeles.

Although Easy takes on a range of jobs in the novels (gardener, aircraft mechanic, janitor) he finds himself most consistently, if often reluctantly, employed as a private investigator. As he reflects in *White Butterfly*, 'In my time I had done work for the numbers runners, churchgoers, businessmen, and even the police. Somewhere along the line I had slipped into the role of a confidential agent who represented people when the law broke down'.[25] As these comments suggest Easy is within the tradition of the liminal detective hero who operates on the boundaries of the law, but his slippage into this role is notably facilitated by conventional perceptions of black agency and representation. Mosley has observed of his protagonist:

Easy knows how to pay attention to details. He can read the streets as well as a woodsman can read skat. He is educated in the ways of desperation and crime by a lifetime of poverty. Now when Easy gets around white people they may be afraid of him, but they never suspect that he has the smarts of some kind of agent trying to glean their secrets. Turn the coin over: when Easy comes into a bar or church in the Watts community everybody thinks they know by his color that no white man would trust him with a mission. Easy has become invisible by virtue of his skin.[26]

Mosley makes ready use of the trope of invisibility in his novels to explore the meanings of racial difference and identity. In *Devil in a Blue Dress*, Easy reflects on his first experiences of working as a detective: 'Nobody knew what I was up to and that made me sort of invisible; people thought that they saw me but what they really saw was an illusion of me, something that wasn't real'.[27] The disparities between illusion and reality signified by the trope of invisibility are complexly figured throughout the novels to depict a social world in which racial perceptions are rarely stable and invariably infused with issues of power and control. Easy's manipulation of his identity affords him (and ironically parodies) the agent autonomy and freedom of movement traditionally associated with the white detective. Yet Easy's movements through Los Angeles are also constrained by white powers. While his role as a detective broadens possibilities for transgressing established racialised and spatial limits, race nonetheless moulds the boundaries of social identity and mobility.

Devil in a Blue Dress, the novel I will concentrate on here, details Easy's first experience of working as a private investigator. Set in 1948, it introduces Easy at a point when he has been recently fired by his employer, Champion Aircraft, and is worried about defaulting on the mortgage for his small house in Watts. The investigative narrative is initiated when he is hired by a white gangster to search for a woman named Daphne Monet, a central figure in a local political conspiracy. Easy's search for Daphne takes him on a journey through diverse social spaces in Los Angeles and into conflict with racist police and corrupt politicians. With the help of Mouse, his violent childhood friend, Easy finds Daphne and the bad guys are either killed or outwitted. More compelling than the plot development is what psychologically underpins it: Easy's journey into a paranoid world of illusion, fear, and desire where secure referents of meaning and value begin to dissolve and race is revealed as the most disturbing site of mystery and transgression.

Devil in a Blue Dress opens with a scene of transgression as a white gangster, DeWitt Albright, enters a black bar in Watts. His entry is observed by Easy:

I was surprised to see a white man walk into Joppy's bar. It's not just that he was white but he wore an off-white linen suit and shirt with a Panama straw hat and bone shoes over flashing white silk socks. His skin was smooth and pale with just a few freckles. One lick of strawberry-blond hair escaped the band of his hat. He stopped in the doorway, filling it with his large frame, and surveyed the room with pale eyes; not a color I'd seen in a man's eyes.

When he looked at me I felt a thrill of fear, but that went away quickly because I was used to white people by 1948. (p. 9)

Opening the narrative in this way Mosley immediately foregrounds the distinctly black point of view of his first person narrator and draws attention to whiteness as a category of identity. The passage is ethnographic in detail and the attention to whiteness is notably excessive, associating it with power. Easy is not only 'surprised' due to the incongruity of the white man's presence in a black space, but he also feels fear in response to this excessive whiteness. This fear is founded on his experiences of racism and the hegemony of white power, and although his experiences in the Second World War have demythologised whiteness ('I killed enough blue-eyed young men to know that they were just as afraid to die as I was' (p. 9)) he retains a residual sense of its 'terrorising' potential.[28] By decoding the meanings of whiteness Mosley interrogates its privileged neutrality at the same time as he establishes the racial identity of his protagonist and his immediate culture. The opening of the novel is a suggestive inversion (and perhaps an intentional critical parody) of the opening of Chandler's *Farewell, My Lovely*. In both novels a white gangster enters a second-storey black bar in Watts in search of a woman, a search then taken up by the detective. Whereas Chandler exoticises blackness in his stereotyping of the bar's inhabitants and assumes the reader's interest in the white character's point of view, Mosley inflates whiteness as a cultural signifier and introduces a black perspective.

Where Chandler treats Watts as alien and exotic territory, Mosley represents it as a living community. In his detailed attention to the black social spaces Easy inhabits – the bars, clubs, churches, barber shops, pool halls and whore houses – Mosley treats them as the loci of black culture as a way of life, a normative system of behaviour and expression, attitudes and values. He is not interested in romanticising the poverty of Watts or in exoticising the violence that marks the lives of many of Easy's associates.[29] He represents the black 'ghetto' as a discreet if immiserated community which offers some insulation from the white world and has its own distinctive history and patterns of life. Easy is a part of this culture, and shares with many of its inhabitants a Southern background. His use of dialect, his choice of food, his tastes in music, and much more are influenced by this background. His sense of being a displaced Southerner also sharpens his self-consciousness about racial oppression in a Los Angeles environment. He describes his entry into an illegal nightclub:

When I opened the door I was slapped in the face by the force of Lips' alto horn. I had been hearing Lips and Willie and Flattop since I was a boy in Houston. All of them and John and half the people in that crowded room had migrated from Houston after the war, and some before that. California was like heaven for the Southern Negro. People told stories of how you could eat fruit right off the trees and get enough work to retire one day. The stories were true for the most part but the truth wasn't like the dream. Life was still hard in L.A. and if you worked every day you still found yourself on the bottom.

But being on the bottom didn't feel so bad if you could come to John's now and then and remember how it felt back home in Texas, dreaming about California. (p. 34)

This bittersweet commentary registers the need for a sustaining cultural life for the migrant community of Southern African-Americans while recognising utopian delusion in the dream (articulated by Du Bois above) of opportunity and prosperity.

Easy's strong attachment to, and knowledge of, the culture of the migrant community in Watts distinguishes his role as a detective. He knows where and how to seek information in this culture: 'I wanted to find out the whereabouts of Frank Green but it had to come up in normal conversation. Most barbers know all the important information in the community. That's why I was getting my hair cut' (p. 138). Bars and pool rooms are often concealed from public gaze and entry is not open to all: 'Ricardo's [Pool Room] was just a hole-in-the-wall with no windows and only one door. There was no name out front because either you knew where Ricardo's was or you didn't belong there at all' (p. 129). It is not only this cultural knowledge which distinguishes Easy as a black detective but his sense of responsibility to a community. Mosley has stressed that this sense of responsibility sets his protagonist apart from the detective heroes of classic hard-boiled fiction:

the earlier gumshoes who I like, they are White men of European descent who have no mother, no father, no sister, no brother, no property, no job. So they don't have anything that would make them responsible to the world. Easy isn't like that. Easy has a wife, or, at least an ex-wife, he has children, he has friends, he has property, he has things that make him have to do things in the world. . . . I think the earlier fiction was necessary, but Easy answers moral questions by being implicated in the world, rather than being perfect.[30]

Mosley embeds Easy in local networks of social and cultural relations that play an important part in determining his values and actions.

However, Easy is not only bound within the social and cultural relations peculiar to the black community, he is also subject to a larger and more oppressive system of relations organised by the dominant white world. Transgression, as I noted above, marks race relations in the novel, and Easy's role as a detective frequently takes him beyond the relative cultural security of Watts into white Los Angeles. Although he can play on white ignorance of his role he constantly feels vulnerable to racist perspectives: 'It was fifteen blocks to John's speak and I had to keep telling myself to slow down. I knew that a patrol car would arrest any sprinting Negro they encountered' (p. 83). His knowledge of racism and segregation in Los Angeles determines his cognitive map of the city as a racialised landscape of invisible boundaries and prohibitions. When he enters distinctly white social spaces he is frequently perceived as a threatening presence. The opening scene of the novel is turned around when Easy visits Albright to accept his offer of money to search for Daphne Monet. Albright's residence is 'a long drive from Watts' (p. 13) in a white area of the city, and on arrival there Easy is confronted by a white porter who asks:

'Who are you looking for?'
He was a little white man wearing a suit that was also a uniform.
'I'm looking for, um . . . ah . . .' I stuttered. I forgot the name. I had to squint so that the room wouldn't start spinning.
It was a habit I developed in Texas when I was a boy. Sometimes, when a white man of authority would catch me off guard, I'd empty my head of everything so I was unable to say anything. 'The less you know, the less trouble you find,' they used to say. I hated myself for it but I also hated white people, and colored people too, for making me that way.
'Can I help you?' the white man asked. He had curly red hair and a pointed nose. When I still couldn't answer he said, 'We only take deliveries between nine and six'. (p. 21)

The confrontation emphasises the sense of dislocation Easy experiences due to the interpellating gaze and questioning of the white man. His 'habit' of stuttering and falling silent is learned through everyday experiences in a racist environment and internalised as a survival mechanism. The association of knowledge with danger is acutely underlined by Easy's transgression into white space for he is, socially as well as geographically, out of place. He reflects: 'That little white man had convinced me that I was in the wrong place. I was ready to go back home' (p. 22). Time and again in the novel Mosley explores how discrete social spaces mediate his protagonist's understanding

of relations between knowledge and power, morality and justice, in a world in which he is denied 'rights'.[31]

Easy's desire 'to go back home' is recurrent in the novel, symbolising a need for security, but to the degree that it announces a desire to escape the racist white world it is impossible to fulfil. It is important to recognise that Easy is drawn into conflict with this world in part due to his aspirations. While he is sceptical of the African-American dream of opportunity and prosperity in Los Angeles, he nonetheless has aspirations that are distinctly material and middle class. This is most clearly articulated in relation to property with his strong desire to own his own house: 'I felt that I was just as good as any white man, but if I didn't even own my front door then people would look at me like just another poor beggar, with his hand outstretched' (p. 16). (In later novels he buys several properties and moves to a black middle-class neighbourhood.) Easy's house materialises the desire for 'ordinariness' we found also in Chester Himes' protagonist in *If He Hollers Let Him Go*.[32] But this desire, both Himes and Mosley indicate, is also an implicit claim to normative citizenship that is powerfully circumscribed by white society. Easy recognises that his desire for ownership creates dangerous new relationships: 'when I got that mortgage I found that I needed more than just friendship. Mr. Albright wasn't a friend but he had what I needed' (p. 28). Needing money, Easy's acceptance of Albright's proposition moves him more fully into the system of capitalist exchange and control, to the degree that he may be said to mortgage his black identity. This is clearly indicated when Albright refuses Easy's efforts to return his payment:

'Too late for that Mr. Rawlins. You take my money and you belong to me. . . . We all owe out something, Easy. When you owe out then you're in debt and when you're in debt then you can't be your own man. That's capitalism.' (pp. 108–9)

Capitalism, in these terms, is a system of dependency, structured around debt and ownership, and a powerful force in the fashioning of social freedoms and subjugations. In racial terms Easy's debt implies a master–slave relationship: 'Money bought everything', he reflects, 'I got the idea, somehow, that if I got enough money then maybe I could buy my own life back' (p. 127).

Easy is caught up in webs of racist social control and coercion from which he cannot easily extract himself. Mosley's depiction of this dilemma is subtly handled and reflects his intention to portray

'both external and internal' factors that mediate the meanings of autonomy and self-sufficiency for a black subject. More particularly, he wants to explore what these may mean for a black *male* subject, for Easy's desire for self-sufficiency has distinctive gender as well as economic connotations. When he decides to accept Albright's money he reasons that he does so not only to pay his mortgage but also because:

DeWitt Albright made me a little nervous. He was a big man, and powerful by the look of him. You could tell by the way he held his shoulders that he was full of violence. But I was a big man too. . . . Whether he knew it or not, DeWitt Albright had me caught by my own pride. The more I was afraid of him, I was that much more certain to take the job he offered. (p. 20)

Easy is drawn into the complex relationship with Albright as much through a sense of male pride as through economic need. In Easy's responses to Albright and other white men, Mosley emphasises the intersection of a 'masculine mystique' with institutional racism and draws attention to 'the racial dialectic of projection and internalisation through which white and black men have shaped their masks of masculinity'.[33] This dialectic is at work in Easy's need for white recognition of his masculinity and demand for 'respect' (p. 73) from white men. Mosley's treatment of this dialectic further distinguishes his representation of Easy as a 'tough guy' of the hard-boiled type. Easy's mask of masculinity barely conceals the deep divisions in his subjectivity.[34] In *Devil in a Blue Dress* the instability of his masculine identity is foregrounded in his psychological struggles to come to terms with the violence of his past; throughout the narrative he reflects upon violent experiences and in his dreams is haunted by them as scenes of trauma. His memories of his childhood friend Mouse – 'He could put a knife in a man's stomach and ten minutes later sit down to a plate of spaghetti' (p. 55) – and of action in the war frequently puncture the narrative to illustrate his ambivalence about violent assertions of masculinity. Easy's desire for upward mobility represents an effort to escape the horrors of the past but he remains inexorably 'caught' in legacies of racism and violence which have traumatised black male subjectivity.

The divisions within Easy are mirrored in the instability of his narrative authority and the challenges posed to any secure position of truth or knowledge in the construction of identity. This narrative instability is most potently figured in Easy's search for Daphne

Monet, the eponymous 'devil in a blue dress'. Daphne is an excessively enigmatic character whose identity is curiously unstable to Easy's eyes:

Her face was beautiful. More beautiful than the photograph. Wavy hair so light brown that you might have called it blond from a distance, and eyes that were either green or blue depending on how she held her head. Her cheekbones were high but her face was full enough that it didn't make her seem severe. (p. 96)

Daphne's identity appears to shift and change under Easy's gaze – neither hair colour, nor eye colour, nor facial structure remain constant – and it is with some perturbation that he observes 'Daphne was like the chameleon lizard. She changed for her man' (p. 187). Mysterious, sexually attractive and dangerous Daphne is very much in the *noir* tradition of the 'dark woman' or femme fatale, but the variable effect of her identity quite literally defamiliarises the conventional racial encoding of this figure.[35] Daphne, as Easy (and the reader) discovers near the end of the narrative, is a figure of racial masquerade, she is a mulatto who passes as white; her other identity is that of Ruby Hanks, the half-sister of a black gangster. Easy, who experiences a strong sexual and emotional attraction to Daphne, is shocked at the discovery of her double identity:

I had only been in an earthquake once but the feeling was the same: The ground under me seemed to shift. I looked at her to see the truth. But it wasn't there. Her nose, cheeks, her skin color – they were white. Daphne was a white woman. (p. 205)

The 'shifting ground' to which Easy refers underlines the arbitrariness of social indicators of racial difference and identity, particularly as these privilege the visible as the surest ground of evidence. There is considerable irony of course in Easy's shock at this revelation for he had begun to pride himself in his own form of masquerade: 'people thought that they saw me but what they really saw was an illusion of me, something that wasn't real'. The figure of Daphne/Ruby gives a further twist to the meanings of the 'interiorities and exteriorities' which structure racial knowledge and identity.

The relationship between Easy and Daphne has significant consequences for the dialectic of truth and deception in the novel. While the perspective of the black detective is privileged he discovers the inadequacies of his own racial knowledge as well as that of the broader social texts. There is no hidden 'truth' of racial being for Easy

to discover or uncover, though there is much to be learned in his quest about the indeterminacy of 'race' as a social epistemology and categorical sign of difference. Mosley questions the existence of an essence of racial difference as the secure locus of identity formation. Easy's friend Mouse expresses an essentialist position when he warns Easy:

You learn stuff and you be thinkin' like white men be thinkin'. You be thinkin' that what's right fo' them is right fo' you. [Daphne] look like she white and you think like you white. But brother you don't know that you both poor niggers. And a nigger ain't never gonna be happy 'less he accept what he is. (p. 209)

Easy has no answer to this statement but his desires and actions do not reflect the coherence of racial identification Mouse articulates. Mosley does not ascribe an essence to his black subjects, rather he represents them, and Easy in particular, as complexly constituted in both interracial and intraracial relations. He emphasises his protagonist's urge to self-invention while detailing the powerful racist prohibitions on this process and the dialectics of power, fear and desire which shape it internally.

Mosley has observed of Easy 'he does make it here in America. But how he makes it is flawed and scarred'.[36] This statement points up the author's efforts to represent and interrogate utopian and dystopian features of black experiences in Los Angeles. In doing so he defamiliarises the conventionally white co-ordinates of *noir*'s countermythologising. Mosley's black *noir* appropriates key elements of classic hard-boiled fiction – the tough guy persona, the femme fatale, the corrupt police and politicians, the quest for a hidden truth, the paranoid imaginary – yet is much more than a critical parody of earlier white writers. If, as Mike Davis, proposes, 'L.A. understands its past . . . through a robust fiction called *noir*' then Mosley has used this conduit of historical memory to produce a critical history of race relations in the city and to illuminate the cultural history of people who have come to be pathologised as an 'underclass'.[37] His postwar Los Angeles is observed through cultural and ideological categories of the present time in which he writes. It is a culturally hybrid world, but not a multicultural melting pot, in which racial transgressions haunt individual and collective identities. It also shows much evidence of the 'paranoid spatiality' Davis identifies with 1990s Los Angeles.[38] In Mosley's revisionist *noir*, race dominates the fantasies, fears and repressions which shadow the divisions of a virtually apartheid city. In this city's dark streets the black detective's search

for freedom, truth and justice is also an investigation into the meanings of racial difference and identity.

YOU CAN'T GO HOME AGAIN: RICHARD PRICE'S *CLOCKERS*

Richard Price spent four years with dealers and cops on the violent mean streets of urban America, risking his life while researching the raw material of this outstanding novel. The result is a work of such powerful authenticity that all other recent stories of city-jungle life pale into insignificance beside it.[39]

So runs the blurb on the paperback edition of Richard Price's novel *Clockers*, first published in 1992. The cliched emphasis on the authenticity of subject matter would seem to place the book in relation to the True Crime genre of writing which flourished in the late 1980s and 1990s and which invariably advertised the dangerous research undertaken by authors. Unlike the vast output of this genre though Price's research was undertaken to produce a novel rather than documentary reportage, while in his writing he eschews the staple authorial position of the True Crime writer, that of an initiate on the mean streets whose persona mediates violence and voyeurism for the reader. In *Clockers* Price carefully expunges the subjectivity of the narrator to attempt a 'realistic' presentation of ghetto life in which authenticity inheres in presentation of character and detail rather than the experience of the writer. And yet the issue of his experience shadows the book for it reads in part as an urgent dispatch from the underclass ghetto and half of the narrative is focalised through the consciousness of a young, black drug dealer. While reviewers generally celebrated the novel some wondered if a white writer could render the reality of black inner-city poverty. For the most part they answered in the affirmative, commending the reality effects of Price's 'novelistic realism' and his ability to get 'inside' his young black protagonist.[40] However, Price's efforts to get 'inside' the world he represents merit fuller analysis.

In his review of *Clockers* Luc Sante proposes the novel 'possesses an authenticity that is more than journalistic and can only derive from the author's identification with his subjects'.[41] Price echoes this himself in interviews where he frequently points to his background as evidence of experience that has prepared him for such identification. Price grew up in a Jewish family in the Parkside Projects in the Bronx, a postwar housing project built for blue-collar families. His

first novel *The Wanderers* (1974) drew on this experience to tell the story of teenage gangs in the Bronx in the 1950s. Three subsequent novels mined similar material – Price has referred to them as his 'four autobiographies'. In the mid 1980s, struggling with cocaine addiction and feeling he had no more to say as a novelist, he managed to successfully switch his creative energies to writing screenplays, authoring *The Color of Money*, *Sea of Love*, and *Night and the City* among other scripts. He has stated that his youth in the projects, his drug addiction and later teaching experience in a rehabilitation centre in the Bronx, and a fascination with media coverage of crack cocaine in the late 1980s all fed into the genesis of *Clockers*. He adds that the incentive to write the novel was born in what appears to have been an epiphanic moment which occurred in 1989 while he was researching *Sea of Love* by spending time with police in housing projects in Jersey City:

We went to these projects looking for a witness to a homicide, and that night I looked around, and even though I'd spent the first eighteen years of my life in buildings like these, I felt like I had landed on a distant planet. They had turned into such tiger pits. The only things that looked familiar to me were the bricks. I felt this disorientation; it made me feel like, 'I know this, but I don't know this. Actually, I don't know *anything.*' And I was seized by the desire to understand what happened to the projects. I felt compelled to return to the world I came from to find out what happened.[42]

Return he did, at least to the environs of Jersey City to carry out three years of intensive research accompanying police and drug dealers. Whether he returned to the world he came from is a more complex issue. This desire to understand married to a compulsion to return is only barely apparent on the surface of *Clockers*' realist prose but it powerfully shapes the telling of this ghetto tale, not least in its admixture of white ethnic point of view and black ghetto reality.

Christopher Wilson has noted that in the mid 1980s 'True Crime seemed to enter into social terrain where traditional crime journalism now feared to tread'.[43] The same may be said of *Clockers* in relation to contemporary American literature. Of course, the writing of crime novels continued, even flourished, in this period, and some writers (as we have seen with Walter Mosley) sought to stretch the genre in relation to issues of race, crime and justice. However, *Clockers*, while trading off the crime novel genre (including, for example, its depiction of a disillusioned homicide cop, its use of aspects of the mystery procedural, its use of the conceit of a good/bad brother juxtaposition)

is clearly designed to transcend it as a hefty realist novel of serious literary merit and ambitious report on the state of affairs in urban America. As such its most obvious precursor in contemporary times is Tom Wolfe's *The Bonfire of the Vanities*. In 'Stalking the Billion Footed Beast', his manifesto for a 'new realism', Wolfe argues that 'a highly detailed realism based on reporting' is required to adequately represent race relations in the emergent urban order.[44] In practice, in his novel, Wolfe decidedly reigns in on scope and perspective, content to settle for satiric comedy in his treatment of the white upper middle class of Manhattan and stereotypical brevity in his representation of the black 'outer boroughs' and underclass characters more generally. Price is truer to aspects of Wolfe's polemical call for a new realism. In his novel he draws on prodigious research to detail the reality of the ghetto and provides a truer balance of racial perspectives in his treatment of white homicide cops and black drug dealers. Price also writes with a resolve to give voice to what he terms the 'disenfranchised', whereas Wolfe seeks to warn his white readers of the dangers attending disintegration of urban centres. Price's intent and perspective is also shaped by his appreciation of a particular lineage of American social realism. In interview he somewhat flippantly claims he is the 'last of the Depression Era social realists' yet he clearly takes this literary formation seriously and also identifies with later inheritors such as Nelson Algren and Hubert Selby.[45] Price inflects his realist prose with a form of social consciousness Wolfe has little interest in and moves further onto the terrain of naturalism in the style of Algren and Selby to investigate environmental sources and forces which shape urban character.

The plotting of *Clockers* is somewhat formulaic, mimicking crime genre patterns, though the narrative lends some complexity to the structure by doubling perspectives on the unfolding events. The chapters alternate between the viewpoints of Strike, a nineteen-year-old clocker (a drug dealer prepared to work all hours) who lives in and deals from a housing project in Dempsy (a fictional city based on Jersey City) and Rocco Klein, a white homicide cop who grew up in the local projects but now resides in Manhattan and is considering retirement. Plot begins to tie them together when Strike is asked by his drug-dealer boss Rodney to kill a competitor and thereby get off the streets and earn more money within Rodney's organisation. The competitor is killed, but not by Strike and the reader is not told the identity of the killer. Strike's brother Victor, a soft-spoken family man holding down two badly paid jobs, steps forward and confesses to the crime. Rocco, investigating the homicide, refuses to believe Victor and

becomes convinced his brother is the killer. He harasses Strike and sets Rodney against him in order to pressure him to confess. Violence arises from this plotting, but not in a way any had foreseen. Tyrone, a young boy in the project housing who idolises Strike, steals his gun and kills the hitman Rodney has dispatched to kill Strike. Driven by fear to Rocco, Strike finally convinces the detective that Victor carried out the first homicide. Numbed by this revelation Rocco delivers Strike to Manhattan where he purchases a bus ticket with little sense of where he is going yet is vaguely conscious of the possibilities of 'a new life . . . a second chance' (p. 647). Rocco, chastened yet also curiously energised by his experience, returns to Dempsy and the novel closes with him going through the routine of canvassing the crime scene of another homicide.

The plotting of *Clockers* is elaborate, but the pacing is slow and motivation occasionally weak. The novel's dramatic energies reside in the dialogue and interactions of characters, while the pacing is to the advantage of building environmental detail and deepening the text's reality effect. The world of the novel is imbued with a ground-tone of insecurity that is established in the first chapter, narrated through Strike's point of view. We first encounter Strike 'seated on the top slant of his bench, his customary perch' in the courtyards of the Roosevelt Houses, a complex of 'thirteen high rises, twelve hundred families over two square blocks' (p. 4). While Strike's power base this is also an insecure space for 'the housing office gave [the police] access to any vacant apartment for surveillance, so Strike never knew when or where they might be scoping him out' (p. 4). Strike is a figure of 'vigilant fretfulness' (p. 9) as he scans his territory, worrying about the incompetence of the clockers he controls as well as potential raids by the police. Through his eyes we observe the daily routines of the clockers while he reflects on the lack of trust in this subculture: 'after all the We Are Family bullshit went down, everybody was really just out for themselves' (p. 23). Distrust and disinformation are at the centre of the elaborate 'game' (p. 25) of cops and dealers. In Strike's view:

everybody was full of shit in this game. The cops bullshitted each other, the dealers bullshitted each other, the cops bullshitted the dealers, the dealers bullshitted the cops, the cops took bribes, the dealers ratted each other out. Nobody knew for sure which side anybody was on; no one really knew how much or how little money anybody else was making. Everything was smoke. Everything was pay phones in the middle of the night. (p. 25)

Strike's bubbling paranoia effectively translates his growing sense of entrapment in this game. He is not its sole victim though, for even the police feel they are part of what Rocco terms a 'cycle of shit' (p. 107), the routinisation of criminality and its policing which blurs the boundaries between law and lawlessness.

A notable effect of the constant bullshitting is that all players in the game are performers, acting out roles. Price lends wit and depth to this performativity of character through his ability to render every-day talk and gesture with sensitivity to inflections of race, class and gender. In the verbal exchanges between the police and clockers a rhetorical sparring is intricately developed though casually presented by the author. At one point Rocco observes 'three black kids sitting on a tenement stoop' and reads their behaviour as 'guilty' as they try to ignore the stare of the police.

'Hey you'. Rocco picked out the tallest of the three, a kid sporting red acid-washed dungarees, L.A. Gear sneakers with the price tag still attached and a Chicago Bulls cap jerked sideways. 'C'mere for a minute. . . . Let me ask you something. . . . Where do you get those hats with the bills over the *ear* like that? Alls I can find are the ones with the bills in front. I looked all over . . . ' The kid shrugged, scowled down the street. 'All you got to do is turn them around sideways'. The answer was so straight-forward that Rocco couldn't tell if the kid was stupid or just throwing it right back at him. (p. 35)

The exchange, an 'attitude contest' (p. 36), is emblematic of the per-formed masculinity that is crucial to police and clockers alike as they play out their game in public settings. As a fellow cop tells Rocco, 'You got a crowd on you, you best got to act the part or you're *nothing*. It's unfortunate but them's the rules' (p. 382). Through his use of voice Price is also able to enhance characterisation and distinguish cultural difference, allowing speech rhythms and jargon to communicate coded meanings. His white cops frequently talk 'black' in a mocking fashion (there is a trace of this in the above passage when Rocco says 'Alls'), while black dealers such as Rodney have distinctive speech patterns which become a signature of character as we read. There are dud notes when voices express outside their established registers, as when we are told Strike feels he is 'nailed to the face of time' (p. 537). Such flourishes are rare though. Overall, as many reviewers noted, Price's 'black dialect rings true' and the bleak tone of the novel is maintained and enriched by expressive use of voices that seem consonant with their environment.[46]

Complementing Price's use of voice in his orchestration of 'novel-istic realism' is his close attention to details. The reader absorbs a

great deal of information: on how police examine a homicide scene, on how a deli functions as a public bar for ghetto dwellers, on the economics of drug sales, on the use of baking soda and scouring pads in the smoking of cocaine. As one reviewer notes, 'So much information is disseminated that by the end of the novel the reader feels more or less ready to investigate a homicide or start up a drug operation, or both'.[47] Price's vivid descriptions of cop bars, station houses, projects courtyards, and ghetto stores are rich in detail and establish a sense of locale (if not community) which adds to our comprehension of the dense social milieu within which characters are embedded. Such attention to environmental detail might be expected of a social realist novel, but Price arguably has a harder task than most of his predecessors in establishing the reality of the urban milieu he seeks to represent. As Luc Sante notes, *Clockers* bears a particular 'burden of association' in that 'the surface particulars of the inner city experience have been represented with varying degrees of glibness so many times that they have become hollow conventions in the minds of most people who do not live there'.[48] Price's difficult task is to effect a recognition of the real by the reader that transcends these hollow conventions. His scrupulous attention to everyday details, as with his careful depiction of voice, is intended to do just this by immersing his reader in an 'inner city experience' in a manner that defamiliarises the stock representations of the mass media.

To truly challenge these hollow conventions as a novelist he also has to take us into the interior lives of his paired protagonists, Strike and Rocco. Strike is drawn as a character constantly under pressure, his growing anxieties and sense of vulnerability affecting him physically as well as psychologically. He is constantly in pain due to an undiagnosed ulcer and speaks with a stammer when stressed. These ailments might be construed as latent symbols of an inner doubt about his work as a drug dealer, but Price never presents them so crudely and indeed avoids easy sentimentalisation of Strike's dilemma. The reader's empathy is more subtly invited through our intimate understanding of Strike's growing paranoia as he feels harassed by all around him. We are invited to share his confusions and humiliations and recognise his belaboured comprehension of what is happening. Time itself, as the title suggests, seems to be bearing down on Strike; he knows that few last in his position beyond six months and he has already been dealing for nine. His conscious life seems to be a constant routine of calculating his options and the machinations of others and coming up with no answers. Yet he is set apart from the other junior clockers whom he despises 'because they never see past

the next two minutes' (p. 4). Strike struggles to see further than this and though he in no tangible way succeeds his efforts imbue his frustration with a self-questioning and moral complexity that engages the reader's sympathies. Having already been adopted into his present role by the paternalistic Rodney, Strike comes to see through Rodney's patronage of children in the projects, yet sets out to adopt the young Tyrone in a similar manner – the 'cycle of shit' at work. However, he chaffs at this undertaking and finally withdraws his friendship from Tyrone, in part because he has been warned to do so, in part because he wants to save the child from a life of drugs and violence, and in part because he is in some vague way hoping to save himself. Strike barely understands the redemption his author has him inarticulately seek, but the reader is invited to understand and will him towards it.

Rocco is much more self-consciously pursuing redemption. As a jaded homicide cop with a streak of humanity Rocco is close to caricature, but Price twists the stereotype and deepens the conventional characterisation. We are told Rocco is weary of:

feeling up to his eyeballs in the nothingness of people's lives, the objects and odors, the little game plans and deceptions, underwear and tinfoil, dope and booze, all the shitty secrets, the hiding places, everything adding up to a stain on a sidewalk, the only evidence these people had ever existed. (pp. 206–7)

Rocco's conventional weariness is invested with a casual racism that is less conventionally (less self-consciously) portrayed in crime fiction. While Rocco is largely unaware of his racism we recognise that it is central to his efforts to express his own humanity by proving Victor is innocent and Strike guilty. Rocco is convinced of Victor's innocence because of the way he unconsciously reads signs of race and character; he refers to and generally views Victor as a 'good, decent, hard-working guy' (p. 319) based on his work ethic and family orientation. Rocco invests his own hopes for redemption in his belief in Victor's innocence and is half-conscious of this as he reflects on how he has turned the homicide case into a mission: 'Maybe a mission was just the thing he needed to clean himself out – salvation through obsession, get that small wheel of gifts rolling, discover a way to live beyond the time clock' (p. 425). Wanting to beat the clock as much as Strike, Rocco's frustrations seem more mundane – a loss of energy and purpose, a confused sense of fatherhood, an unsatisfying relationship with his young wife and alienation from her social circle – yet resolution is more clearly articulated: 'It was just a matter of finding a few

small gifts of connection. He had to have something to take home with him, something to bring into work, just get a little wheel of gifts going' (p. 362). Rocco desperately wants to control the plot he is caught up in, to give it and himself a meaning he can believe in, but he sadly misreads the evidence. As with Strike, his frustrations and humiliations are bared to the reader and he garners pathos as a result. By the time he finally admits to himself that he needed Strike to be guilty 'in order to anchor himself in his job before he drowned in his own banal terrors' (p. 639) this insight comes as no surprise to the reader and resonates with his character.

Clockers is an ambitious novel in its social and philosophical dimensions; it is at once a slice of life from the contemporary ghetto and a morality tale of flawed humanity barely meeting the demands of conscience. Price does not want the morality tale to usurp the realism of his prose but to be carried and authenticated by it. He knows that the reality effect of the realist novel inheres in the construction of an illusion of the representation of reality in which a reader can believe. Price is skilled at presenting this illusion; his writing is remarkably controlled in filling out the large canvas, carefully calibrating the degree and kind of knowledge shared by characters and reader, persuading us – as realist fiction at its best will – that we have 'found' the meanings the author has carefully manufactured. In short, the reader is rarely aware of the hand of the author at work. However, if we return to the question of authenticity with which we began there are issues of authorship and realism still to be considered beyond the technical merits of Price's writing.

The points of view of Strike and Rocco are not as balanced as the author wants us to believe. To be sure there are significant balancing factors: both are flawed men, both are struggling to understand and act on conscience, both are under pressures enforced by time, circumstance and their own limited imaginations. However, while Strike is more centrally positioned in relation to the mechanisms of plot, it is the inner life of Rocco that is the more fully empowered by the narrative. In part, this imbalance may be adduced as a necessary result of characterisation, for though Strike is intelligent he barely comprehends issues of power and morality he struggles with. In interview with Rocco he tries 'to find the words to describe Rodney's power, his effortless hold over him. But the language eluded him' (p. 634). Rocco, too, of course, fails to comprehend important aspects of the world around him but he is endowed with a language that is commensurate with that failure. While his imagination and knowledge remain limited – Price does not allow him to become a figure of

enlightenment at the novel's end – we are asked to recognise that he has found some of the 'few small gifts of connection' he sought as a form of redemption. Strike, on the other hand, has been granted several *See America* bus tickets and an 'airy disbelief' in his good fortune at embarking on a new life with 'no idea what he had done to deserve it' (p. 647). Again, Strike's lack of understanding may be true to character but his exit from the ghetto and the novel all too swiftly and neatly closes off the moral complexities which had preoccupied him for several hundred pages. It is Rocco who returns to Dempsy and to the 'cycle of shit', not utterly changed but with a self-redeeming sense of having discovered what Price calls 'the connective tissue' underlying race relations in urban America.[49]

Rocco is Price's alter ego in *Clockers*, though the author attempts to steer the reader away from recognising this identification. His most blatant effort to do this is through the use of a secondary character, the actor Sean Touhey who shadows Rocco for several days as research preparation for a film. Touhey revels in the authenticity of ghetto policing and Price provides considerable humour at the actor's expense. Apart from humour, Touhey has two obvious functions in the narrative: to act as a temporary point of fixation for Rocco's desire for recognition in his life and to allow Price to critically parody mass media stereotyping of, and ignorance about, ghetto policing. But Touhey also has a more subliminal function, that of deflecting close attention from Price's identification with Rocco while enhancing the reader's appreciation of the author's authentic representation of the ghetto. Touhey is a mock figure of the author; his insensitive and gratuitous relation to Rocco's world is a distorted mirror image of Price's sensitive and informed understanding. Through this self-parody Price registers his self-consciousness about his role as a privileged white author writing about the impoverished and predominantly black inner city. His gamble is that Touhey will absorb any suspicions the reader might have about the legitimacy and authenticity of his writing, but as an all too obvious device Touhey is mishandled by Price and becomes a caricature who only serves to draw our attention to the author.

Rocco is an altogether more interesting double of the author. We recall Price's comments on the genesis of *Clockers*: 'I was seized by the desire to understand what happened to the projects. I felt compelled to return to the world I came from to find out what happened'. It is principally through Rocco that he seeks to return. Rocco remembers Dempsy when it was a predominantly white city. Regarding JFK Boulevard as 'two miles of funk' he recalls when it 'was Frawley

Avenue. You could walk down the street naked, middle of the night. It was a pleasure' (p. 132). Price accentuates the nostalgia, asking the reader and Rocco to focus on the reality of the present when Dempsy is 'a city of three-hundred thousand mostly angry blue-collar and welfare families' (p. 34). Yet the white ghetto past haunts both Rocco's and Price's perspectives on the present. When Rocco visits a derelict hospital where those 'at the bottom of the junkie chain' (p. 237) reside, he is 'seized by a combination of nostalgia and anxiety' (p. 240) and overwhelmed with a ferocious sense of pride at being born in this ruin . . . pride at being a local boy, a son of Dempsy, a street kid, a regular guy' (p. 241). Throughout the novel we sense that Rocco's efforts to redeem himself hinge on his relationship to Dempsy, past and present. He feels dislocated living in Manhattan, in a Tribeca loft, amidst an alien social circle. At the end of the novel, having left Strike at the bus station, he drives toward Dempsy 'instead of turning east for the loft. . . . He'd be home soon enough' (p. 650). The implication is clear: he is now able to reclaim Dempsy as home due to his sense of redemption and (re)discovery of 'connective tissue'.

Price's relationship to Rocco's discovery of 'home' as the ground of redemption is artfully complex. His compulsion 'to return to the world [he] came from' implicitly maps the past onto the present and suggests not only a return to a ghetto environment but also to his beginnings as a novelist. In interview he comments that in writing *Clockers* he was 'going back to my roots as a writer. I started out with *The Wanderers*, writing about housing projects. I was writing about housing projects again'.[50] Rocco feels his homicide case has 'brought him back to himself' (p. 251) and we might wonder if Price feels something similar in his return to his literary roots. In interview he evinces considerable pride at having 'returned' as a novelist, hinting at a form of redemption in and of his own career as a writer.

I got an awful lot of confidence back as a writer because my screenplays were well-regarded. But at the same time I never wanted to be a screenwriter, first and foremost because a screenwriter is not a real writer. You're not an architect; you're a draftsman. I wanted to be a real writer again . . . when I felt like I had something to write about.[51]

For Price, being a 'real writer' means transmuting experience into art (a view shared by many working-class ethnic writers in the tradition he claims).[52] It also suggests that his 'return' to a scene of origins represents a crossing of aesthetic as well as class and ethnic territories

in which 'the real' connotes an essential value. Straddling these ter-
ritories (real and imaginary, past and present) his writing evidences
the doubleness of his position in the tensions between his roles as
omniscient narrator and inside reporter.

Though not at all overtly a work of memory in the manner of the
novels examined in Chapter 2 of this study, *Clockers* poses some
similar questions about the relationship of the white ethnic author to
inner-city spaces, past and present. Ron Rosenbaum notes that Price's
first novel *The Wanderers* appeared:

at a time when a sixties-weary culture seemed ready for gritty and lurid
fantasies of the greaser era . . . its appeal went beyond blue collar readers to
a generation of suburban baby-boomers encountering the disturbing com-
plexity of adulthood and looking for a romantic Myth of Origins in the
retrospective 'He's a Rebel' soundtrack of their youth.[53]

The Wanderers, like so many novels and films of the 1970s, imagines
the symbolic passage from inner city to suburbia as a narrative of lost
youth and encourages readers to romanticise this sense of loss as a
remedial ingredient of contemporary ethnic identity. Price eschews
such blatant romanticism in *Clockers*, yet this novel too takes on a
symbolic relationship to the dislocation of white ethnics from the
inner city. On its surface it knowingly presents Rocco's attachment
to Dempsy as nostalgic; yet in its deeper structures it reproduces
this sense of attachment to place as authenticating the redemptive
possibilities of connection between black and white, across time and
space.

The romance of *Clockers*, cutting against its gritty realism, is
Price's presumption that Rocco's need for his life to be 'healed' by
'finding a few small gifts of connection' (p. 362) stands in for the
collective need of American society in its response to urban race
relations. It is this need which denotes Price's investment in writing
Clockers as an act of melioration and understanding. It is in many
ways a daring act, not simply because the author moves 'onto terrain
that others might wish to call forbidden' but because he does so with
a will to communicate the reality of that terrain as challenging yet
commensurate to the imagination and understanding of those who
do not dwell there, and because he believes that an understanding of
that reality is necessary to break down the irremediable suspicions
separating black and white in the United States.[54] One result of
this approach is a valuable reinterpretation of the role of the white
ethnic cop in crime writing where he all too commonly functions as

a surrogate for 'the sense of victimization and powerlessness of urban, working-class white ethnics' and mediates fear and misunderstanding as voyeuristic entertainment.[55] Price's narrative is fired by a vision of reparation rather than resentment; he is determined to manufacture a fresh ethos for his jaded cop and to debunk stereotypes of black ghetto criminality. The imbalance of black and white points of view in the novel remain important, however, for while Price works hard to represent the reality of the black ghetto as a lived space his framing of this representation renders him an outsider looking in, however sympathetically or responsibly. The author's 'desire to understand what happened to the projects' is also Rocco's and implicitly the reader's — it is not Strike's.

ONLY THE DEAD KNOW BROOKLYN: SPIKE LEE'S *CLOCKERS*

Price's first two novels, *The Wanderers* and *Bloodbrothers*, were made into films and he acknowledges that they 'were very cinematic. I had grown up on TV and movies as much as on books, and it showed — a visual and aural momentum that lent itself very easily to film'.[56] *Clockers*, despite its length, has a similar momentum and also takes reference points from television and cinema. Add to this Price's close connection to the movie industry and it is not surprising it should have been made into a film. The rights to film the novel were bought by Universal Pictures for Martin Scorsese to direct and initial plans included Robert De Niro playing Rocco. In the event Scorsese and De Niro opted to make *Casino* and, at Scorsese's suggestion as executive producer, *Clockers* was offered to Spike Lee. Lee recalls:

I read the novel and looked at the various scripts that Marty and Richard Price had worked on. But as I did I started getting ideas about how to add my own vision while still being true to the book. I met with Marty, Richard and De Niro, and they all seemed to be in line with what I wanted to do, so I went ahead and made the movie.[57]

Lee certainly did add his own vision and the resulting film was not enthusiastically received by Price who is credited with co-writing the screenplay with Lee. We will return to some of Price's criticisms. In the first instance we need to acknowledge and analyse the film *Clockers* as a separate creation, not simply a retelling of the novel. We must also recognise that the intertextuality surrounding the film

includes not only Price's novel but also white ethnic crime films and black ghettocentric films.

It is not surprising that *Clockers* should interest Lee. Stories of white and black trying to 'do the right thing' in urban environments are a staple of his work. However, for Lee, the imperative to do the right thing is rarely a matter of individual conscience or choice, but rather both an effect of, and response to, racialised structures of power. Most generally, it refers to the urgent need for forms of action, including militant action, in the face of hegemonic indifference to racism and its effects in American society. In his filmmaking practice it is translated as a responsibility to 'get to the truth'.[58] Not all critics believe he has lived up to this responsibility and he has been sensitive to some of the criticisms. With *Clockers* he more directly addresses immiserated realities of postindustrial ghetto life – particularly the roles of drugs and violence – than in any of his earlier work. He also saw the making of this film as an opportunity to cinematically respond to the genre of ghettocentric filmmaking which blossomed in the early 1990s. Lee is no advocate of the genre, having frequently expressed his distaste for it and his hope that African-American directors would 'go on to explore other subject matter'.[59] It is charac- teristic of his self-recognition as a leading black filmmaker that he should enter into the generic mould of ghettocentric film in order to try and break it open to fresh issues and representations. He puts the issue of his approach more polemically when he claims that *Clockers* is intended to drive 'the final nail in the coffin' of the genre.[60]

The opening credit sequence of the film is a startling and provoca- tive example of Lee's approach to the ghettocentric genre. *Boyz N the Hood* we recall begins with a bare statement of statistics concerning black male mortality. *Clockers*' credit sequence consists of a shocking montage of reconstructed police file photographs of bloody corpses of black men, memorial wall art devoted to young men who have died violently, tabloid headlines and magazine images referring to guns, and fragments of a violent ghetto-focused videogame. While Lee wants us to read across these images to aggregate meanings of race and violence in the ghetto and consider their representations, it is the bloody corpses which most horrify and attract the eye as the camera moves close up to entrance and exit bullet wounds and lingers on these for what seems like an interminable few seconds. This is both an act of voyeurism and an act of critical revulsion at voyeurism, as the director signifies by having the camera frequently cutting to and moving across police tape holding back onlookers at a crime scene – on the tape (which also has symbolic use at the beginning of *Boyz N*

the Hood) is printed 'Crime Scene Do Not Cross'. Taking us into this prohibited space Lee is not only questioning the voyeurism of the moment, he is also drawing attention to what Deborah E. McDowell has termed a 'cultural fixation on the dead bodies of non-white males' in the United States.[61] Lee's credit sequence bears an uneasy relationship to the aura and imagery of death that pervades mass media representations of urban black male youth. While it recontextualises shocking images it also foregrounds the frames of representation and the act of looking, and the film as a whole works to narrativise the conditions of life for those symbolically dead, thereby challenging the casual reification of morbidity surrounding postindustrial ghetto life.

Lee says of this opening sequence: 'We did this for effect; we wanted the viewers to know, before they even settled into their seats, that our film was about serious business'.[62] The visual and emotional power of this sequence is such that the narrative that follows never quite approximates its horror, though it does develop many of its impacted significations about race and violence. The sequence is also a form of signature, suggesting this is Lee's film, something more than a visual retelling of Price's novel. In other words, Lee makes use of specific resources of his medium to announce theme and intent in a way that is simply impossible for Price to do. As the film narrative begins we soon see that there are further important changes of setting and point of view: Lee moves the setting to Brooklyn, an environment he is more familiar with, and centres Strike's point of view while sidelining Rocco's. However, it is cinematography and editing which more subtly and provocatively transform the story of the novel, reproducing the latter's key themes in a manner which shifts the moral and social implications of the narrative into a distinctively African-American register of concerns. The film is less centrally about betrayal and redemption, though these themes are present, than a critical illumination of the impact of drug dealing and violence on the consciousness, actions and relations of ghetto dwellers. The film visually reproduces the bleak realism of the novel but adds new dimensions to it with expressionistic camerawork that enriches characterisation and accentuates the spatial components of action and interaction. The editing provides a distinctive rhythm – fast paced and erratic, yet circular and repetitive – to produce a much more fragmented narrative structure than that in the novel. The result is that it is difficult, as the opening sequence forewarns, for the viewer to be comfortable in watching the film; we are drawn into a realistic milieu yet made aware of our position as spectators.

The stylistic virtuosity on display in *Clockers* is not simply Lee's, though he has a remarkable degree of control over many aspects of the filmmaking process. The technical inventiveness of his cinematographer Malik Sayeed has a major impact on the film's look. Sayeed convinced Lee to shoot much of the film using Kodak's 5239 film stock, a stock only very rarely used in mainstream filmmaking due to the elaborate cross-processing it requires. The particular qualities of this stock are the rawness and distinctive colour-accents of the imagery it produces. For Sayeed, it aptly conveyed the visualisation of the Brooklyn housing projects he sought:

I saw the film process itself as a metaphor for what exists in the ghetto; you have this really messed-up environment, but there's still a beautiful culture within that environment. Likewise, the 5239 has a completely raw grain structure, but it also has intense vivid colors.[63]

Sayeed's use of the stock is the basis of the gritty look and raw emotional atmosphere of the film; in particular, the use of different visual textures and colour registers deepen the realism of the project settings. The realism is enhanced by careful use of lighting – using practical lights for many of the set-ups – and camera movement. An important sequence in establishing the daily routine of the clockers is shot in a manner that resembles police surveillance, using long lenses and jerky movements to suggest an external yet immediate perspective on the action. 'We shot that scene with three cameras', Sayeed comments, 'We positioned ourselves as outsiders looking in'.[64]

For much of the film, though, it is the insider's perspective, that of Strike, which is predominant. We first see Strike as he strides across the courtyard of the housing project and stands on a circular concrete platform. It is an image of self-confidence and power, but this setting soon becomes a site of paranoia and confinement. As Amy Taubin notes in her review of the film: 'The courtyard is both stage and prison – an inversion of Foucault's panoptican. Trapped within it Strike is under constant surveillance, vulnerable to aggressors who enter from all sides'.[65] This *mise-en-scène* dramatically emphasises the spatial ambiguities of Strike's position in the narrative, symbolising both power and powerlessness. It becomes increasingly expressive of his sense of entrapment within the plots of others, representing the interiorised space of his growing confusion and vulnerability. At one point, as Rocco questions Strike while they stand on the concrete platform the camera (on circular dolly tracks) revolves around them, emphasising the pressure Strike is under from Rocco's questioning.

Time and again in the film, the movement of the camera technically signifies both his paranoia and his hyper-visibility.

As with most of Lee's films the narrative of *Clockers* has a strong dialectical impetus, developing by argument and opposed points of view. Unlike many ghettocentric films (though in line with the novel) it explicitly juxtaposes black and white perspectives on ghetto life. While Rocco's point of view in the film is less central than in the novel his casual racism is more deliberately foregrounded. As he had previously done with the figure of the Italian-American pizzeria owner Sal in *Do the Right Thing* (1989), Lee produces a subtle critique of the naturalised embodiment of racism in the actions of a white man who paternalistically believes he 'knows' the ghetto. Much more than in the novel, Rocco is a figure of colonisation, an outsider 'obsessed with proving the truth of his master narrative'.[66] Though frequently filmed on the periphery of action, he remains a figure of power, moving freely into and out of Strike's world in pursuit of this truth. He is also clearly associated with the more collective forms of racism expressed by the white police officers throughout the film. Following the death of the drug dealer competing with Rodney white policemen stand over the body of the dead black man bantering in crudely racist terms, talking to the corpse as well as each other, referring to it as 'another stain on the sidewalk'. Whether casual, crude or vicious, Lee posits a continuum of racism in the policing of the ghetto. At the same time, though, he pulls the white characters into the framing and perspective of the urban spaces they police in such a way as to suggest not only their arrogant power but their effective entrapment within structures of racial conflict and difference they barely comprehend.

Also in line with his earlier films, Lee draws characters within a web of fate even as he poses complex questions about autonomy, choice and responsibility. As we have already seen, such questions attend much ghettocentric filmmaking, especially in relation to issues of family, community and 'escaping' the ghetto. In *Clockers* the structure of family is shown to be either shattered or dissolved into alternative arrangements. The most obvious alternative is that of the clockers grouped around Rodney who projects himself as a father figure, expounding to the kids who sit in his store the rules and wiles of making money through dealing. Unlike *Boyz N the Hood* where black male parenting is presented as a solution to black on black violence, in *Clockers* the lines of assent and authority are much more blurred and conflicted. Strike is very much on his own without resources of family or community to fall back on (unlike in the novel,

his mother overtly rejects him when he tries to communicate with her and help Victor); he is coldly exposed to the machinations of two dangerous figures signifying the law of the father, Rodney and Rocco. Like many ghettocentric films, *Clockers* draws attention to elements of autodestruction in black ghetto communities – drug dealing and black on black violence – and posits a dilemma of spatial constriction which seems to have no narrative resolution other than escape or death. *Boyz N the Hood*, we recall, ends with Tre preparing to leave for college in Atlanta. *Clockers* ends with Strike seated on a train looking in rapture at vast rural landscapes. However, Lee also questions the logic of this dilemma as a trope of the genre by intercutting Strike's escape with alternative endings, including images of his brother leaving jail and walking into the arms of his family and images of a fellow clocker lying dead in the courtyard, a reprise of earlier crime scenes. Strike's departure has little redemptive relevance to the continued patterns of life and death in the ghetto he has left.

These more muted, though no less symbolic, forms of closure are the more continuous with the film's downbeat treatment of the roles of drugs and violence in the ghetto. With few images of drug addicts in the film the focus on the subculture of the drug dealers accentuates the pettiness and dull routines of the clockers' everyday lives. The singular exception to this is a scene in which the hitman Errol, his body seriously deteriorating due to drug abuse and AIDS, grabs Strike and warns him he could 'end up like me'. As with Furious Styles' speech on gentrification in *Boyz N the Hood* this is clearly aimed at educating the audience, but in its delivery and framing (against the background of a memorial mural) is just as leadenly symbolic. Lee is generally more subtle in his critique of violence. Throughout the film he intercuts brief sequences from videos and videogames in which ghetto spaces are sites of spectacular violence. As with the opening of the film, he draws attention to varied fields of representation in which race, the ghetto and violence are connected in the eye of the viewer. Apart from these sequences there is little direct attention to the physical enactment of violence in the film, which very deliberately eschews Hollywood conventions of shootouts or elaborately constructed killings. As Leonard Quart has observed, '*Clockers* is about a lethal world that is depicted in a contemplative and restrained rather than action-oriented style. Lee wants to turn his adolescent audience away from violence, rather than ostensibly moralize against it'.[67] *Clockers* is not entirely free of moralising about violence, but Quart is right to stress the contemplative

style. Unfortunately, it is quite possibly this style that made the film unattractive to young audiences – despite general critical praise, *Clockers* performed poorly at the box office.

Lee's eschewal of an 'action-oriented style' in *Clockers* is at one with his efforts to critique the ghettocentric genre from within and make a film that is realistic in its treatment of drugs and violence. The film is intended to illuminate and challenge established discourses about urban blackness and ghetto life – this is what Lee means when he states he had 'ideas about adding my own vision while still being true to the book'. For Richard Price, though, Lee's vision distorts the reality the novel represents. In interview, Price generally commends Lee's filmmaking but criticises several aspects of the film, all having to do with issues of realism. He argues that Lee fails to give Rocco 'an inner life' and thereby diminishes the reality of Strike too, and contends that the fragmentation of narrative and use of special camera effects press the film into didactic terrain where it becomes 'about issues, not about life'.[68] While the comments are carefully articulated and illustrated, there is the implication that Price's novel is truer to the reality of black ghetto life – an implication he hardens when he compares his and Lee's relationship to their subject matter:

I don't think filmmaking should be political advocacy. It is about the complexity of life.... It's not about which side you are on, it's about art. Why can't a guy just be an artist, and not have a social obligation to be part of the black team? Spike is a middle-class guy who went to a four-year college.... Why should Spike be more of an expert on the Gowanus projects than me or anybody else? He didn't grow up there.... I think I know more about that world than he does, and I know it only because I hung in and did all this first-hand work there. Being black doesn't make you an expert on poverty.[69]

Price's comments echo those he made following the novel's publication on the importance of his first-hand research in the Jersey projects and his fashioning of documentary material into art. In researching the projects he says he 'had to learn enough about the texture of *truth* out there in order to have the confidence to make up lies, responsible lies'.[70] However, here and elsewhere, Price's sensitivity to questions about authenticity and representation produces answers which blur the meaning of the relationship between art and responsibility, and between insiders and outsiders. As we have seen, his novel remains the work of an outsider largely due to his (and the implied reader's)

identification with Rocco, yet he continues to insist that 'art' tran-
scends lines of racial representation and point of view.

Ironically, Price's comments help draw attention to the all too
casual ways in which race and authenticity are intertwined in repre-
sentation while ignoring his own autobiographical essentialism in
prizing his ethnic and class roots. His question 'Why can't a guy just
be an artist?' seems naive in relation to the representational politics
surrounding race and ethnicity in the United States. It is instructive
to consider his question in relation to the view of a white filmmaker
on Lee's balancing of art and responsibility. In a symposium on Lee's
film *Do the Right Thing*, Paul Shrader comments:

I remember when I was young and very angry I wrote this movie *Taxi Driver*.
Spike Lee does not have that privilege; he doesn't have the privilege to be
angry. Society won't let him. It's too dangerous for a black person to be that
psychopathically angry at whites, the way that white character in *Taxi Driver*
was at blacks. It's just not allowed to him. Art doesn't need to be responsible.
Art can be incendiary. Art can be inflammatory. Spike has been held to an
extraordinary level of responsibility, and he has risen to it. Which is more
than we should ever ask of any artist, and to his great credit that he did.[71]

There is an honest directness about Shrader's comments – particularly
on his own treatment of race in *Taxi Driver* – but they also offer a
backhanded compliment to Lee that miscues the issue of responsi-
bility. Shrader criticises the restraints placed upon black artists 'in
the position of power', yet, like Price, assumes 'art doesn't need to be
responsible'. While decrying a double standard he also denies Lee
recognition of his powers of expression or of his own sense of
responsibility. (He also makes the questionable assumption that psy-
chopathic black anger is the structure of feeling Lee is restraining in
his filmmaking.)[72] Certainly, Lee is all too keenly aware of a special
burden of responsibility placed on black artists, but he defines this
as a responsibility he consciously embraces. 'White artists don't have
to face the burden that we have', he comments, 'We're artists and we
have to be responsible. It can become a delicate high-wire act. I've
always felt you have to try to get to the truth and let the chips fall
where they may'.[73] This statement speaks to the complex discourse
of realism that surrounds Lee's work and runs through it, combining
in tension the meanings of representation as the power to represent
the underrepresented and the aesthetics of realistic representation.
The issue of realism implicates both his positionality and his aes-
thetics in a way that is different from white filmmakers or authors.

Neither Price nor Lee are insiders of the world they seek in their

different ways to realistically depict in the novel and film. However, their references to 'truth' and 'responsibility' signal their recognition of a particular 'burden of association' that attends representations of black inner-city experience. There is a complex dialogue between the two texts, which cuts across broad fields of race and representation and implicates the unresolved tensions between white and black imaginaries of spatial justice.

Notes

1. Carlo Rotella, *October Cities: The Redevelopment of Urban Literature* (Berkeley, CA: University of California Press, 1998), p. 215.
2. Mike Davis, *City of Quartz: Excavating the Future in Los Angeles* (London: Verso, 1990), p. 270.
3. Robert Warshow famously described the gangster as a 'man of the city' in his essay 'The Gangster as Tragic Hero', in *The Immediate Experience: Movies, Comics, Theatre and Other Aspects of Popular Culture* (New York: Atheneum, 1971), pp. 41–63.
4. These directors were at the forefront of what Andrew Ross has described as 'the reign of Italian-American figures as the favoured, semi-integrated ethnic presence in Hollywood film.' Andrew Ross, 'Ballots, Bullets, or Batmen: Can Cultural Studies Do The Right Thing', *Screen* 31/1 (Spring 1990), p. 40.
5. This is not to say there have been no imaginative treatments of the white ethnic gangster since the 1970s. Quentin Tarantino, for example, has brought a postmodern sensibility to the genre, mining its conventions with an admixture of play and respect. In doing so he has both used racial stereotypes and borrowed heavily from black expressive culture to animate his white gangster figures. As Manthia Diawara observes, the film *Pulp Fiction* (1996) 'derives its narrative pleasure from the deployment of some of the most visible signs of black male pathology, black nihilism, and black youth as menace to society'. Diawara goes on to illustrate ways in which the recognisably Italian-American actor John Travolta 'plays' blackness in the film. Manthia Diawara in interview with Silvia Kolbowski, 'Homeboy Cosmopolitan', *October* 83 (Winter 1998), pp. 51–3. While television has all but exhausted the gangster genre, some signs of inventiveness are apparent here too, and again suggestive of urban transformation. The most critically acclaimed series of the 1999 season was the Home Box Office produced *The Sopranos*, which relocates the Italian-American gangster to New Jersey suburbs. While the series registers the loss of inner-city referents it finds considerable energy and satiric comedy in this transposition.
6. The African-American culture critic Nelson George recalls watching Blaxploitation films in his youth in Brownsville:
 Coming as it did after the riots of the sixties and during the massive

white flight of the Nixon years, blaxploitation presented an urban land-scape where blacks were at the center of the universe and whites, while still impacting on our lives from outside the core community, were less important to our day-to-day lives. . . . One of the chief appeals of blax-ploitation's best films . . . was that by changing the point of view of a generic film you could capture, even fleetingly, some glimpse of our urban reality.

Nelson George, *Blackface: Reflections on African-Americans and the Movies* (New York: Harper Collins, 1994), p. 30.

7. David Simon, *Homicide: A Year on the Killing Streets* (Boston, MA: Houghton, 1991). This book became the basis for the NBC series titled *Homicide*. It also coincided with the popular emergence of voyeuristic 'reality TV' shows depicting the policing of inner cities.

8. Christopher P. Wilson, 'True and True(r) Crime: Cop Shops and Crime Scenes in the 1980s', *American Literary History* (Fall 1998), pp. 720–1.

9. Raymond Chandler, 'Introduction', *The Smell of Fear* (London: Hamish Hamilton, 1973), p. 9.

10. Toni Morrison, *Playing in the Dark: Whiteness and the Literary Imagination* (New York: Random House, 1992), p. 17.

11. Richard Slotkin, *Gunfighter Nation: The Myth of the Frontier in Twentieth Century America* (New York: Atheneum, 1992), p. 154.

12. Ibid., p. 219.

13. *Black Mask* magazine, which was central to the development of hard-boiled detective fiction as a discreet genre in the 1920s, published a 'Ku Klux Klan Number' in 1923, and throughout the decade published stories in which the presence of African-Americans (and selected immigrant groups) connotes pathological violence, sexual licence, lack of civilisation, and absence of morality. See Frankie Y. Bailey, *Out of the Woodpile: Black Characters in Crime and Detective Fiction* (Westport, CT: Greenwood Press, 1991), pp. 41–3.

14. For a stimulating analysis of racial introjection in 'the construction of American whiteness', see Eric Lott, 'White like Me: Cross-Dressing and the Construction of American Whiteness', in Amy Kaplan and Donald Pease (eds), *Cultures of United States Imperialism* (Durham, NC: Duke University Press, 1993), pp. 474–8.

15. Dashiell Hammett, *The Dain Curse* in *Dashiell Hammett: Five Complete Novels* (New York: Avenel, 1980), pp. 152–60.

16. Raymond Chandler, *Farewell, My Lovely* (Harmondsworth: Penguin, 1949), pp. 7–18.

17. David Theo Goldberg, *Racist Culture: Philosophy and the Politics of Meaning* (Oxford: Blackwell, 1993), p. 186.

18. Davis, *City of Quartz*, p. 20.

19. Quoted in Lynell George, *No Crystal Stair: African-Americans in the City of Angels* (London: Verso, 1991), p. 17.

20. Chester Himes, *If He Hollers Let Him Go* (London: Pluto, 1945, 1986), p. 153.

21. Goldberg, *Racist Culture*, p. 205.

22. Charles L. P. Silet, 'The Other Side of Those Mean Streets: An Interview With Walter Mosley', *The Armchair Detective* 26/4 (1993), p. 11.

23. Richard Maidment (ed.), *American Conversations* (London: Hodder and Stoughton, 1995), p. 68.

24. Silet, 'The Other Side', p. 12.
25. Walter Mosley, *White Butterfly* (London: Pan, 1992, 1994), p. 17.
26. Walter Mosley, 'The Black Dick', in Philomena Mariani (ed.), *Critical Fictions: The Politics of Imaginative Writing* (Seattle, WA: Bay Press, 1991), pp. 132–3.
27. Walter Mosley, *Devil in a Blue Dress* (London: Pan, 1990, 1992), p. 135. Further page references will appear in the text.
28. See bell hooks, 'Representing Whiteness in the Black Imagination', in Lawrence Grossberg, Cary Nelson and Paula A. Treichler (eds), *Cultural Studies* (London: Routledge, 1992), pp. 338–46.
29. Mosley has observed 'poverty is tattooed on black and brown skins. Ignorance and violence, sex and criminality are deeply etched in Hispanic and African hues. If you're not white it is hard to get out of the slums'. Mosley, 'The Black Dick', p. 132.
30. Maidment, *American Conversations*, p. 71.
31. The issue of rights is made violently explicit when Easy is arrested by two white policemen: '"I've got the right to know why you're taking me" [Easy]. "You got a right to fall down and break your face, nigger. You got a right to die" [policeman]. . . . Then he hit me in the diaphragm' (p. 75).
32. More than a sign of economic independence, Easy's house is an important site of psychic security. It is a deeply subjective space in the novel where Easy's propensity for self-reflection is often at its most intense. As such it follows a tradition in African-American literature of representing the house as 'inside space', a semi-autonomous realm of belonging and identity. See Charles Scruggs, *Sweet Home: Invisible Cities in the Afro-American Novel* (Baltimore, MD: Johns Hopkins University Press, 1993).
33. Kobena Mercer and Isaac Julien, 'Race, Sexual Politics and Black Masculinity: A Dossier', in Rowena Chapman and Jonathan Rutherford (eds), *Male Order: Unwrapping Masculinity* (London: Lawrence and Wishart, 1988), p. 99.
34. In the hard-boiled genre the male hero's subjectivity is often split or decentred as a position of narrative authority. See Frank Krutnik, *In A Lonely Street: Film Noir, Genre, Masculinity* (London: Routledge, 1991), pp. 128–9.
35. See Mary Ann Doane, *Femmes Fatales: Feminism, Film Theory, Psychoanalysis* (London: Routledge, 1991).
36. Silet, 'The Other Side', p. 12.
37. Mike Davis, *City of Quartz*, pp. 15–97.
38. Ibid., pp. 221–63.
39. Richard Price, *Clockers* (London: Phoenix, 1995).
40. See, for example, Luc Sante, 'The Possessed', *The New York Review of Books*, 16 July 1992, p. 25; Ron Rosenbaum, 'Return of the Wanderer,' *Vanity Fair* 55/6 (June 1992), p. 164; and Jim Shepard, 'Sympathy for the Dealer', *The New York Times Book Review*, 21 June 1992, p. 10.
41. Sante, 'The Possessed', p. 25.
42. In interview with James Linville, 'Richard Price: The Art of Fiction CXLIV', *Paris Review* 138 (1996), p. 145.
43. Wilson, 'True and True(r) Crime', p. 720.
44. Tom Wolfe, 'Stalking the Billion-Footed Beast: A Literary Manifesto for the New Social Novel', *Harper's Magazine* (November 1989), p. 45.
45. Quoted in Alex Clark, 'A Black and White View', *Guardian*, 9 July 1998, p. 6.

46. Whitney Balliett, 'Rewinding "Clockers"', *The New Yorker*, 5 October 1992, p. 176.
47. Jim Shepard, 'Sympathy for the Dealer', p. 10.
48. Sante, 'The Possessed', p. 25.
49. Quoted in Clark, 'A Black and White View', p. 7.
50. Rosenbaum, 'Return of the Wanderer', p. 163.
51. Linville, 'Richard Price', p. 159.
52. Peter Brooker comments on 'the importance of commercial and artistic success' to Price and other working-class writers within the social realist tradition. Peter Brooker, *New York Fictions: Modernity, Postmodernism, The New Modern* (London: Longman, 1996), p. 148, p. 169.
53. Rosenbaum, 'Return of the Wanderer', p. 162.
54. Clark, 'A Black and White View', p. 7.
55. Wilson, 'True and True(r) Crime', p. 721.
56. Linville, 'Richard Price', p. 155.
57. Stephen Pizello, 'Between "Rock" and a Hard Place', *American Cinematographer* (September 1995), p. 37.
58. Quoted in Judy Sloane, 'Inside Story: Spike Takes on the Blockbusters', *Film Review* 582 (June 1999), p. 10.
59. Leonard Quart, 'Spike Lee's *Clockers*: A Lament for the Urban Ghetto', *Cineaste* (1996), p. 9.
60. Ibid.
61. Deborah E. McDowell, 'R.I.P./RIP: Memorial Wall Art – A Peaceful Disturbance', *Radical America* 26/1 (1996), p. 49.
62. Pizello, 'Between', p. 36.
63. Ibid., p. 40.
64. Ibid., p. 43.
65. Amy Taubin, 'Clocking In', *Village Voice*, 19 September 1995, p. 71.
66. Ibid.
67. Quart, 'Spike Lee's *Clockers*, p. 11.
68. Leonard Quart and Albert Auster, 'A Novelist and Screenwriter Eyeballs the Inner City: An Interview with Richard Price', *Cineaste* (1996), p. 15.
69. Ibid., p. 14.
70. Linville, 'Richard Price', p. 149.
71. '"Do the Right Thing": Issues and Images', *The New York Times*, 9 July 1989, p. A23.
72. Shrader implies that the psychopathic anger of *Taxi Driver* is simply unavailable to Lee, but this is disingenuous. The anger expressed by Travis Bickle in the film is distinctively coded as white, drawing on narratives and mythologies of white American masculinity in its construction. See Chapter 1 of this study for commentary on how the film *Falling Down* makes similar references, including reference to *Taxi Driver*.
73. Quoted in Sloane, 'Inside Story', p. 10.

Citizens and Strangers

Race has proved 'a privileged metaphor' in representations of the city, promising to make legible the meanings of urban transformation for American society as a whole. As we have seen, however, it is a volatile and over-determined metaphor that is as often used to elide rather than illuminate the conditions of social inequality and spatial exclusion in urban centres. Infused with fears and fantasies, memories and desires, it metaphorises complex and conflicting urban imaginaries. Cast as the symbolic vehicle of 'the American dilemma' it continues to be perceived as 'a problem', unsettling the boundaries and meanings of citizenship. John Edgar Wideman implicitly understands this when he has one of his narrators in *Philadelphia Fire* assert the need for Americans to 'begin disentangling ourselves from this miasma, this fever of shakes and jitters, of self-defeating selfishness called urbanization'.[1] Conscious of his own use of metaphor here, Wideman uses 'miasma' to refer to an ongoing history of separations and exclusions: 'the unresolved question of slavery, the unresolved question of racism, the unresolved question of majority rule that leads to majority domination and oppression'.[2] Positioning race as the crux of unresolved questions (rather than the source of unresolvable problems) he attempts to open a provisional space for imagination and discourse to prepare some answers and begin the act of disentanglement.

Human separation characterises the urban condition Wideman describes and he finds it powerfully maintained and policed in central Philadelphia. The operations of power in urban space cannot be ignored for, as we have seen throughout this study, space is a modality through which racial relations of domination and subordination are naturalised. The operations of power are everywhere evident in space: space is hierarchical – zoned, segregated, gated – and encodes

both freedoms and restrictions – of mobility, of access, of vision – in the city. As David Goldberg argues, 'the rationality of social space . . . is a fundamental determining feature in the social relations of power and their reproduction. The built environment is made in, and reifies, the image and architecture of "pyramidal power" '.[3] In *Philadelphia Fire* Wideman provides us with a less abstract depiction of the operations of power in space when one of the narrators ascends a hill to the entrance of the art museum and turns to survey the neatly planned vista of the city with City Hall at the centre of the horizon. Observing the people at leisure in the museum's grounds and the police cars slowly patrolling the space, he reflects on the barely visible 'rules' at work:

Everybody had zones. Addicts, prostitutes, porn merchants, derelicts. Even people who were black and poor had a zone. Everybody granted the right to lie in the bed they had made for themselves. As long as they didn't contaminate good citizens who disapproved. . . . As long as everybody knew they had to give up their zone, scurry down off this hill, no questions asked, when the cops blow the whistle.[4]

The zoning referred to here is geographical and imaginary, marking the spatial difference between citizens and strangers in the formation of urban identities. Universal norms of justice and rights (under the symbol of City Hall) are delimited by this zoning, setting boundaries on recognition of those who are and are not active participants of the civic polis.

This zoning of the urban populace, Wideman proposes, blights the performance and possibilities of citizenship in public space. It is both a social and mental form of separation that exacerbates the 'miasma of urbanization'. Literary and visual representations of the American city have contributed to this separation – aggravating the fear and paranoia surrounding urban race relations – and sought to bridge it through imaginative acts of empathy and narratives of interconnectedness. The act of imaginative bridging is rife with contradictory investments though, as we have seen in many instances in this study. Alex Kotlowitz, for example, promotes empathy with figures of black urban poverty in an attempt to meliorate misunderstandings and prejudices, yet also reproduces common assumptions about the underclass. Richard Price imaginatively gets 'inside' the character of a young black drug dealer, but ultimately tells us much more about the inner life of a white cop (and about his own urban passage). These are valuable and informative acts of imagination

in their intentionality, but they also evidence the difficulties of 'disentangling ourselves' from established perceptions and structures of feeling surrounding race and the city.

Wideman, too, inscribes contradictory investments in his literary representation of the city. On the one hand, challenging his reader to imagine 'the ashes of this city we share', he posits an imagined community – civic and national – connected by urban crisis.[5] Asserting the need for a collective act of imagination to spur remedial action he reanimates James Baldwin's jeremiad vision of 'the fire next time' and views his own writing as an attempt 'to bridge, to synthesize past, present and future sources' of the fevered misunderstandings surrounding racial difference in the city.[6] On the other hand, Wideman questions the legitimacy of literature as a mode of communication between different communities and questions the role of the writer as a reporter and mediator of urban crisis. Unable to invest literature with a clear social purpose or confidently address an implied audience his writing represents urban social relations as a fragmented, polyphonic 'community of strangers'.[7] Wideman's difficulty in maintaining narrative order in his representation of the city registers his anxiety about the inevitable 'distortion' that attends efforts to imaginatively suture spaces of difference within narratives of interconnectedness. It also reflects a more widespread loss of coherence in the idea of the city as a synthetic totality and crucible of nationhood. His writing is both a critical response to and symptomatic of a post-national crisis of urban representation.

What Wideman's writing ambivalently attests to is the loss of the spatial promise of the city as a site of American identity formation, a promise shared by many cultural producers throughout the twentieth century who articulated their understanding of the city as a totality. For much of the century, stories of and about the American city have been stories about the making of Americans. 'Urbanism as a way of life' made the modern American city 'center and symbol of our times'.[8] In doing so it affirmed the interests of a national symbolic order, containing dissensus within a closed system of symbolic struggles (to assimilate, to escape the ghetto) and positing the city as the privileged site of Americanisation, thereby perpetuating the exceptionalist ideology that claims the United States as a microcosm of the world. In the last twenty years, processes of economic and cultural globalisation and of transnational migrancy have destabilised this symbolic order, revealing the permeability of both material and imaginary borders. These processes are opening up a closed national system, drawing attention to what Homi Bhabha calls 'the disjunctive,

liminal space of national society' that eludes totalisation as it emerges from the volatile realignment of relations between the local, the national and the global.[9] In this realignment the central city is a principal (though by no means the only) site of new struggles over representation and identity and of new articulations of national and transnational association.

It is now widely argued that to the degree that American cities represent the localisation of global forces in their built environments and social fabrics they signify the exhaustion of national modes of citizenship. Affirming the role of cities as 'the strategic arena for the development of citizenship', James Holston and Arjun Appadurai argue that they have displaced the role of the nation state in defining the meaning of membership in society:

With their concentrations of the nonlocal, the strange, the mixed, and the public, cities engage most palpably the tumult of citizenship. Their crowds catalyze processes which decisively expand and erode the rules, meanings, and practices of citizenship. . . . But if cities have historically been the locus of such tumult, they experience today an unsettling of national citizenship which promises unprecedented change . . . cities are challenging, diverging from, and even replacing nations as the important space of citizenship – as the lived space not only of its uncertainties but also of its emergent forms.[10]

The 'unsettling of national citizenship' has been a common theme of urban representation in the 1980s and 1990s – as we have seen, discourses of urban decline have acted as a symbolic screen for its projection in a wide range of narratives and images. These discourses, though, have struggled to contain the urgent questions about power, representation and identity emergent from the dislocations of nation-hood and citizenship.

What Holston and Appadurai view as a growing disjunction 'between national space and its urban centres' has important implications for the representation and meanings of race as a 'privileged metaphor' of American urbanism.[11] On the one hand, it suggests that as citizenship is reconstituted race must be reconfigured as a metaphor of urbanism to re-present the relations between local and global modes of identity formation. There is evidence of such reconfiguration, as many critics and cultural producers have begun to map dynamic features of cultural and textual exchange within transcultural frameworks. They register 'the constitutive potency of space' as diasporic networks of association compose imaginary geographies of race and ethnicity that redefine ideas of territory, place and community in transformed urban cores.[12] On the other hand, proponents

of globalisation and postmodern urbanism have promoted the cultural primacy of the city in a manner which has all but erased race as a constitutive feature of citizenship and celebrated ethnicity as the model for urban 'diversity' and 'multiplicity'.[13] The breakdown in nationality does not necessarily betoken a more democratic public sphere of citizenship – of civility and urbanity – for racialised minorities in the American city. Global influences have in many ways intensified the 'underlying relations of repression, surveillance and exclusion' in contemporary urbanism, restricting access to representation in the pseudo-public spaces of revitalised urban cores.[14] The compaction and reterritorialisation of cultural groups in the central city may produce pressure for new forms of citizenship but it has also been responded to with heightened forms of segregation and privatisation. Race remains a potent metaphor of irreducible difference and disassociation in the drama of citizenship.

The postnational crisis of urban representation refers both to the exhaustion of established modes and narratives of representation and the emergence of new ones around the reconfigured issues of citizenship in the American city.[15] Increasingly, the axis of white (WASP and ethnic) and black (African-American) urban relations seems incommensurate to the drama of citizenship the city promotes. Yet, even in its dislocation, reflecting the growing disjunction between urban space and the space of the nation, this axis continues to shape representations of race in the United States and reflect the 'conflicts of belonging' that attend the socio-spatial transformations of the city.[16] The city remains both a primal and strategic scene for representations of blackness in the white imagination and representations of whiteness in the black imagination. It is a palimpsest of these imaginings, of different histories of urban passage and association and of different claims to entitlement and belonging. As such it inscribes both the transparent presence and the signifying absence of race in the productions of urban space.

Notes

1. John Edgar Wideman, *Philadelphia Fire* (New York: Vintage, 1990), p. 157.
2. Charles H. Rowell, 'An Interview with John Edgar Wideman', in Bonnie TuSmith (ed.), *Conversations with John Edgar Wideman* (Jackson, MI: University Press of Mississippi, 1998), p. 100.

3. David Theo Goldberg, '"Polluting the Body Politic": Racist Discourse and Urban Location', in Malcolm Cross and Michael Keith (eds), *Racism, the City and the State* (London: Routledge, 1993).

4. Wideman, *Philadelphia Fire*, pp. 45–6.

5. Ibid., p. 120.

6. Rowell, 'An Interview', p. 100.

7. Jan Clausen, 'Native Fathers', *Kenyon Review* 14/2 (1992), p. 50.

8. I refer here to Louis Wirth's now classic essay 'Urbanism as a Way of Life', first published in 1938, reprinted in Richard T. LeGates and Frederic Stout (eds), *The City Reader* (London: Routledge, 1996), pp. 189–97, and to Philip Kasinitz (ed.), *Metropolis: Center and Symbol of Our Times* (London: Macmillan, 1994). The impetus of the myth of the American city as 'center and symbol of our times' needs to be questioned, as do attendant claims for the American metropolis as the epicentre of a universal modernity (and now postmodernity), or as the privileged locus of globalism and its urban futures.

9. Homi Bhabha, 'Dissemination: Time, Narrative, and the Margins of the Modern Nation', in Homi Bhabha (ed.), *Nation and Narration* (London: Routledge, 1990), p. 312.

10. James Holston and Arjun Appadurai, 'Cities and Citizenship', *Public Culture* 8 (1996), pp. 188–9.

11. Ibid., p. 189.

12. Paul Gilroy, 'Diaspora', *Paragraph* 7 (1997), p. 207.

13. In their analysis of postmodern urbanism Michael Keith and Malcolm Cross argue: 'Ethnicity is acceptable, or even celebrated, in the collage of the exotic cultural pick-and-mix, while race remains a taboo vestige of colonial and neo-colonial exploitation which was, and is, anything but playful. But like all taboos, it remains ever present, even in the systematic silences and exclusions', Michael Keith and Malcolm Cross, 'Racism and the Postmodern City', in Cross and Keith (eds), *Racism, the City and the State*, p. 8.

14. Mike Davis, *City of Quartz: Excavating the Future in Los Angeles* (London: Verso, 1990), p. 238.

15. New modes (and technologies) of representation are also evident in mass media responses to the loss of coherence and confidence in the idea of the city as a synthetic totality. A striking example is the use of the TV skycam – helicopter-based cameras – in local news coverage of American cities. The airborne lens brings a new legibility to urban representation; it promises to make the city both knowable and governable through its panoramic surveillance and its 'line-of-sight' access to both private and public spaces. Notably, the city it attaches the viewer to is a dysfunctional space of crime, congestion and disaster. See Pascal Pinck, 'From the Sofa to the Crime Scene: Skycam, Local News and the Televisual City', in Maria Balshaw and Liam Kennedy (eds), *Urban Space and Representation* (London: Pluto Press, 1999), pp. 81–101.

16. Holston and Appadurai, 'Cities and Citizenship', p. 201.

Index